BERLIN

architektur und kunst

art and architecture

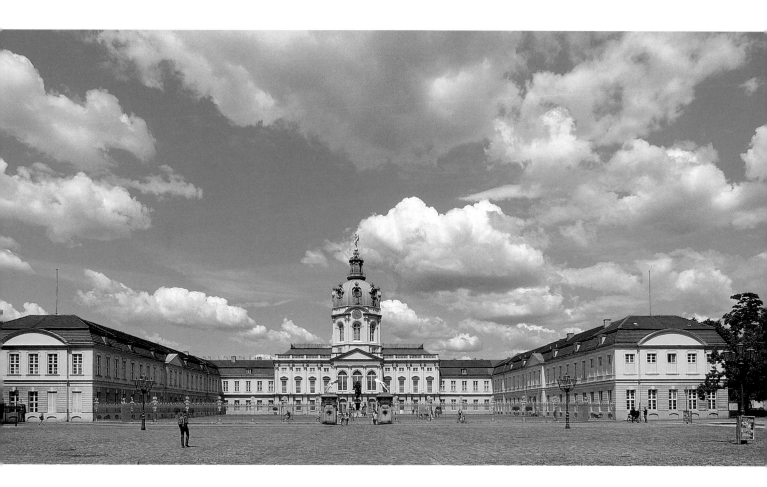

Michael Imhof Verlag

Inhalt

contents

20./21. Jahrhundert 130

20th/21st century *130*

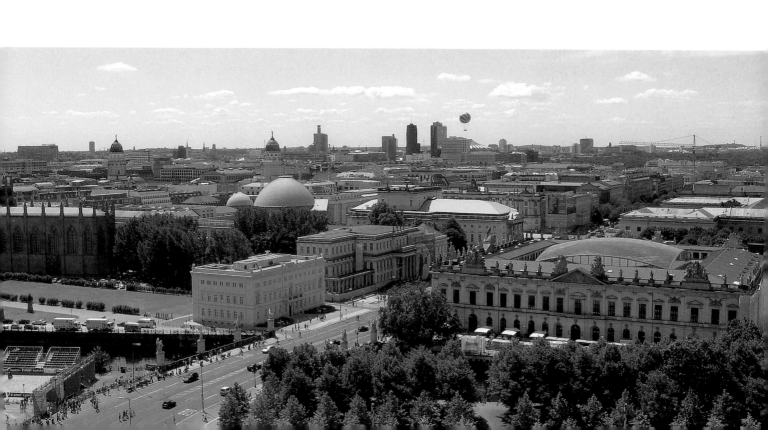

Mittelalter

Geschichte

Im 6. und 7. Jahrhundert wanderten slawische Siedlergruppen aus dem Süden und Osten in das fast unbewohnte und wahrscheinlich auch herrschaftsfreie Gebiet des heutigen Berlin ein. Die slawischen Stämme errichteten kleine Ansiedlungen mit meist ebenerdigen Häusern in Blockbauweise. Ackerbau und Viehzucht bildeten ihre Lebensgrundlage. Hinzu kamen handwerkliche Tätigkeiten wie Weben, Eisen- und Knochenverarbeitung sowie Töpfern. Mehrere Dörfer besaßen gemeinsam eine Burganlage und bildeten so einen Stammesverbund. Hauptorte innerhalb des heutigen Berliner Stadtgebiets waren seit der Zeit um 700 Spandau (am Zusammenfluss von Spree und Havel) und Köpenick (am Zusammenfluss von Spree und Dahme). Beide Ortschaften entwickelten sich um eine Burganlage in einer geschützten Insellage.

Im 10. Jahrhundert versuchten die ottonischen Herrscher des Römischen Reichs deutscher Nation ihr Reich nach Osten zu erweitern. 928/29 gelang es König Heinrich I. (919-36), Brandenburg zu erobern. Sein Nachfolger Otto der Große (936–73) unterwarf alle Gebiete bis zur Oder und versuchte durch die Errichtung der Mark Meißen und der Mark Lausitz sowie der Bistümer Brandenburg und Havelberg die Herrschaft in diesem Gebiet zu sichern. Doch schon 983 mussten sich die ottonischen Herrscher nach dem großen Slawenaufstand, bei dem unter anderem Spandau zerstört wurde, bis hinter die Elbe zurückziehen.

rechts: Museumsdorf Düppel in Berlin-Zehlendorf, Rekonstruktion eines kleinen hufeisenförmig angelegten Dorfes um 1200. Auf dem Stadtgebiet Berlins sind weitere über 30 Wüstungen aus dem Mittelalter bekannt, die oft schon während der ersten Besiedlungsphase aufgegeben worden waren. Auch die Siedlung des Museumsdorfs Düppel existierte nur etwa 30 Jahre. Da sie nicht überbaut wurde, konnte sie authentisch mit ihren Blockhäusern, darunter einer Schmiede, einem Backhaus und einem Getreidespeicher, rekonstruiert werden. Die Siedlung bestand aus 14 Gehöften, gruppiert um einen ovalen Dorfplatz und geschützt durch eine befestigte Toranlage. Die Anordnung der Häuser in Form eines Haufendorfs hatte ohnehin keinen längeren Bestand. Stattdessen setzten sich große Anger- und Straßendörfer durch. Zu den Dorfgründern gehörten auch die Templer, die mit Tempelhof, Marienfelde und Mariendorf eine Komturei bauen und hier vom Markgrafen aus militärischen Gründen angesiedelt wurden.

Middel Ages

History

In the 6th and 7th centuries, groups of Slavic settlers emmigrated from the south and east into the area of what is now Berlin, then an almost uninhabited region, probably also without a ruler. The Slavic tribes erected small settlements of largely single-storey dwellings built in the style of log cabins. Their lives were based on tilling the land and animal husbandry, plus manual crafts such as weaving, working with iron and bone, and making pottery. Several villages would jointly own one castle complex, thus forming a tribal union. From around the year 700, the key locations in the area of present-day Berlin were Spandau (at the confluence of the Spree and the Havel) and Köpenick (at the confluence of the Spree and the Dahme). Both towns developed around a castle complex in a protected island location.

In the 10th century, the Ottonian rulers of the Holy Roman Empire of the German Nation attempted to extend their empire eastwards. In 928/29, King Heinrich I (919-36) succeeded in conquering Brandenburg. His successor, Otto the Great (936-73), subjugated all districts as far as the Oder and tried to secure control of this region by setting up the marks of Meißen and Lausitz, plus the dioceses of Brandenburg and Havelburg. However, as early as 983, following the great Slav uprising, during which Spandau amongst other towns was destroyed, the Ottonian rulers had to pull back beyond the Elbe.

Right: Düppel museum village in the Zehlendorf district of Berlin, a reconstruction of a small horseshoe-shaped village c. 1200. Over 30 other villages from the Middle Ages are known of in the Berlin area, many of which were abandoned during the first phase of settlement. The Düppel museum village settlement also only existed for around 30 years. However, as it was never overbuilt, it has been possible to produce an authentic reconstruction of its log-cabin buildings, including a smithy, a bake house and a wheat store. The settlement consisted of 14 homesteads grouped around an oval village green and protected by a fortified gateway structure. This concept of arranging houses in a clustered village form did not, however, have a long life, with large meadow and street-based villages coming to the fore instead. The founders of these villages included the Templars, who with Tempelhof, Marienfelde and Mariendorf built a commandery, where for military purposes the margraves settled.

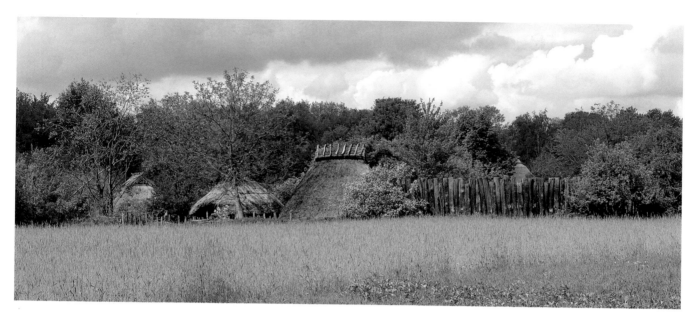

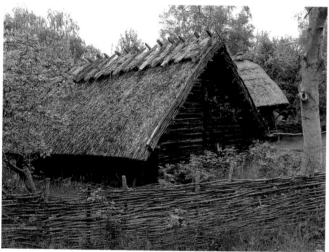

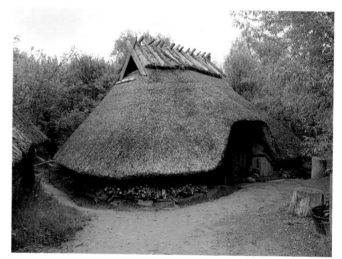

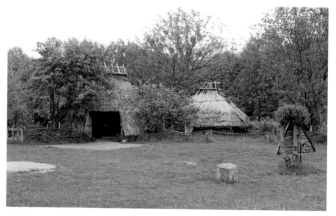

Die Anfänge von Berlin-Mitte, dem heutigen Zentrum Berlins, fallen in den Zeitraum der allmählichen Landnahme des von slawischen Stämmen besiedelten Gebiets zwischen Elbe und Oder durch deutsche Territorialfürsten. In Brandenburg herrschte der 1127 zum Christentum übergetretene Hevellerfürst Pribislaw-Heinrich, der Unterstützung beim deutschen König Lothar III. und dem ostsächsischen Hochadel suchte. Besonders enge Beziehungen bestanden zu Albrecht dem Bären aus dem Haus der Askanier, der im Raum um Köthen, Bernburg und Aschersleben (heute nördliches Sachsen-Anhalt) herrschte und den der kinderlose Pribislaw-Heinrich zu seinem Erben bestimmte. 1150 konnte Albrecht die Herrschaft in Brandenburg übernehmen. Nachdem bis 1157 die kriegerischen Auseinandersetzungen mit einem slawischen Herrscher namens Jaxa, bei dem es sich wahrscheinlich um den Sprewanenfürsten in Köpenick handelte, beendet waren, trug Albrecht den Titel „Markgraf von Brandenburg". Noch während seiner Regierungszeit (bis 1170) begann der Landesausbau mit der Anwerbung und Ansiedlung deutscher Bauern und Handwerker sowie die Errichtung von Städten und neuen Dörfern. Bis zum 13. Jahrhundert war der askanische Herrschaftsbereich bis zur Oder ausgedehnt.

In diesem Zusammenhang entstanden – getragen von Kaufleuten und Fernhändlern – beiderseits der Spree um 1170 an einem günstigen Flussübergang die Städte Cölln, am Südwestufer auf einer von einem Nebenarm der Spree gebildeten Insel, und Berlin, am Nordostufer der Spree. Beide Siedlungen besaßen schon im ausgehenden 12. Jahrhundert jeweils eine Kirche mit Friedhof. St. Nikolai bildete die Keimzelle von Berlin, St. Petri diejenige Cöllns. Gegen 1250 wurde Berlin um die

The beginnings of Berlin-Mitte, the present-day centre of Berlin, come from the time when German territorial princes gradually took control of the district between the Elbe and the Oder settled by the Slavic tribes. Brandenburg was ruled by the Heveller prince Pribislaw-Heinrich, who had converted to Christianity in 1127. Pribislaw-Heinrich sought support from the German King Lothar III and the nobility of East Saxony. He established a particularly close relationship with Albrecht the Bear from the House of the Ascania, who ruled the area around Köthen, Bernburg and Aschersleben (now northern Saxony-Anhalt), who made the childless Pribislaw-Heinrich his heir. In 1150, Albrecht succeeded in taking control of Brandenburg. From 1157, by which time an end had come to the warlike disputes with a Slavic ruler known as Jaxa, probably the Sprevjane prince in Köpenick, Albrecht carried the title 'Margrave of Brandenburg'. Even during the period of his rule (until 1170), the region began to be developed with the enlisting and settlement of German farmers and craftsmen and the construction of towns and villages. By the 13th century, the area under Ascanian rule had extended to the Oder.

In this connection – supported by merchants and regional traders – two towns emerged around 1170 on either side of the Spree at a convenient river crossing: Cölln, on the southwest bank on an island formed by one of the Spree's tributaries, and Berlin, on the northeast bank of the Spree. As early as the end of the 12th century, both settlements possessed a church and graveyard. St. Nikolai formed the nucleus of Berlin, St. Petri that of Cölln. Shortly before 1250, Berlin was extended by the addition of the new town with its Marienkirche (St. Mary's Church). The first mention of Cölln was made in 1237, that

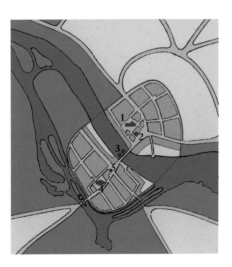

Doppelstadt Cölln-Berlin um 1200

The twin city of Cölln-Berlin c. 1200

1. *St. Nikolaus*
2. *Berliner Rathaus (Berlin Town Hall)*
3. *Mühlendamm (Millbank)*
4. *St. Peter*
5. *Cöllner Rathaus (Cölln Town Hall)*

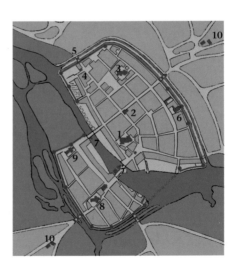

Doppelstadt Cölln-Berlin zu Beginn des 15. Jahrhunderts

The twin city of Cölln-Berlin at the start of the 15th century

1. *St. Nikolaus*
2. *Berliner Rathaus*
3. *St. Marien*
4. *Hl.-Geist-Spital*
5. *Spandauer Tor*
6. *Franziskanerkirche*
7. *Rathaus*
8. *St. Peter*
9. *Dominikanerkirche*
10. *Hospital*

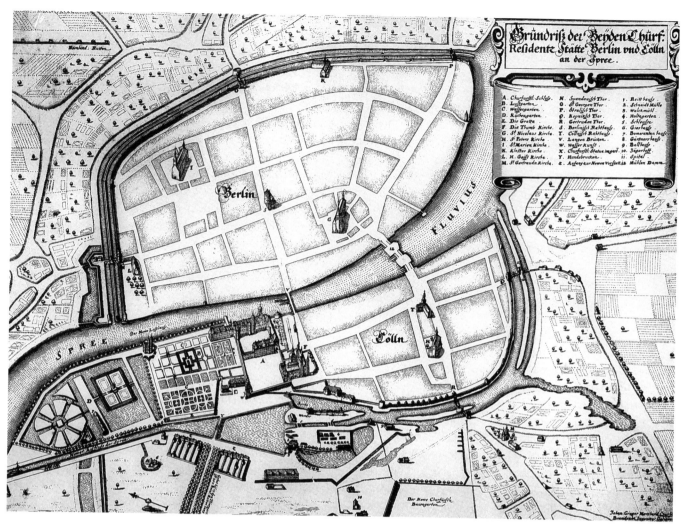

Geosteter Plan der Doppelstadt Berlin-Cölln an der Spree, Kupferstich von Johann Gregor Memhardt, 1652. Hervorgehoben sind – in Vogelperspektive dargestellt – die Rathäuser in der Mitte von Berlin und Cölln sowie die Kirchen St. Nicolai, St. Marien und an der Stadtmauer die Franziskanerkirche (oben) und die Heiliggeistkapelle (links) sowie St. Petri in Cölln. Der Schlossbereich befindet sich links unten.

Overhead plan of the twin city of Berlin-Cölln on the Spree. Copper etching by Johann Gregor Memhardt, 1652. Emphasised and portrayed in birdseye view are the town halls in the middle of Berlin and Cölln, the St. Nicolai and St. Marien churches, and, next to the city wall, the Franciscan Church (top) and the Chapel of the Holy Spirit (left), plus St. Peter's Church in Cölln. The palace area is bottom left.

Legende

A	Churfürstl. Schloß	H	St. Peters Kirche	Q	Kepniksch Thor	Y	Hundsbrucken
B	Lustgarten	I	St. Marien Kirche	R	Gertruden Thor	Z	Anfang zur Newen Vorstatt
C	Wassergarten	K	Kloster Kirche	S	Berlinisch Rahthauß		
D	Küchengarten	L	H. Geist Kirche	T	Cöllnisch Rahthauß	1	Reitthauß
E	Die Grotta	M	St. Gertraudn Kirche	V	Langen Brücken	2	Schneidt Mühle
F	Die Thumb Kirche [Domkirche]	N	Spandauisch Thor	W	Wasser Kunst	3	Walckmühl
G	St. Nicolaus Kirche	O	St. Georgen Thor	X	Churfürstl. Statua im gart.	4	Holtzgarten
		P	Stralisch Thor			5	Schleuße

6	Gieshauß
7	Bomerantznhauß
8	Gärtnershauß
9	Ballhauß
10	Jägerhoff
11	Spital
12	Mühlen Damm

Neustadt mit der Marienkirche erweitert. Die erste Erwähnung Cöllns erfolgte 1237, diejenige Berlins 1244. Zu diesem Zeitpunkt besaßen bereits beide Orte Stadtrecht. Die Doppelstadt – seit 1307 zu einer Bundesstadt zusammengeschlossen – entwickelte sich rasch zur wichtigsten Ortschaft der Mark Brandenburg und war seit dem 14. Jahrhundert Teil der Hanse. Seit dem späten 13. Jahrhundert erbaute man die Stadtmauer mit doppeltem, von der Spree gespeistem Graben und der aus Feldsteinen errichteten Mauer. Um 1450 zählte man in Cölln 300 und in Berlin 700 Häuser, in denen insgesamt 5000 bis 6000 Menschen lebten.

Von den baulichen Zeugnissen der älteren Teilstadt Cölln sind nach schweren Kriegszerstörungen im 2. Weltkrieg und den Flächenabrissen in den 1960er-Jahren nur noch Ansätze nachvollziehbar. Das ehemals bedeutendste Gebäude – die Petrikirche an der Gertraudenstraße, zuletzt 1846–53 nach Entwurf von Heinrich Strack neugotisch erneuert – wurde nach Kriegsschäden 1960–64 beseitigt. An das 1297 gegründete Kloster der Dominikaner erinnert der Name der Brüderstraße. Die Kirche des Dominikanerklosters bezog man 1536 als Domkirche und Grablege der Hohenzollern in den kurfürstlichen Hofbereich ein. Außerhalb der Stadt lag unmittelbar vor dem Gertraudentor das ebenfalls seit dem späten 13. Jahrhundert bestehende Gertrauden-Spital, das dem späteren Spittelmarkt den Namen gab. Das Cöllnische Rathaus lag an der Ecke Breite Straße/Gertraudenstraße.

Geprägt wurde das mittelalterliche Stadtbild des jüngeren Stadtteils Berlin von seinen Pfarrkirchen, die gleichzeitig die Märkte der Stadt markierten: von der Nikolaikirche, die in den 1240er-Jahren romanisch vollendet und später gotisch erneuert wurde, und von der jüngeren Marienkirche, mit der um 1270 begonnen wurde. Das Rathaus verlegte man Mitte des 13. Jahrhunderts genau zwischen den beiden Märkten an die Spandauer Straße, nachdem das ältere Rathaus noch östlich von St. Nicolai gelegen hatte. Ältester profaner Massivbau war das „Hohe Haus" der brandenburgischen Markgrafen an der Klosterstraße, das vielleicht bereits in den 1240er-Jahren errichtet worden war. Kurz vor 1250 siedelten sich in unmittelbarer Nähe die Franziskaner an, deren stattliche frühgotische Klosterkirche als Kriegsruine erhalten ist. Hinzu kamen mit dem erstmals 1272 genannten Heiliggeist-Spital an der Spandauer Straße nahe dem Spandauer Tor und dem außerhalb der Stadt erbauten Georgen-Spital vor dem Oderberger Tor im Nordwesten weitere kirchliche Gründungen.

of Berlin in 1244. By this time, both places already possessed city rights. The twin city – having merged into one in 1307 – quickly grew into the most important place in the Mark of Brandenburg and from the 14th century was part of the Hanseatic League. In the late 13th century, work began on the city wall, consisting of a double moat, fed by the Spree, and the wall itself, built in stone. Around 1450, Cölln had 300 houses and Berlin 700, which were home in total to between five and six thousand people.

Following major destruction in the Second World War and wholesale land clearance in the 1960s, only signs of the architectural heritage of the older part of Cölln can still be traced. What was formerly the most significant building, the Petriskirche (St. Peter's Church), which had last been restored in 1846-53 to a Neo-Gothic design by Heinrich Stack, was demolished in 1960-64, having been badly damaged in the War. The name 'Bruderstrasse' (Brothers Street) is a reminder of the Dominican monastery that was founded in 1297. The monastery's church was moved in 1536 into the grounds of the electoral court as the cathedral and final resting place of the Hohenzollerns. Outside of the city, just beyond the Gertraudentor (Gertrude Gate), stood the Gertrauden-Spital (Gertrude Hospital), also dating from the late 13th century, which gave what later became 'Spittelmarkt' its name. Cölln's Rathaus (town hall) stood on the corner of Breite Straße (Broad Street) and Gertraudenstraße (Gertrude Street).

The medieval appearance of the newer part of Berlin was dominated by its parish churches, which at the same time marked the city's market squares, These were the Nikolaikirche (St. Nicholas's), which was finished in Romanesque style in the 1240s and later remodelled with a Gothic look, and the newer Marienkirche (St. Mary's), on which work began around 1270. While the old Rathaus (town hall) had been located to the east of St. Nikolai, a new one was built in the middle of the 13th century on Spandauer Straße, exactly half-way between the two markets. The oldest substantial secular building was the Brandenburg margraves' 'Hohes Haus' (High House) on Klosterstraße, which was possibly built as early the 1240s. Shortly before 1250, the Franciscan monks settled very close to here and their stately, early Gothic monastery church has been retained as a ruin of war. Further church establishments included the Heiliggeist-Spital (Holy Spirit Hospital, first mentioned in 1272) near the Spandauer Tor (Spandau Gate) on Spandauer Straße and the Georgen-Spital (St. George's Hospital), built to the northwest outside the Oderberger Tor (Oderberg Gate).

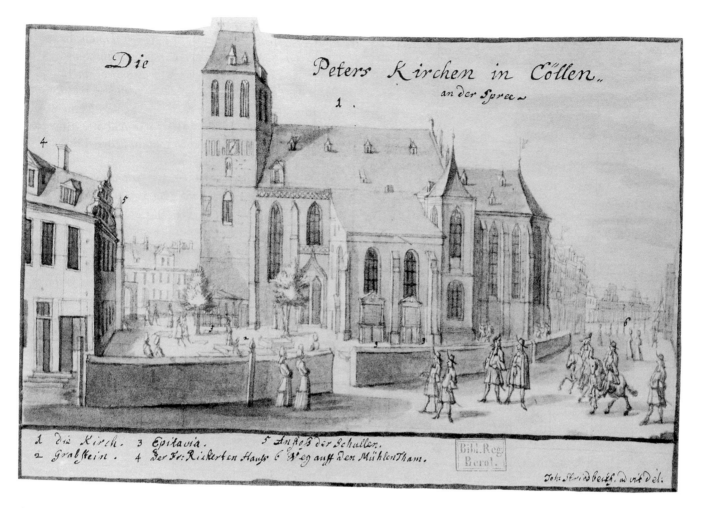

Blick von der Gertraudenstraße auf den Petriplatz und die Peterskirche in Cölln, Zeichnung von Johann Stridbeck d. J., 1690 (Berlin, Staatsbibliothek zu Berlin – Preußischer Kulturbesitz, Reproduktion nach einem Faksimile). Die älteste Kirche von Cölln war wie der Dom in Köln am Rhein dem hl. Petrus geweiht, vielleicht ein Hinweis auf frühe Zuwanderer aus dem Rheinland. Der Ursprungsbau war eine spätromanische Feldsteinkirche aus der 1. Hälfte des 13. Jahrhunderts. Die Darstellung zeigt die Ende des 14. Jahrhunderts erneuerte dreischiffige gotische Hallenkirche, die ab 1717 umgebaut worden war. Nach einem Brand 1809 wurde die Kirche 1846–53 von Johann Heinrich Strack neugotisch erneuert und mit einem 96 Meter hohen Turm versehen. Nach schweren Kriegsschäden wurde die Ruine 1960 abgetragen.

Der Augsburger Kupferstecher Johann Stridbeck der Jüngere (1665–1714) hielt während seines Besuchs 1690–91 den Bereich um das kurfürstliche Schloss an der Spree mit seinen Gebäuden, Höfen und Gärten sowie wichtige Straßenzüge (den Mühlendamm, die Brüderstraße, die Klosterstraße und Unter den Linden) in Aquarellen fest. Die Blätter sind Reisenotizen und sollten als Vorlagen zu nicht ausgeführten Stichen dienen. Die Darstellungen sind von unschätzbarem dokumentarischen Wert. Acht Blätter wurden aquarelliert, die anderen sind mit dem Pinsel laviert.

View from Gertraudenstraße onto St. Peter's Square and St. Peter's Church in Cölln. Drawing by Johann Stridbeck the Younger, 1690 (Berlin State Library – Prussian Cultural Heritage, Berlin; reproduction from a facsimile). Cölln's oldest church was consecrated, like the cathedral in Cologne (German: Köln) on the River Rhine, to St. Peter, possibly indicating early settlers here from the Rhineland. The original building was a late Romanesque quarry stone church dating from the first half of the 13th century. The picture shows the three-aisled Gothic hall-style church renovated at the end of the 14th century, which was remodelled in the years following 1717. Following a fire in 1809, the church was renovated in Neo-Gothic style by Johann Heinrich Strack in 1846-53, with a 96-metre tower added. Following severe war damage, the ruins were cleared away in 1960.

During his visit in 1690-91, the Augsburg copper etchings artist Johann Stridbeck the Younger (1665-1714) made a watercolour record of the area around the electoral palace on the Spree, including its range of buildings, courtyards and gardens, and of a number of the main streets (i.e. Mühlendamm, Brüderstraße, Klosterstraße and Unter den Linden). The pictures were travel notes, which he intended to use as templates for etchings that he ultimately never made. They are of incalculable documentary value. Eight were done as watercolours, the others were brush-washed.

1380 zerstörte ein Brand die Bürgerhausbebauung, die fast ausschließlich aus Holzhäusern bestand. In einer Quelle heißt es, es seien „kaum sechs Häuser stehengeblieben". Ausgrabungen im Bereich Breite Straße/Mühlendamm (heute Gebäude des Deutschen Industrie- und Handelstags) erbrachte folgende Entwicklung: Die früheste Bebauung (ab um 1170) bildeten Holzkeller, über denen Fachwerk- oder Holzhäuser errichtet wurden. An das Wohnhaus, dessen Giebel zur Straße stand, fügte sich im rückwärtigen Hofbereich ein Wirtschaftsgebäude an. Ergrabene Reitersporen, hochwertige Keramik und Glas sprechen für einen relativen Wohlstand der Bewohner. Grabungen entlang der Spandauer Straße erbrachten ebenfalls Befunde von Holzkellern und bemerkenswerterweise die Erkenntnis, dass bereits im 13. Jahrhundert die Häuser mit Dachziegeln, den sog. Mönch-Nonnen-Ziegeln, gedeckt waren. Die Verwendung von Dachziegeln bei hölzernen Häusern war im 13. Jahrhundert sicher eine Ausnahme, da ansonsten die weiche Deckung aus Stroh, Schilf oder Holzschindeln üblich war.

Nach dem verheerenden Stadtbrand von 1380 wurden neben Fachwerkhäusern vereinzelt auch Wohnhäuser in Backstein errichtet, insbesondere die Wohnstätten des städtischen Patriziats. Bis Ende des 15. Jahrhunderts waren es mindestens neun Steinbauten – zum Vergleich: in Brandenburg und Spandau bestanden mindestens vier, in Frankfurt/Oder zwölf Steinhäuser. Im heutigen Berliner Stadtgebiet erhalten ist das gotische Haus Breite Straße 32 in Spandau. Erst ab dem 17. Jahrhundert „versteinerten" die Straßenzüge der Stadt, indem Steinhäuser die verbliebenen Fachwerkbauten ersetzten oder Fachwerkfassaden

In 1380, a fire destroyed nearly all of the townsfolk's housing, which was almost exclusively made of wood. One source records that "scarcely six houses were left standing". Excavations around Breite Straße/Mühlendamm (now the building of the German Association of Chambers of Commerce and Industry) have revealed that the earliest development (from around 1170) was formed of wooden cellars, over which timber of half-timbered houses were erected. The gable of the house faced the street, while in the yard area to the back an outbuilding was attached. Riders' spurs, good quality ceramics and glass indicate that the inhabitants were relatively wealthy. Excavations along Spandauer Straße also produced finds of wooden cellars and, remarkably, evidence too that even in the 13th century these houses were roofed with roofing tiles, the so-called 'monk and nun tiles'. Using tiles on timber-built houses was undoubtedly out of the ordinary in the 13th century, as soft roofing with straw, reeds or wooden clapboards was then the norm.

Following the terrible fire of 1380, one or two brick houses were built in addition to half-timbered ones, in particular the homes of the city fathers. By the end of the 15th century there were at least nine stone buildings. By comparison, in Brandenburg and Spandau at least four stone houses were built and in Frankfurt an der Oder twelve. Still preserved in the present-day greater Berlin area is the Gothic house at 32 Breite Straße in Spandau. It was not until the 17th century that whole rows of houses along the city's streets 'turned to stone', either by replacing the remaining half-timbered houses with stone-built ones or by plastering over half-timbered façades. What until then had al-

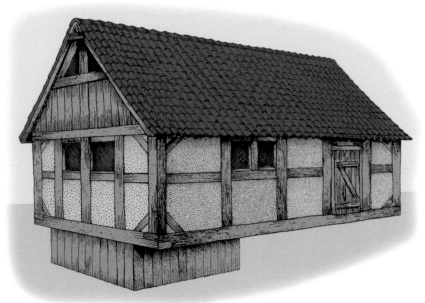

Rekonstruktion eines teilunterkellerten Fachwerkhauses mit Ziegeldach aus der 2. Hälfte des 13. Jahrhunderts an der Spandauer Straße in Berlin, Umzeichnung nach Felicitas Hofmann aus: Michael Hofmann: Mittelalterliche Straßen- und Hausbefunde in der Spandauer Straße. In: Miscellanea Archaeologica II (hg. v. Jörg Haspel u. Wilfried Menghin), Petersberg 2005, S. 201.

Reconstruction of a half-timbered house from the second half of the 13th century, with partial cellar and tiled roof, on Spandauer Straße in Berlin. Redrawn from the original by Felicitas Hofmann in: 'Mittelalterliche Straßen- und Hausbefunde in der Spandauer Straße' by Michael Hofmann, published in Miscellanea Archaeologica II by Jörg Haspel and Wilfried Menghin, Petersberg 2005, p. 201.

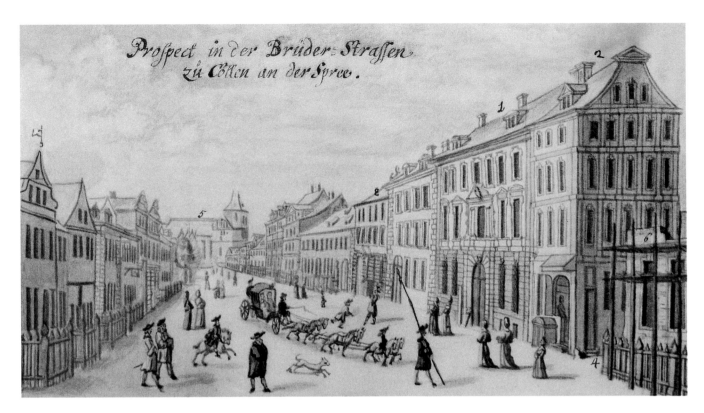

Prospect in der Brüder-Straßen zu Cölln an der Spree.

Brüderstraße in Cölln an der Spree, Zeichnung von Johann Stridbeck d. J., 1690. 1297 siedelten sich die Dominikaner an der Stelle des späteren Schlossplatzes an. Die zum Kloster führende Straße erhielt den Namen „Brüderstraße", die im 16. Jahrhundert ebenso wie die Breite Straße zur Wohnstraße für adlige Hofbedienstete wurde. Die Abbildung zeigt den südlichen Teil der Straße mit Blick zur Petrikirche im Hintergrund. Die giebelständigen Häuser stammen noch aus der Zeit der Renaissance, die traufständigen aus der Barockzeit. Vor den Fassaden befinden sich noch kleine Vorgärten, deren Beseitigung 1690 angeordnet worden war. Das fünfte Gebäude von rechts erwarb 1787 der Buchhändler Nicolai. Das Barockgebäude überlebte den 2. Weltkrieg.

Brüderstraße in Cölln on the Spree. Drawing by Johann Stridbeck the Younger, 1690. In 1297, the Dominican monks settled on what was later to be Schlossplatz (Palace Square). The road leading to the monastery was given the name 'Brüderstraße' (Brothers Street), becoming in the 16th century, like 'Breite Strasse' (Broad Street), a residential road for aristocratic courtiers. The illustration shows the southern part of the street, looking towards St. Peter's Church in the background. The houses with their gable ends facing the street still stem from the Renaissance period, while those with their eaves facing the road are from the Baroque era. In front of the houses there are still small front gardens, which were ordered to be cleared away in 1690. The Baroque building fifth from the right was purchased in 1787 by the book dealer Nicolai and survived the 2nd World War.

Gertraudenhospital, Zeichnung von Johann Stridbeck d. J., 1690. Die Kirche („Spittelkirche") des Gertraudenhospitals wurde 1405–11 erbaut und 1881 abgebrochen. Das Hospital lag außerhalb der Stadt vor dem gleichnamigen Tor (Gertraudisches Tor) in Cölln am heutigen Spittelmarkt.

Gertrude Hospital. Drawing by Johann Stridbeck the Younger, 1690. The hospital's church ('Spittelkirche') was built in 1405-11 and demolished in 1881. The hospital stood outside the city, just beyond the city gate of the same name (Gertrautisches Tor) in Cölln, on what is now Spittelmarkt.

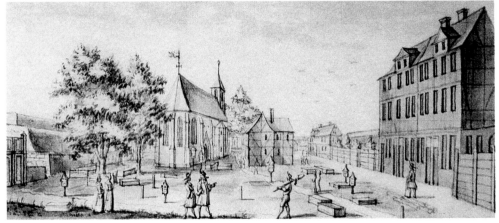

verputzt wurden. Die bis dahin lockere Bauweise wich zudem einer verdichteten Bebauung und intensiven Nutzung mit Wohn- und Wirtschaftsgebäuden.

1411 ernannte der deutsche König Sigismund den Burggrafen Friedrich VI. von Nürnberg aus dem Hause der Hohenzollern zum Markgrafen und Kurfürsten der Mark. Er gehörte damit zu den wichtigsten Männern seiner Zeit. Als Friedrich I. durften er und seine Erben den deutschen König wählen. Damit begann die mehr als 500-jährige Herrschaft der Hohenzollern über die Mark, die erst 1918 mit der Abdankung Kaiser Wilhelms II. endete.

Die Hohenzollern bestimmten Berlin und Cölln zu kurfürstlichen Residenzen, veranschaulicht durch den Bau der ersten Burg in Cölln ab 1443 durch Friedrich II., Kurfürst von Bran-

so been a relatively loose style of building also gave way to more dense development and intensive utilisation of residential and commercial buildings.

In 1411, the German King Sigismund made Burgrave Frederick VI of Nuremberg (from the House of Hollenzollern) Margrave and Elector of the Mark of Brandenburg. He was thus one of the most important men of his time. As Friedrich I, he and his heirs were permitted to participate in electing the German King. Thus began the Hohenzollern's rule over the Mark that lasted for more than 500 years, not ending until the abdication of Kaiser Wilhelm II in 1918.

The Hohenzollerns decided on Berlin and Cölln as electoral residencies, demonstrated by Friedrich II, Elector of Brandenburg, building the first castle in Cölln from 1443, from which the

Blick um 1930 über den Dom auf das mittelalterliche Stadtzentrum mit der Börse (links vorne), der Marienkirche (links hinten), dem Roten Rathaus (Mitte), dem Stadthaus und der Nikolaikirche (rechts hinten) sowie dem Stadtschloss (rechts).

View c. 1930 via the cathedral onto the medieval town centre with the stock market (front left), St. Mary's Church (rear left), the 'Red Town Hall' (centre), the Stadthaus and the Nikolaikirche (rear right) and the City Palace (right).

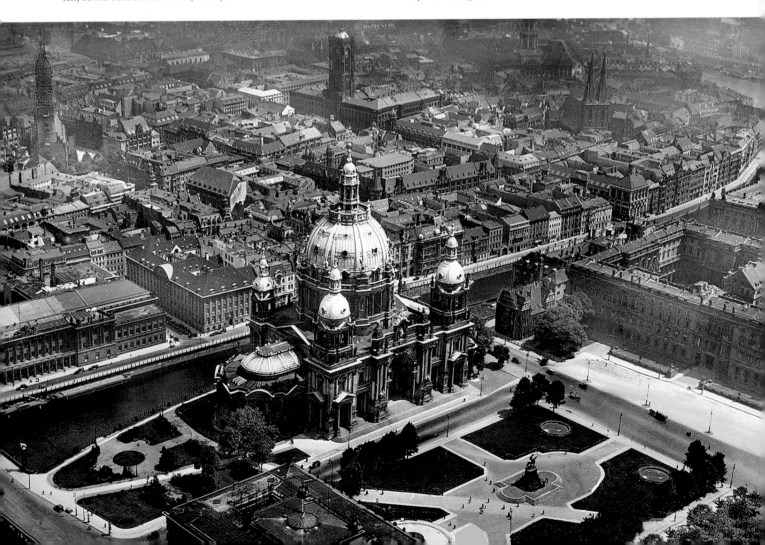

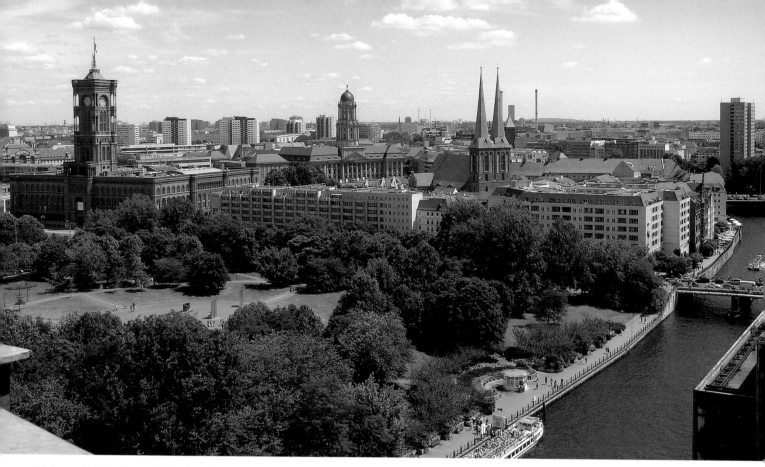

Blick vom Berliner Dom auf das ehemalige mittelalterliche Stadtzentrum mit dem Roten Rathaus (links), dem Stadthaus (Mitte) und der Nikolaikirche (rechts).

View from Berlin Cathedral onto the former medieval town centre with the 'Red Town Hall' (left), the Stadthaus (centre) and the Nikolaikirche (right).

denburg, aus der das Berliner Schloss hervorging. Mit der Niederschlagung des sog. „Berliner Unwillens" 1447/48 konnte der Kurfürst seine Macht stärken und Einschränkungen der städtischen Autonomie erzwingen. Die Doppelstadt hatte ihre Verbindungen zur Hanse, die seit 1430 intensiviert worden waren, aufzugeben, ebenso den gemeinsamen Rat. Einen geistigen Mittelpunkt erhielt die Residenz durch ein an der Schlosskapelle 1450 gegründetes Domstift. Ständige Residenz der Brandenburgischen Kurfürsten wurde Berlin 1486.

Nikolaiviertel

Das mittelalterliche Berlin, das noch bis zu seiner Zerstörung im 2. Weltkrieg mit seinem Straßensystem erhalten war, ist fast völlig verschwunden. Durch den Wiederaufbau als Hauptstadt der DDR entstanden – begünstigt durch das sozialistische Bodenrecht der DDR – große Freianlagen mit Grünflächen rund um den Fernsehturm, sechs- bis zehnspu-

'Berliner Schloss' (Berlin Castle) subsequently evolved. With the ending of the so-called 'Berliner Unwille' (Berlin Resistance) in 1447/48, the Elector was able to increase his power and force through restrictions on the city's autonomy. The twin city had to give up both its joint council and its links to the Hanseatic League, which it had intensified in the years since 1430. The electoral residence was given a spiritual focal point with the addition in 1450 of a chapter house next to the castle chapel. Berlin became the permanent residence of the Brandenburg electors in 1486.

Nikolaiviertel

Medieval Berlin, which with its road system had remained intact until it was destroyed in the Second World War, has almost completely disappeared. Helped by the GDR's socialist land laws, reconstruction as the capital of East Germany produced large open areas and parks around the television tower, six to ten-lane thoroughfares (e.g. the Karl Marx Allee and Leipziger Straße) and

oben: Nikolaiviertel mit Nikolaikirche von Osten

Above: Nikolai quarter and Nikolaikirche from the east

Gerichtslaube (Rathaus). Die Gerichtslaube (Abb. S. 15) wiederholt unter Verwendung alter Bauteile die um 1270 errichtete und in der Barockzeit veränderte Gerichtslaube (Grundriss und Schnitt Abb. rechts), die 1871 abgebrochen und im Park von Schloss Babelsberg gotisierend nach Plänen von J. H. Strack wieder aufgebaut wurde (Abb. links).

The town hall 'Gerichtslaube' ('Courtroom Gazebo'). The 'Neue Gerichtslaube' (pictured p. 15) is a copy, using old building components, of the gazebo built around 1270 and altered in the Baroque era (floor plan and cross-section pictured right), which was dismantled in 1871 and rebuilt in more Gothic style in the park at Schloss Babelsberg to a design by J. H. Strack (pictured left).

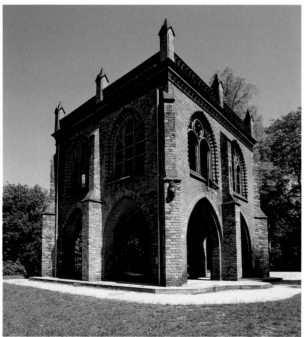

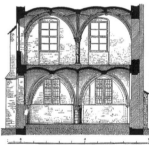

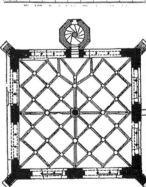

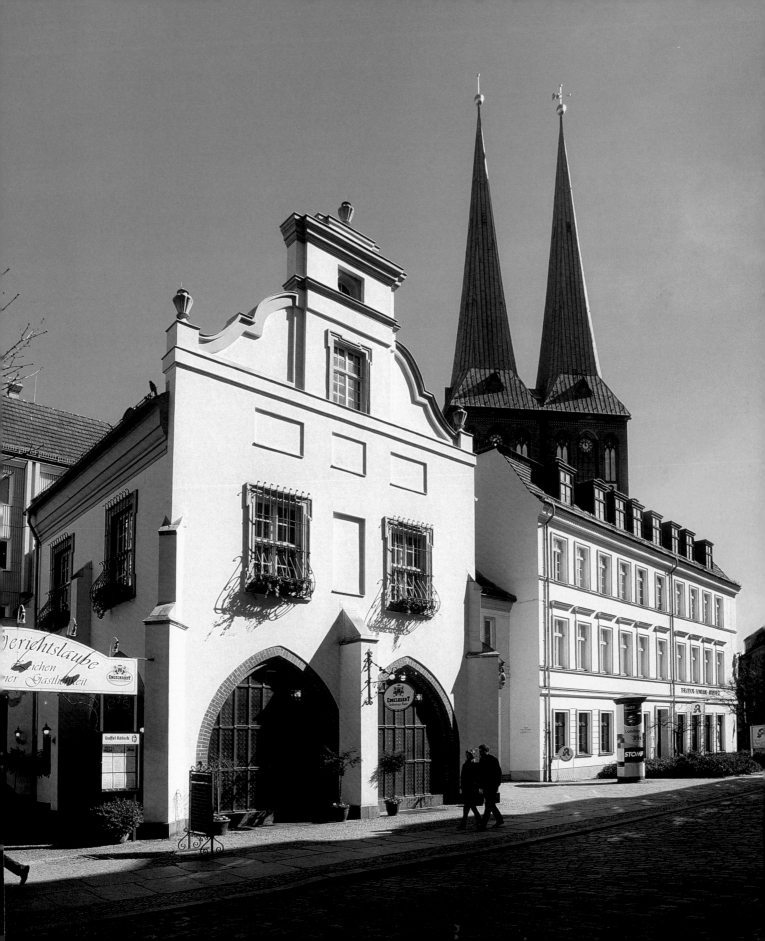

rige Durchgangsstraßen (z. B. Karl-Marx-Allee, Leipziger Straße) und monotone Wohnblocks anstelle der kleinteiligen historischen Bebauung. Trotz der nur wenigen erhaltenen älteren Gebäude und der Baumaßnahmen seit dem Mauerfall 1989 ist die Struktur des alten Berlin mit Hilfe der verbliebenen Objekte jedoch noch nachvollziehbar.

Bereits Ende der DDR-Zeit hatte sich der Wunsch nach einem „historischen" Gesicht der Stadtmitte geregt, sodass zwischen 1980 und 1987 anlässlich der 750-Jahr-Feier der Stadt Berlin der Wiederaufbau des brachliegenden Nikolaiviertels mit der als Ruine belassenen Nikolaikirche vollzogen wurde. Man wählte eine kleinteilige Architektur in Großplattenbauweise oder aus Fertigteilen mit Giebelgruppen, die sechs erhaltene Wohnhäuser (darunter das Knoblauchhaus von 1759/60 und 1835) sowie rekonstruierte Gebäude auf einem mittelalterlich anmutenden Stadtgrundriss mit schmalen, unregelmäßig verlaufenden Gassen ergänzten. Durch nachgebaute historische Laternen, Reklameschilder und anderes Stadtmobiliar sollte die Aura des „Alten" Berlin mit etwa 800 Wohnungen, zahlreichen Geschäften und Gaststätten wiedererweckt werden.

Rekonstruiert, jedoch an verändertem Ort wiederaufgebaut, wurden unter anderem die Gaststätte „Zum Nußbaum" (ursprünglich 15./16. Jahrhundert), die Gerichtslaube des Rathauses (ursprünglich um 1270 errichtet, 1555 und in der Barockzeit verändert und 1871 abgebrochen) und das Gasthaus „Zur Rippe" (um 1690 erbaut, 1935 abgebrochen). Das barocke Ephraim-Palais wurde – um einige Meter westlich von seinem

monotonous blocks of flats in place of the small-scale, piecemeal historic development. While only a few of the older buildings and constructions remain since the fall of the Wall in 1989, the structure of old Berlin can nevertheless still be traced with the help of the surviving properties.

As soon as the GDR era had come to an end, a desire emerged to give the city centre an 'historic' visage. Between 1980 and 1987, therefore, to coincide with Berlin's 750th anniversary, the reconstruction was undertaken of the derelict Nikolaiviertel (Nikolai Quarter), including the Nikolaikirche (St. Nicholas's Church), which had previously been left in ruins. The planners chose a small-scale form of architecture in large panel construction or using prefabricated components with groups of gables. These complimented six preserved residential properties (including the Knoblauchhaus dating from 1759/60 and 1835) and several reconstructed buildings in an urban layout with a medieval air and narrow, irregular lanes. By using reproduced historic streetlamps, advertising boards and other urban paraphernalia, the plan was to reawaken the aura of 'old' Berlin with around 800 apartments and numerous shops and restaurants.

Buildings reconstructed at this time included, although rebuilt in a different location, the 'Zum Nußbaum' restaurant ('The Nut Tree', originally 15th/16th century), the town hall's 'Gerichtslaube' ('Courtroom Gazebo', originally built around 1270, altered in 1555 and in the Baroque era and torn down in 1871) and the 'Zur Rippe' tavern ('Rib Inn', built around 1690, demolished 1935). The Baroque Ephraim Palace was rebuilt using parts of the original building, offset a few metres to the west of

links: Das Gasthaus „Zum Nußbaum" ist eine Nachbildung eines Giebelhauses aus der Cöllner Fischerstraße 21, das 1943 zerstört worden war. Die Giebelstellung verrät ein hohes Alter (15./16. Jahrhundert), die Geschossauskragung die einstige überputzte Fachwerkkonstruktion. Der Kellereingang war inschriftlich auf 1571, die Wetterfahnen waren auf 1586 datiert. Aus dieser Zeit stammten auch die relativ großen Fenster, die wahrscheinlich ursprünglich kleinere ersetzten. Aufgrund seiner günstigen Lage am einzigen Cöllner Stadttor und an der Ausfallstraße florierte der gastronomische Betrieb, in dem schon der Pferdehändler Hans Kohlhase, der 1540 hingerichtet worden war, eingekehrt war.
S. 17: Nikolaikirche

Left: 'Zum Nußbaum' (The Nut Tree) is a copy of a gable building from 21 Fischerstraße in Cölln, which was destroyed in 1943. The position of the gable gives away the original's great age (15th/16th century) and the overhang of the upper floors its once plastered, half-timbered construction. Inscriptions dated the cellar entrance to 1571 and the weather vanes to 1586. The relatively large windows also dated from this time and probably replaced what were originally smaller ones. Due to its advantageous location next to Cölln's only city gate on the arterial road, the restaurant flourished, counting amongst its customers the horse trader Hans Kohlhase, who was hanged in 1540. P. 17: Nikolaikirche

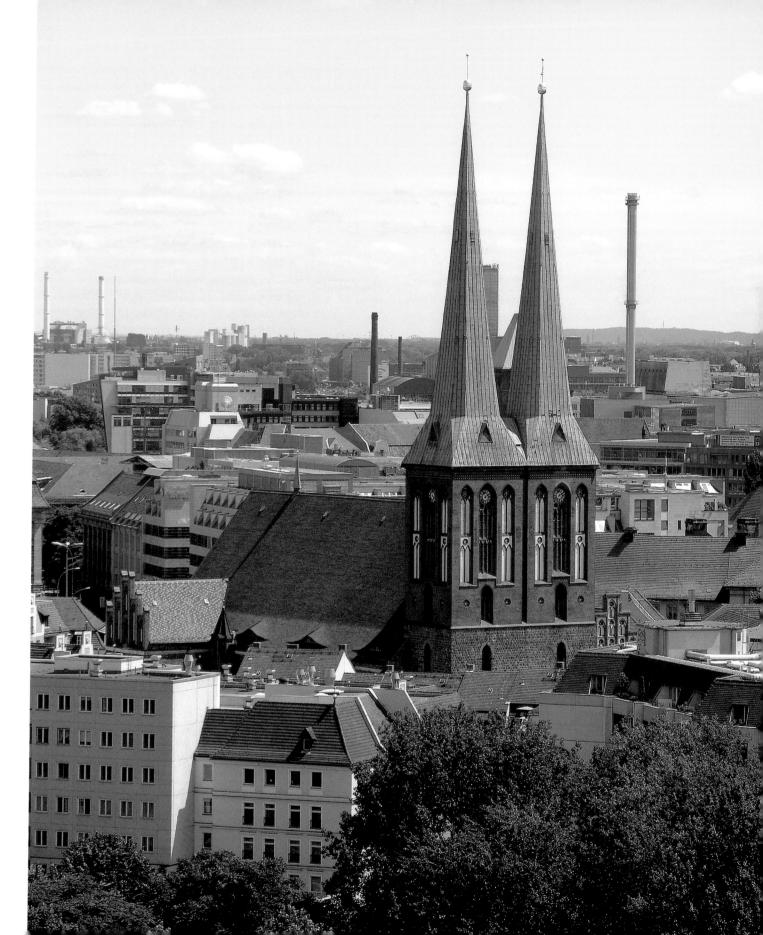

ursprünglichen Standort versetzt – unter Verwendung origi-
naler Bauteile wiedererrichtet. Die Fassaden entlang der
Propststraße und am Nikolaikirchplatz bzw. Mühlendamm
sind Neuschöpfungen im Stil des 18. und 19. Jahrhunderts
nach Plänen von Heinz Mehlan und Rolf Ricken.

its original position. The façades along Propststraße (Provost
Street) and onto Nikolaikirchplatz (St. Nicholas's Square) and
Mühlendamm (Millbank) are new creations in the style of the
18th and 19th century, built to plans by Heinz Mehlan and Rolf
Ricken.

Nikolaikirche

Die Nikolaikirche ist das zentrale Bauwerk des Nikolaiviertels.
Schon zur Gründungszeit Berlins bestand hier eine Kirche mit
Friedhof, dessen älteste nachgewiesene Gräber in das ausge-
hende 12. Jahrhundert datiert werden. Ältester Bauteil und da-
mit ältestes erhaltenes Bauwerk Berlins bildet der Westbau mit
seinen neugotischen Turmobergeschossen. Die unteren drei
Geschosse aus Granitquadern gehören zu einer 1220–30 er-
bauten spätromanischen dreischiffigen Basilika mit lang ge-
strecktem Chor, Querhaus mit Seitenapsiden und dem erhal-
tenen Westbau. Um 1300 ersetzte man das romanische Lang-

Nikolaikirche

*The Nikolaikirche (St. Nicholas's Church) is the central structure of
the Nikolaiviertel. Even in Berlin's founding years, a church with a
graveyard existed here, the oldest proven graves of which are dated
to the late 12th century. The oldest part of the church, and thus the
oldest preserved structure in Berlin, is formed by the western section
and its tower with Neo-Gothic upper floors. The three lower floors,
constructed of square stones of granite, belong to a late Romanesque
three-aisled basilica built in 1220-30 with a long extended chancel,
transept with side apses and the surviving west structure. Around
1300, the Romanesque nave was replaced by a three-aisled early*

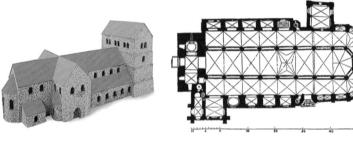

Nikolaikirche, Ansicht vor 1875 (unten links),
Rekonstruktion des Zustands im 13. Jahrhun-
dert und Grundriss 1877 (rechts), Ansicht von
Norden (unten rechts), Ansicht von Südwesten
(S. 19), Langhaus von Süden (S. 20) sowie Inne-
res nach Osten (S. 21)

*Nikolaikirche (St. Nicholas' Church). View
before 1875 (below left). Reconstruction of its
13th century appearance (redrawn from the
original by Uwe Kieling) and 1877 floor plan
(right). View from north (below right), view
from southwest (p. 19), nave from south
(p. 20) and interior looking east (p. 21).*

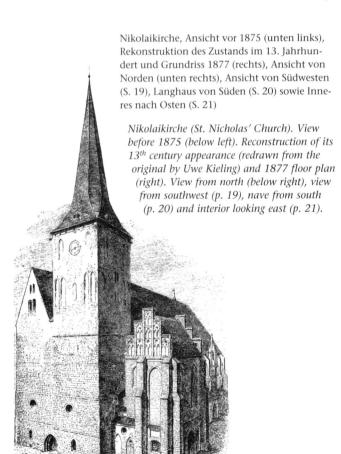

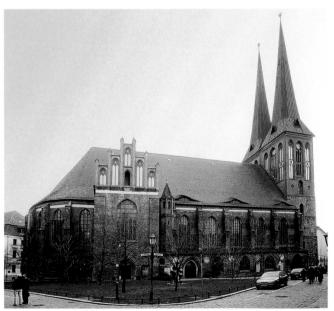

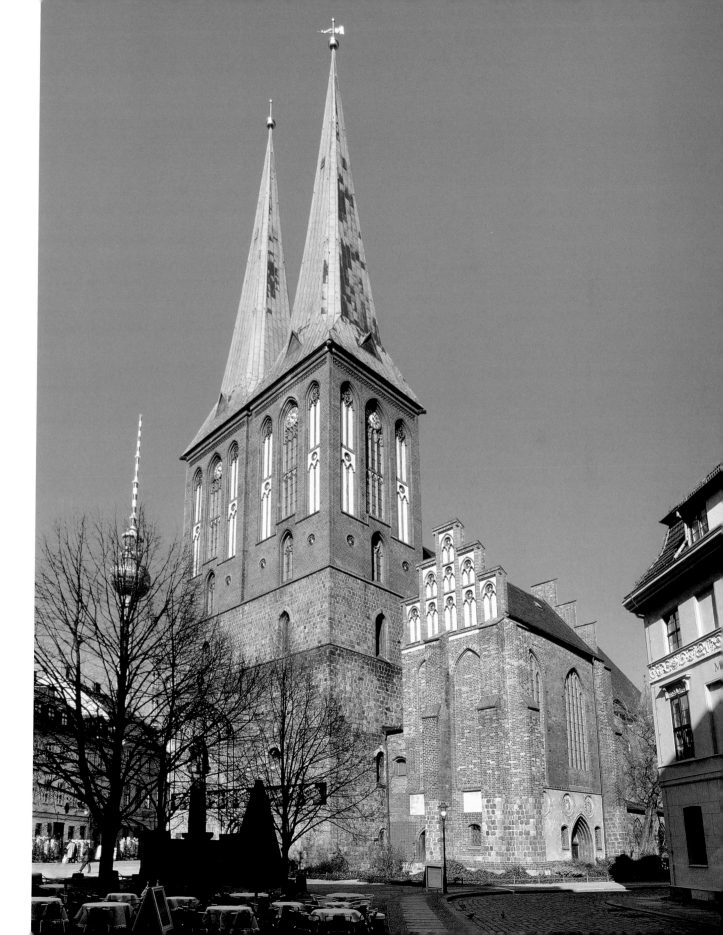

haus durch eine dreischiffige frühgotische Hallenkirche, die ihrerseits um 1380 bis um 1470 durch die heutige spätgotische Hallen-Backsteinkirche mit hochmodernem Hallenumgangschor und Kapellenkranz ersetzt wurde. Die prominent im Südwesten neben der Doppelturmfassade stehende Liebfrauenkapelle mit Treppengiebel konnte 1452 geweiht werden. Ende des 15. Jahrhunderts entstand die zweigeschossige Chornordkapelle für Sakristei und Bibliothek. Auf den drei romanischen Turmuntergeschossen stand ursprünglich ein asymmetrischer Turmaufbau mit gotischem Südturm. Er wurde 1876–78 nach Plänen von Hermann Blankenstein durch den symmetrischen neugotischen Backsteinaufsatz mit zwei Turmspitzen ersetzt. Im 2. Weltkrieg stark beschädigt, wurde die Nikolaikirche 1982–87 mit rekonstruierter spätgotischer Farbgestaltung und vereinfachten Turmhelmen wieder aufgebaut.

Im Innern sind die Gruftkapelle des Finanzministers Johann Andreas Kraut von Johann Georg Glume (1725) und die „Todespforte" von Andreas Schlüter (1701) hervorzuheben.

Gothic hall-style church, which in turn was replaced around 1380 to 1470 by the current late Gothic three-aisled church with a highly modern, halled chancel with ambulatory and ring of chapels. The Liebfrauenkapelle (Chapel of Our Lady), with crow-step gable standing prominently in the southwest next to the twin-towered façade, was consecrated in 1452. The chancel's twin-aisled north chapel for sacristy and library was built at the end of the 15th century. On top of the three Romanesque lower floors of the tower there was originally an asymmetric tower extension with a Gothic south tower. In 1876-78, it was replaced by the symmetric Neo-Gothic brick upper tower section with two spires, based on plans by Hermann Blankenstein. Having been badly damaged in the Second World War, the Nikolaikirche was rebuilt in 1982-87 with a reconstructed late Gothic colour scheme and simplified tops for the towers.

Worthy of particular note inside the church are the burial chapel built by Johann Georg Glume in 1725 for finance minister Johann Andreas Kraut and Andreas Schlüter's 'Todespforte' ('Death's door') from 1701.

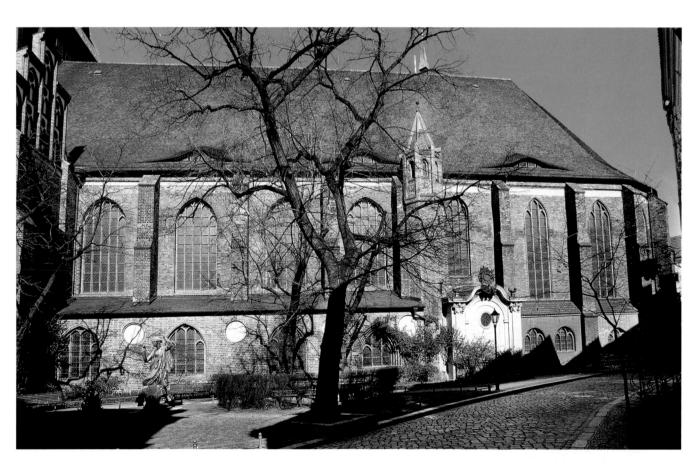

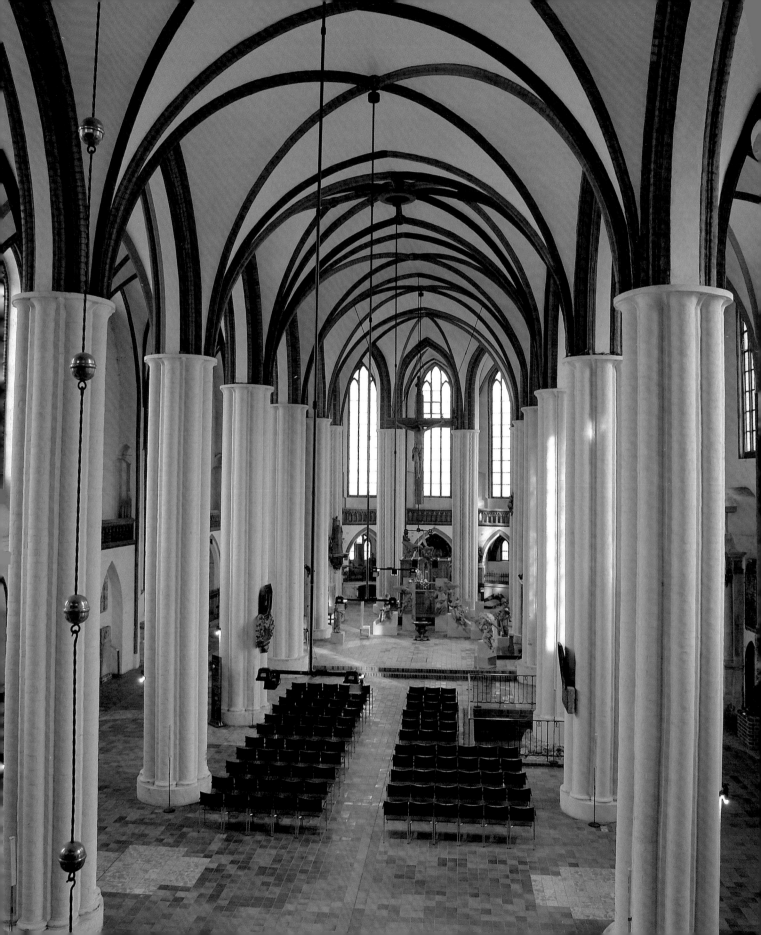

Marienkirche

Die Marienkirche bildete das Zentrum der um 1250 begründeten ersten mittelalterlichen Stadterweiterung Berlins und war die zweite Hauptpfarrkirche der Stadt. Ursprünglich umgeben von einer dichten Bürgerhausbebauung, steht die Marienkirche heute als Solitär auf einer großen Freifläche in unmittelbarer Nähe zum Fernsehturm. Um 1270 begonnen, konnte der Chor im späten 13. Jahrhundert genutzt und die gesamte Kirche im frühen 14. Jahrhundert vollendet werden. Um 1340 erbaute man an der Südseite eine Sakristei. Nach dem großen Stadtbrand von 1380 musste die Kirche erheblich umgebaut werden. Dabei entstanden u. a. neue Pfostenfenster und die spätgotischen Sterngewölbe im Chor sowie im östlichen Langhaus. Ab 1418 bis Ende des 15. Jahrhunderts wurde die Hallenkirche nach Westen erweitert. Der Westturm (15. Jahrhundert, mehrfach zerstört), dessen Untergeschosse als dreischiffige Vorhalle in Bruchsteinmauerwerk erbaut wurde, erhielt seinen heutigen kupferbeschlagenen Aufsatz von Carl Gotthard Langhans 1789/90 (Fialen 19. Jahrhundert). Dabei ging der Architekt eine Verbindung von klassizistischer und gotisierender Form ein und schuf damit eines der frühen Beispiele der Neugotik in Deutschland. Die 1729 im Süden angefügte Magistratsloge gestaltete Hermann Blankenstein 1893/94 neugotisch um, ergänzte nach dem Vorbild der Sakristei eine Vorhalle, sodass sich an der Südfassade eine Reihung von vier dekorativ gestalteten Giebeln ergab. Die Marienkirche überstand den 2. Weltkrieg ohne große Schäden, sodass selbst das mächtige gotische Dachwerk erhalten blieb.

In der Turmhalle befindet sich die 2 m hohe und 22 m lange Wandmalerei mit dem „Totentanz", entstanden nach einer Pestepidemie um 1484–85. Es ist eine der wenigen am Ort original erhaltenen Darstellungen dieses Themas in Deutschland. Das Hauptwerk der spätgotischen Wandmalerei in Berlin zeigt die Vertreter aller Stände im Reigen mit tanzenden Leichnamen.

Unter den vielen bemerkenswerten Ausstattungsstücken sind ein Bronzebecken von 1441, die Alabasterkanzel von Andreas Schlüter (1702/03) und die Orgel von Joachim Wagner (1720/21) mit einem Prospekt von Johann Georg Glume hervorzuheben. Einige Ausstattungsstücke stammen aus der Franziskaner-Klosterkirche.

Marienkirche

The Marienkirche (St. Mary's Church) formed the centre of the first medieval expansion of Berlin, begun around 1250, and was the city's second main parish church. Originally surrounded by dense, middle-class housing, the Marienkirche now stands alone in a large open area very close to the television tower. Begun around 1270, the chancel was able to be used in the late 13th century and the whole church was completed early in the 14th century. Around 1340, a sacristy was built onto the south side. Following the great city fire of 1380, the church required substantial rebuilding. New elements such as the tracery windows and late Gothic stellar vaulted ceiling in the chancel and eastern nave emerged in the process. From 1418 until the end of the 15th century, this hall-style church was extended westwards. The west tower (dating from the 15th century and repeatedly destroyed), the lower floors of which had been built as a triple-aisled portico in quarry stone masonry, was given its present copper-sheathed top section by Carl Gotthard Langhans in 1789/90 (pinnacles 19th century). In doing so, the architect combined Classicist and near Gothic design, thus creating one of the early examples of Neo-Gothicism in Germany. The city fathers' stall added to the south of the church in 1729 was remodelled in Neo-Gothic style by Hermann Blankenstein in 1893/94. Following the example of the sacristy, he also added a portico, thus producing a row of four decoratively configured gables on the south façade. The Marienkirche survived the Second World War with no major damage, with even the mighty Gothic roof remaining intact.

In the tower hall there is a mural, 2 metres high and 22 metres long, depicting the 'Totentanz' (Dance of the Dead), painted following a plague epidemic around 1484-85. It is one of the few examples of this subject still preserved in place in its original form anywhere in Germany. The late Gothic mural's main work shows representatives of all classes in a round dance with dancing corpses.

The many noteworthy fixtures and items of church furniture include in particular a bronze basin dating from 1441, Andreas Schlüter's alabaster pulpit (1702/03) and Joachim Wagner's organ (1720/21), with a backdrop by Johann Georg Glume. Some of the items stem from the Franciscan monastery church.

S. 23: Marienkirche, Ansicht von Südosten

p. 23: Marienkirche (St. Mary's Church), seen from the southeast

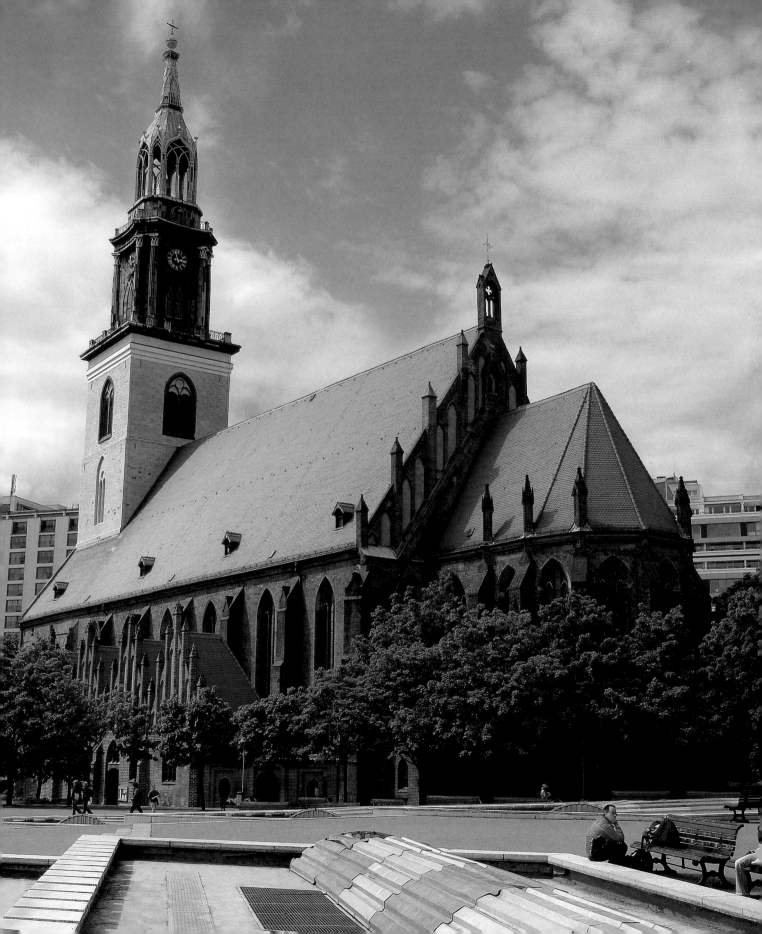

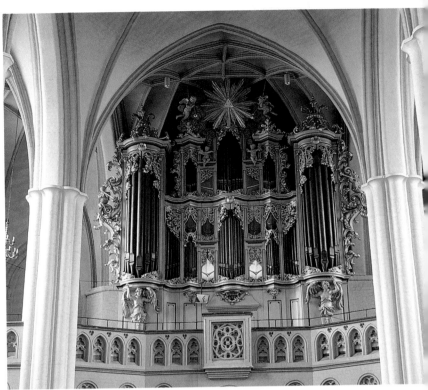

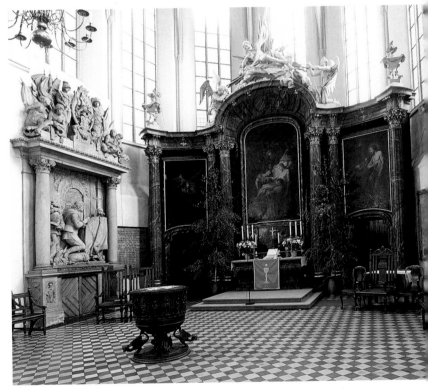

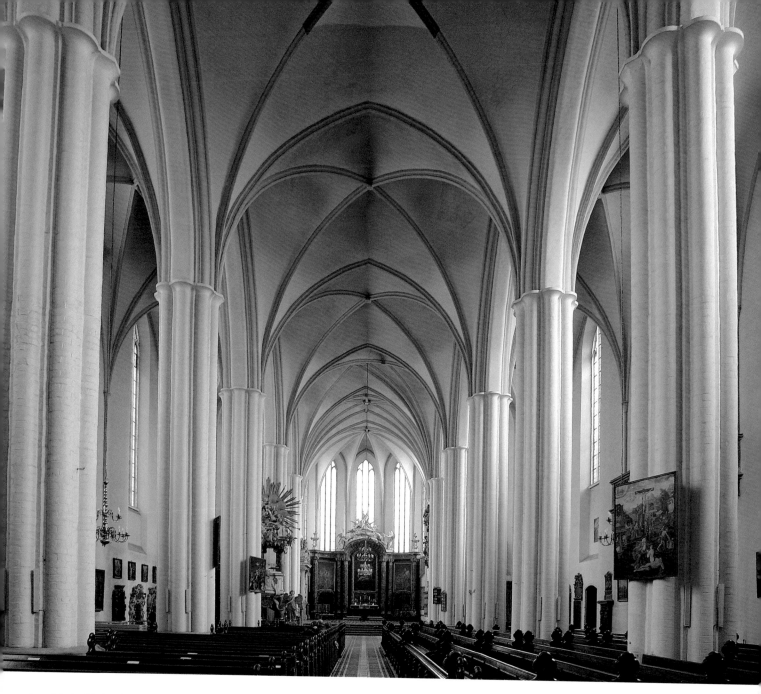

oben: Marienkirche, Ansicht nach Osten

S. 24: links: Marienkirche, Ansicht von Westen
rechts oben: Orgel,1720/21
rechts unten: Chorbereich mit Wandgrabmal des O. Chr. v. Sparr (1662/63 von Artus Quellinus aus Antwerpen), Bronzetaufe von 1437 (wohl von Meister Hinrick von Magdeburg) und Altarwand, 1756–62 nach Entwurf von Andreas Krüger: dreiteiliger architektonischer Säulenaufbau, bekrönt von der Stuckfigurengruppe Christus mit Siegeskreuz und anbetenden Engeln sowie Ölgemälden, 1761 von Bernhard Rode.

Above: Marienkirche (St. Mary's Church), looking east

p. 24: Left: Marienkirche (St. Mary's Church), seen from the west
Above right: Organ, 1720/21
Below right: Chancel area with wall tomb of Otto Christoph von Sparr (1662/63, by Artus Quellinus from Antwerp), bronze font dating from 1437 (probably by Meister Hinrick from Magdeburg) and altar wall (1756-62) to a design by Andreas Krüger featuring a three-part architectural pillar composition, crowned by a stucco statue group of Christ with cross of triumph and worshipping angels, plus oil paintings from 1761 by Bernhard Rode.

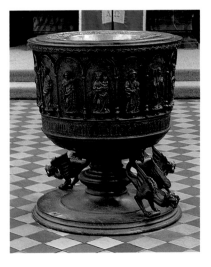

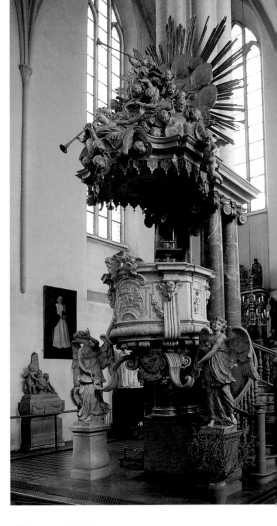

oben links: Marienkirche, Chor: Mittelfigur hl. Georg (Ende 15. Jahrhundert), umgeben von Margarete und Barbara (um 1420), ursprünglich Franziskanerkirche in Berlin
oben Mitte: Marienkirche, Bronzetaufe von 1437
oben rechts: Marienkirche, Alabasterkanzel, 1702–03 von Andreas Schlüter
unten links: Marienkirche, Ansicht nach Westen

Above left: Marienkirche (St. Mary's Church), chancel: Central figure is St. George (late 15th century), surrounded by St. Margaret and St. Barbara (c. 1420), originally in Berlin's Franziskanerkirche (Franciscan Church)
Above centre: Marienkirche, bronze font dating from 1437
Above right: Marienkirche, alabaster chancel, 1702–03 by Andreas Schlüter
Below left: Marienkirche, looking west

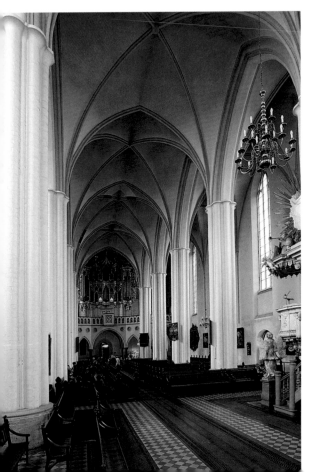

unten Mitte: Marienkirche, Beweinung Christi, um 1515
unten rechts: Marienkirche, Grabmal für Pfarrer F. Roloff und Frau, 1794 von Emanuel Bardou

Below centre: Marienkirche, Mourning of Christ, c. 1515
Below right: Marienkirche, tomb for clergyman F. Roloff and wife, 1794 by Emanuel Bardou

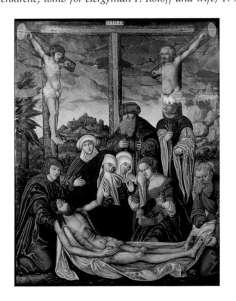

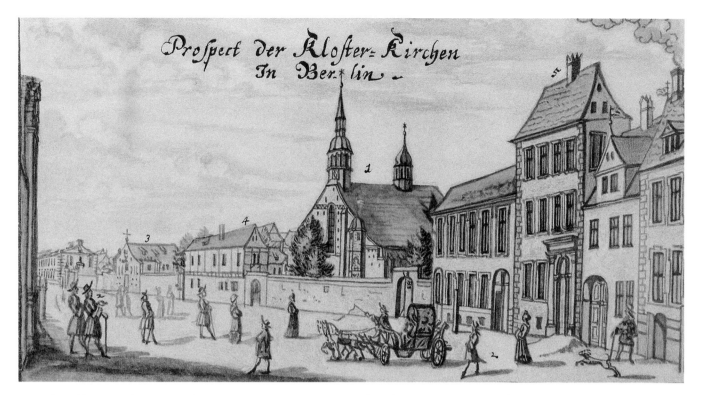

Franziskanerkloster, Zeichnung von Johann Stridbeck d. J., 1690

Franciscan monastery, drawing by Johann Stridbeck the Younger, 1690

Franziskaner-Klosterkirche

Die Kirchenruine bildet den Rest des seit 1249 in Berlin nachweisbaren und nach der Reformation 1539 aufgelösten Franziskanerklosters, dessen Klausurgebäude sich nördlich der Kirche anschlossen und nach Kriegsschäden 1968 abgetragen wurden. Als Grablege der askanischen Markgrafen, d. h. der brandenburgischen Landesherren, wurde die Klosterkirche in architektonisch hoher Qualität erbaut. Sie nahm eine Vorreiterrolle für die Entwicklung der gotischen Baukunst in Berlin und Umgebung ein und galt vor ihrer Zerstörung aufgrund der plastischen Details und der eindrucksvollen Raumschöpfung als bedeutendstes gotisches Bauwerk Berlins.

Von der 1260–70 erbauten dreischiffigen gewölbten Backsteinbasilika sind die Westfassade und die Langhauswände mit ihren kapitellgeschmückten Diensten erhalten. Um 1300 fügte man den einschiffigen Chor an. Die hohen Chorfenster, deren Maßwerk im 19. Jahrhundert erneuert worden war, besitzen ein fein profiliertes Gewände. Teile der ehemaligen Ausstattung befinden sich heute in der Marienkirche.

Franciscan monastery church

The ruins of the 'Franziskaner-Klosterkirche' form the remains of the Franciscan monastery in Berlin, evidence of which dates back to 1249. Following the Reformation, the monastery was dissolved in 1539. Its conclave building was connected to the north of the church and following war damage was cleared away in 1968. As the burial place of the Ascanian margraves, i.e. the rulers of Brandenburg, the monastery church was built in high architectural quality. It took on a pioneering role for the development of Gothic architecture in Berlin and the surrounding area and, by virtue of its sculptural details and impressive creation of space, was regarded prior to its destruction as one of Berlin's most significant Gothic structures.

Of the triple-aisled, vaulted brick basilica built from 1260-70, the west façade and the nave walls with their responds decorated with capitals are still standing. The single-aisled chancel was added around 1300. The high chancel windows, the tracery on which was replaced in the 19th century, have finely textured jambstones. Some items of the former church fittings are now in the Marienkirche (St. Mary's Church).

27

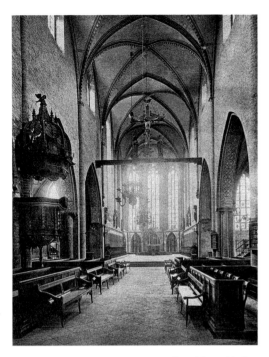

Franziskanerkirche,
Zustand um 1900
und heute

*Franziskanerkirche
(Franciscan
Church), as it was
around 1900 and
today*

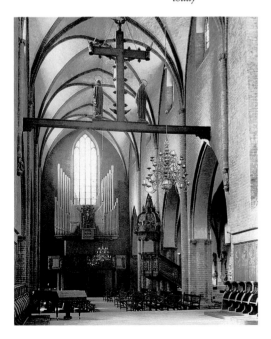

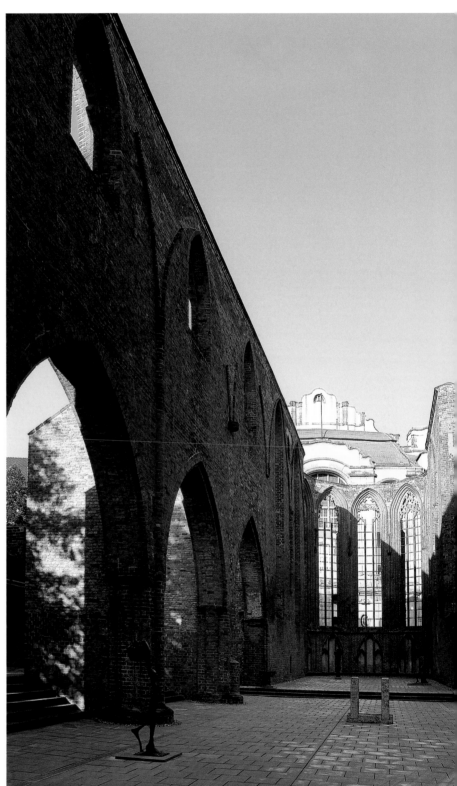

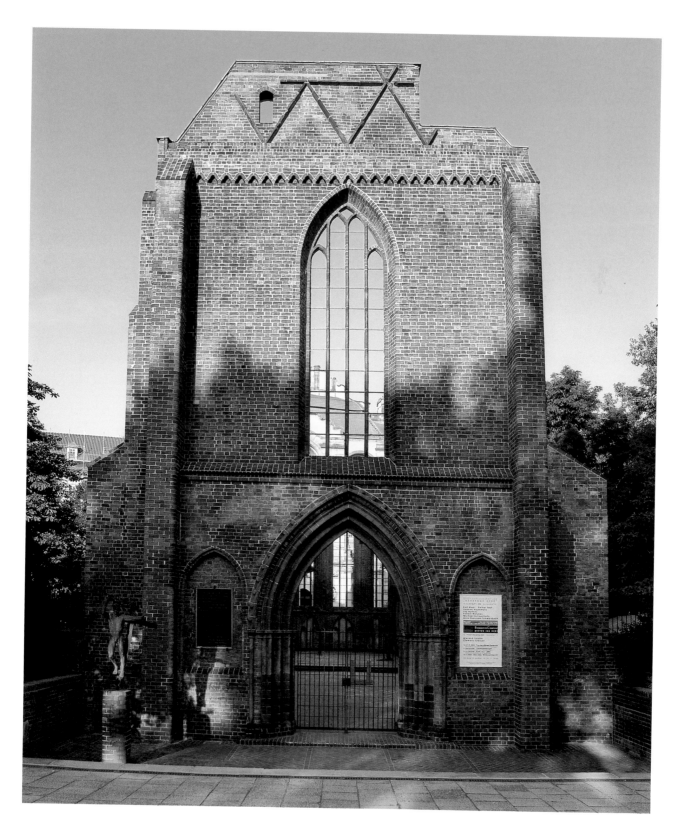

Franziskaner-
klosterkirche,
Kämpfer-
kapitell

*Franciscan
monastery
church, impost
capital*

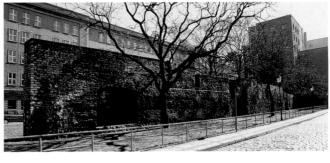

Franziskaner-
klosterkirche,
Säulenbasis

*Franciscan
monastery
church, pillar
base*

Stadtmauer an der
Waisenstraße

*City wall alongside
Waisenstraße*

Mittelalterliche Stadtmauer

Reste der mittelalterlichen Stadtmauer sind in der Waisen-
straße, einer Parallelstraße der Klosterstraße, erhalten. Die
Stadtmauer war zwischen 1250 und 1290 in unregelmäßi-
gem Feldstein-Mauerwerk errichtet und im 14. Jahrhundert
in Backstein ausgebessert und auf etwa vier Meter erhöht
worden. Der Verlauf der aus einem Wall und zwei Gräben be-
stehenden Anlage ist im Plan von 1650 (siehe S. 7) gut er-
kennbar. Demnach bestanden drei Tore im Bereich Berlins
und zwei in Cölln, deren Lage anhand des heutigen Straßen-
verlaufs noch gut nachvollziehbar ist. Als 1658–83 der neue
Festungsring entstand, der auf Berliner Seite unmittelbar vor
der alten Stadtmauer verlief, war diese nutzlos geworden und
konnte nun beiderseits mit Wohnhäusern bebaut werden.
Dadurch blieben entlang der Waisenstraße Mauerreste auf ei-
ner Länge von mehr als 100 Metern erhalten. Ein sichtbares
Mauerstück ist heute nördlich der Gebäude Waisenstraße 14–
16 zu sehen, die, stadteinwärts gelegen, als dreigeschossige,
schlichte Traufenhäuser von geringer Tiefe und ohne Hin-
terhöfe direkt mit der rückwärtigen Wand an die Stadtmau-
er gebaut worden waren. Gleiches gilt auch für das noch gut
erhaltene Wohnhaus Waisenstraße 2, das um 1700 erbaut
und um 1795 aufgestockt wurde.

Medieval city wall

*Remnants of the medieval city wall still exist along
Waisenstraße (Orphan Street), a street running parallel to
Klosterstraße (Monastery Street). The city wall was built
between 1250 and 1290 of rough, uneven quarry stone and
repaired with brick and raised by some four metres in the 14th
century. The course of the full complex, consisting of a wall and
two moats, can be clearly seen on the map of 1650 (see p. 7).
According to this, three city gates were built in the Berlin area
and two in Cölln, the locations of which are still easy to trace
from the present-day road layout. When the new ring of fortifi-
cations was built in 1658-83, which on the Berlin side ran
directly in front of the old city wall, the latter became superflu-
ous and houses could thus be built along it on both sides. This
has resulted in remnants of the wall stretching 100 metres being
retained along Waisenstraße. A visible piece of the wall can be
seen today to the north of the buildings at 14-16 Waisenstraße.
Positioned facing into the city, these were built as simple, eave-
roofed, three-storey houses, of modest depth, with no backyards
and with the backs of the houses hard up against the city wall.
The same also applies to the still well preserved house at 2
Waisenstraße, which was built around 1700 and extended
upwards around 1795.*

Heiliggeistkapelle

Die Heiliggeistkapelle an der Spandauer Straße ist das letzte
bauliche Dokument des 1272 erwähnten Heiliggeist-Spitals,
das als einziges der mittelalterlichen Spitäler innerhalb der
Stadtmauer errichtet worden war. Bis 1886 diente es als
Kranken- und Armenhaus.

Die 20 x 10 Meter große Kapelle – um 1300 erbaut – ist ein
einschiffiger gotischer Backsteinbau auf hohem Feldsteinsockel
mit repräsentativer Giebelfassade zur Spandauer Straße. Sie er-
hielt 1476 den bis heute erhaltenen Dachstuhl und einen
1816 abgebrochenen kleinen Turm sowie 1510/20 das reprä-
sentative Sterngewölbe mit Konsolfiguren und einer Ranken-
malerei. Dabei wurden die ursprünglich schmalen, kleinen
Fensteröffnungen, die sich noch an der Traufwand im Mau-
erwerk abzeichnen, durch die heutigen großen, grau gestri-
chenen Stabwerkfenster ersetzt. 1905/06 bezog man die Ka-
pelle in das neu errichtete Gebäude der Hochschule ein.

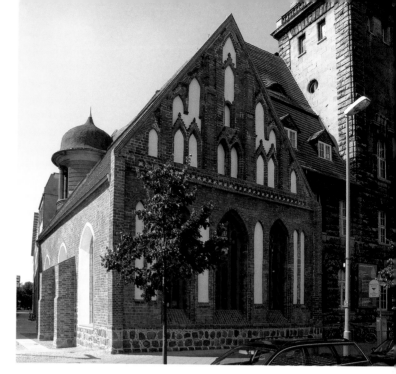

Heiliggeistkapelle

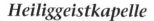

*The 'Heiliggeistkapelle' (Chapel of the Holy Spirit) on Spandauer
Straße is the last structural evidence of the 'Heiliggeist-Spital'
(Holy Spirit Hospital), first mentioned in 1272, which was the
only one of the medieval hospitals built within the city walls. It
continued to serve as a hospital, and as an almshouse, until 1886.
Built around 1300, the chapel measures 20 metres by 10 metres.
It is a single-aisled Gothic brick building built on quarry stone
foundations with a showcase gable façade facing onto Spandauer
Straße. In 1476, the chapel was given its roof truss, which has
been retained to this day, and a small tower, which was demol-
ished in 1816. In 1510/20, the impressive stellar vaulting with
sculpted corbel figures and an entwining mural were also added. In
the process, the originally small and narrow window openings,
which can still be made out in the masonry on the eave wall, were
replaced by today's large, grey-painted lattice windows. In 1905/06,
the chapel was moved into the newly built university building.*

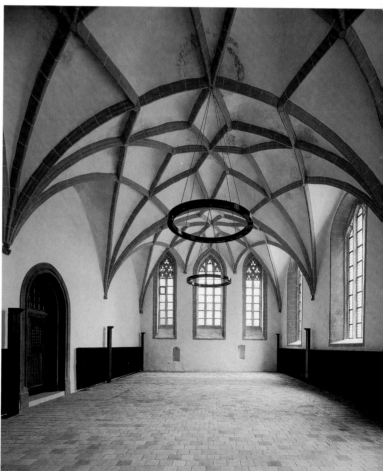

Renaissance

Geschichte

Seit dem 15. Jahrhundert wurde die Geschichte und Bautätigkeit der Doppelstadt Berlin-Cölln maßgeblich durch die Kurfürsten geprägt. Seine erste Blütezeit erlebte die Kunst unter dem Kurfürsten Joachim II. (1535–71), der auswärtige Humanisten, Architekten, Musiker, Astrologen und Alchimisten an den Cöllner Hof holte. Das Schloss ließ er zum prächtigen Fürstensitz im Stil der Renaissance ausbauen. Zu dem Wohlstand hatte die unter dem Kurfürsten ab 1539 eingeleitete Kirchenreformation beigetragen, die nicht nur die Position der Hohenzollern stärkte, sondern auch zusätzlichen Reichtum bescherte, da mit dem protestantischen Bekenntnis dem Landesherrn das Eigentum an wesentlichen Teilen des vormals kirchlichen Grundvermögens zufiel. Mit wenigen Ausnahmen wurde der Kurfürst nun Grundherr und Eigentümer des westlich der Stadt gelegenen Havelraums.

Renaissance

History

From the 15th century, the history of the twin city of Berlin-Cölln and its building activity was largely defined by the fortunes of the electors. Art experienced its first heyday under Elector Joachim II (1535-71), who brought humanists, architects, musicians and alchemists from outside the area into Cölln to the electoral court. He had the castle developed into a grand, Renaissance-style electoral residence. The reformation of the church, instigated under the Elector from 1539, contributed to his wealth. As with the taking of the Protestant faith title to substantial parts of the church's former estates passed to the ruler, it not only strengthened the position of the Hohenzollerns, but also gave them additional riches. With few exceptions, the Elector now became both landlord and owner of the Havel region to the west of the city.

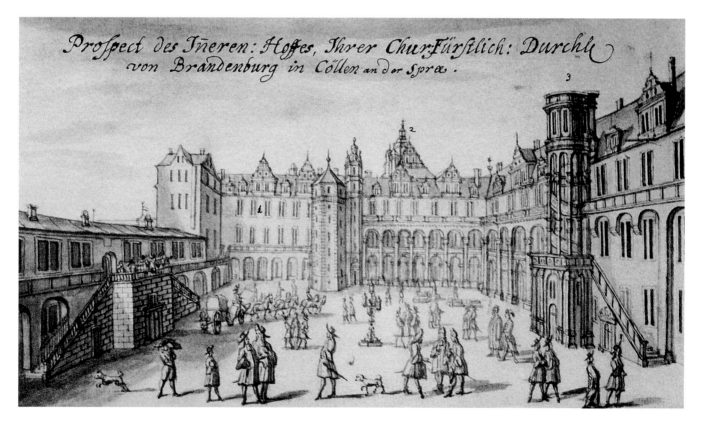

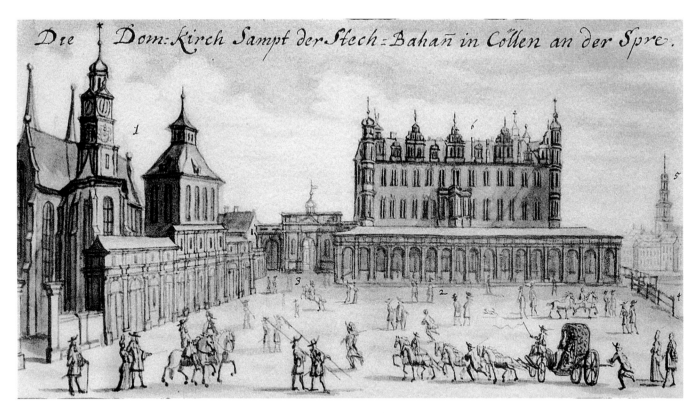

Die Dom-Kirch Sampt der Stech-Bahan in Cöllen an der Spree.

Stadtschloss, 1443–51 als Wasserburg begonnen, ab 1538 unter Kurfürst Joachim II. als Renaissanceschloss ausgebaut, Zeichnungen, 1690 von Johann Stridbeck
oben: Dom, d. h. ehem. Dominikanerkirche (1), Ende 13. Jahrhundert, und Hauptgebäude (6) des Renaissance-Stadtschlosses mit im Erdgeschoss vorgelagerter Arkadenhalle (2) mit 17 Verkaufsläden, 1679–81 von Nering angelegt und „Stechbahn" genannt, sowie Marienkirche (5)
S. 32: Innerer Hof des Renaissance-Stadtschlosses
unten: Wasserfront des Renaissance-Stadtschlosses (1), Dom (2) und Reitstall (3), 1665–71

Stadtschloss (City Palace). Begun 1443-51 as a moated castle and built up into a Renaissance palace from 1538 under Elector Joachim II. Drawings by Johann Stridbeck, 1690.
Above: Cathedral, i.e. the late 13th century Dominican church (1), main building (6) of the Renaissance city palace with arcade hall (2) including 17 shops positioned at the front on the ground floor (built by Nering, 1679-81, and called the 'Stechbahn') and the Marienkirche (5)
p. 32: Inner courtyard of the Renaissance city palace
Below: River frontage of the Renaissance city palace (1), cathedral (2) and stables (3), 1665-71

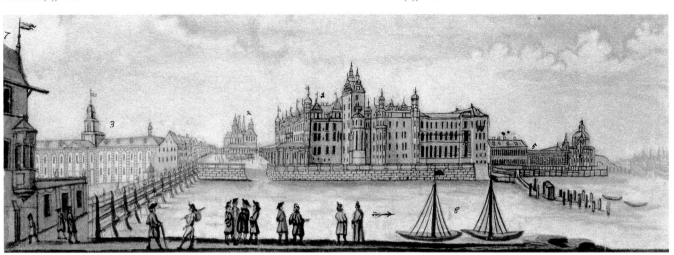

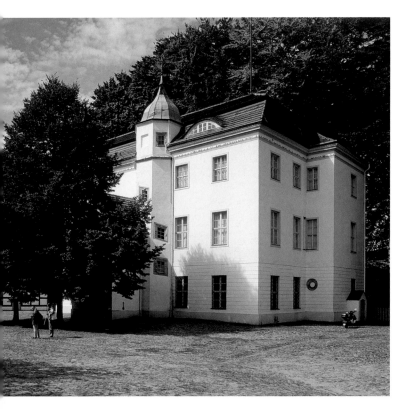

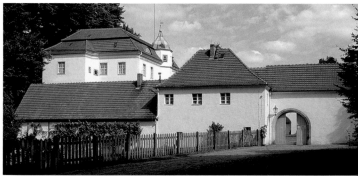

Schloss Grunewald, Hauptgebäude, 1542 von Caspar Theyß für Kurfürst Joachim II. (links), Nebengebäude, 1580–93 durch Baumeister Graf Rochus zu Lynar errichtet (oben). Unter den Baumeistern Arnold Nering und Martin Grünberg erfolgten 1669–1709 Umbauten, unter anderem wurden die Giebel, Türme und Aborterker und das Dach abgetragen und durch ein neues Dach mit Gauben ersetzt, die Wassergräben wurden aufgefüllt.

Schloss Grunewald. Left: Main building, built 1542 by Caspar Theyß for Elector Joachim II. Above: Ancillary building, built 1580-93 by master builder Count Rochus zu Lynar. Alterations followed under the direction of master builders Arnold Nering and Martin Grünberg in 1669-1709, including the removal of the gables, towers, garderobes and roof and replacement with a new roof with dormers. The moats were also filled in.

Rund um die Doppelstadt entstanden nun Jagdschlösser, darunter das im Stil der Renaissance erhaltene Schloss Grunewald und das kleine Jagdhaus in Tegel im Westen des heutigen Stadtgebiets. Ab 1559 vollzog sich der Umbau der Burg Köpenick zum Renaissanceschloss. Zugleich begann der Ausbau Berlin-Cöllns zu einer repräsentativen Residenzstadt, eingeleitet 1536 durch die Umwandlung der Cöllner Dominikanerkirche zur Domstiftskirche als Grablege des Herrscherhauses.

Kurfürst Joachim II. war der erste Kunstsammler, dessen Werke noch heute in den Schlössern und in der Gemäldegalerie zu bewundern sind. Insbesondere aus der Cranachwerkstatt erwarb der Hof zahlreiche Gemälde. 1541 fand zudem die erste Aufführung eines Theaterstücks statt.

Im Mittelalter und der frühen Neuzeit prägten giebelständige Häuser das Stadtbild, während seit dem 16. Jahrhundert die Häuser dagegen zumeist traufständig erbaut wurden. Der einzige erhaltene Renaissancebau der Stadt, das Ribbeck-Haus (Breite Straße 35) von 1624 – in unmittelbarer Nähe zum Residenzschloss erbaut – ist ein derartiger traufständiger Massivbau, dessen geschweifte, reich verzierte Zwerch-

Several hunting palaces were then built around the twin city. These included Schloss Grunewald, preserved to this day in its Renaissance style, and the small hunting lodge in Tegel in the western part of the present-day city. In the years from 1559, Köpenick Castle was converted into a Renaissance palace. At the same time, Berlin-Cölln began to be developed into a prestigious residential city, initiated in 1536 by the transformation of the Cölln's Dominican church into a chapter house church to act as the ruling family's final resting place.

Elector Joachim II was the first art collector whose collection of works can still be admired in the city's palaces and art gallery today. The electoral court bought a particularly large number of paintings from the Cranach studio. In 1541, there was also the first ever staging of a play.

In the Middle Ages and for a while thereafter, houses with their gable end to the street dominated the city landscape, while from the 16th century they were mainly built with the eaves of the roof facing front. The city's only remaining Renaissance building, the Ribbeck Haus (35 Breite Straße, dating from 1624, built very close to the electoral palace), is one such eaves-fronted structure, while its cambered, richly

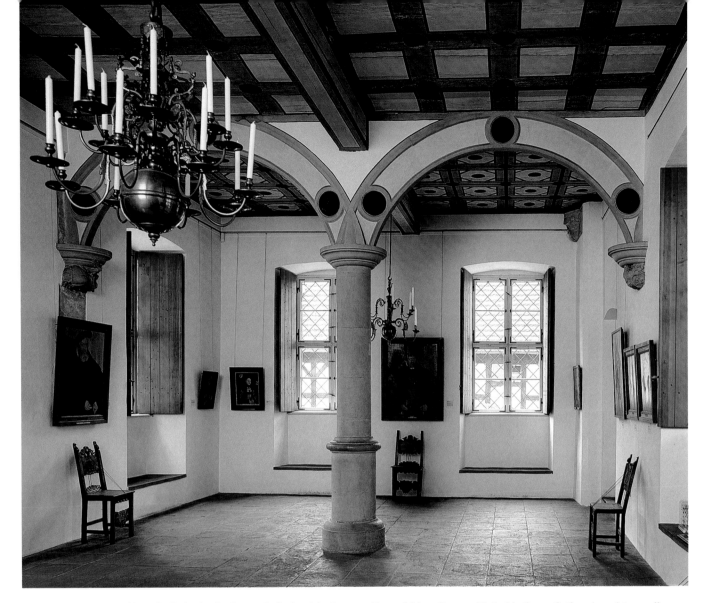

oben: Schloss Grunewald, große Hofstube. Im Innern befindet sich eine Gemäldegalerie mit Werken von Rubens und Cranach.

unten: Freilichtmuseum Domäne Dahlem, Herrenhaus, 1560 errichtet, mehrfach, vor allem im 18. Jahrhundert und zuletzt 1913 erweitert; Ansicht von Süden und sterngewölbter Raum, 16. Jahrhundert.

Above: Schloss Grunewald. Inside the castle there is a picture gallery with paintings by Rubens and Cranach among the works on show.

Below: Domain Dahlem Open-air Museum. Manor house, built 1560 and repeatedly extended, primarily in the 18th century, most recently in 1913. View from south (left) and room with 16th century stellar vaulting (right).

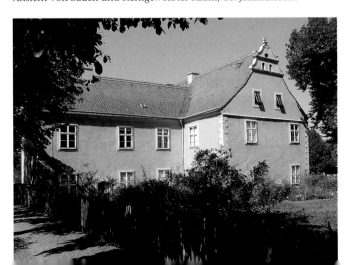

häuser jedoch noch Elemente der giebelständigen Bauweise aufnehmen. Wie für die historische Stadtbebauung üblich, standen die Hauptgebäude an der Straße. Von ihnen liefen Seitenflügel (Wirtschafts-, Arbeits- und Lagergebäude sowie Stallanlagen) in den rückwärtigen Teil des Grundstücks. Hinter dem Hof lagen Gärten. Diese nahmen somit das Innere der von den Gassen und Straßen gebildeten Häuserblocks ein. Mit zunehmender Verdichtung der Bebauung verlegte man jedoch den Anbau von Getreide, Gemüse und Obst in die größeren Gärten vor den Toren der Stadt. Ein dichter Kranz von Gärten umgab den Stadtgraben und den äußeren Wall. Die Gärten reichten bis zu den Weinbergen an den Tempelhofschen Bergen (heute Kreuzberg). Um das Jahr 1600 lebten in Berlin-Cölln etwa 10 000 bis 12 000 Einwohner.

1618 erhielten die brandenburgischen Kurfürsten das ehemalige Land des Deutschen Ordens als nunmehr weltliches Herzogtum Preußens zu Lehen und erzielten damit weiteren Land- und Machtgewinn.

Mehrere Pestepidemien (insbesondere 1631), die ein Viertel der Bevölkerung dahinraffte, und schließlich der Dreißigjährige Krieg (1618–48) brachten Schrecken und Verwüstung über Berlin und ganz Mitteleuropa. Viele der zumeist aus Holz errichteten Häuser waren beschädigt: von 1000 Hausstellen lagen 450 wüst. Die Vorstädte waren größtenteils eingeäschert. Das Schloss war halb verfallen, die Bevölkerung von 12 000 auf fast die Hälfte zurückgegangen. Nach dem Dreißigjährigen Krieg standen ein Viertel der erhaltenen Gebäude leer, in Cölln waren es über die Hälfte.

ornate dormer windows nevertheless still contain elements of the gable-fronted style. As is usual for historic urban development, the main buildings are positioned right at the roadside. Side wings (outbuildings, workshops, stores and stables) run back from them into the rear part of the plot. Behind the courtyard lay gardens. These thus took up the inner area of the residential blocks formed by the roads and alleys. However, as the housing became ever more dense, the cultivation of wheat, vegetables and fruit was moved to larger allotments outside of the city. A think ring of allotments ran around the city moats and outer wall, stretching out to the vineyards on the Tempelhof hills (now Kreuzberg). By around 1600, the population of Berlin-Cölln was between ten and twelve thousand.

In 1618, the electors of Brandenburg took feudal ownership of the Teutonic Order's former lands. With these thereafter to be the secular Duchy of Prussia, the electors thus added further to their territories and power.

Numerous plague epidemics (especially in 1631), which wiped out a quarter of the population, and ultimately the Thirty Years War (1618-48) brought terror and destruction to Berlin and the whole of Central Europe. Many of the largely timber houses were damaged, and 450 out of 1,000 housing plots lay derelict. Much of the outer area of the city was in ashes. The palace was half destroyed, the population of 12,000 reduced almost by half. By the end of the Thirty Years War, a quarter of the buildings stood empty - in Cölln it was more than a half.

rechts oben: Das einzige erhaltene Renaissancegebäude der Doppelstadt Berlin-Cölln ist das Ribbeck-Haus, Breite Straße 35, d. h. in unmittelbarer Nähe zum ehem. Stadtschloss. Die breit gelagerte Putzfassade des 1624 für den kurfürstlichen Kammerherrn Hans Georg von Ribbeck errichteten Baus zeigt sich im ursprünglichen Zustand, nachdem die Aufstockung von 1803–04 des ursprünglich zweigeschossigen Gebäudes nach Beschädigungen im 2. Weltkrieg ab 1959 wieder beseitigt wurde. Die Fassade wird durch vier Zwerchhäuser mit geschweiften Renaissancegiebeln geprägt. Es war eines der ersten Traufenhäuser der Stadt (vgl. auch Abb. S. 11). Im Erdgeschoss sind Räume mit Kreuzgratgewölben erhalten.

rechts unten: Neben dem Ribbeck-Haus steht das Gebäude Breite Straße 36, das den Übergang von der Renaissance zum Barock veranschaulicht. Der Architekt Michael Matthias Smid baute das Hauptgebäude des Alten Marstalls 1665–70 unter Verwendung von Bauteilen des abgebrannten Vorgängerbaus. Die Fassade war nach mehrfachen Veränderungen und Kriegszerstörung im Zuge der Wiederherstellungsmaßnahmen bis 1961 im ursprünglichen spätrenaissance-frühbarocken Zustand mit Zwillingsfenstern, dreiachsigem Risalit mit Dreiecksgiebel sowie ädikulagerahmtem Rundbogenportal wieder hergestellt worden.

Above right: The only Renaissance building of the twin city of Berlin-Cölln to have been preserved is the 'Ribbeck Haus' at 35 Breite Straße, i.e. very close the former city palace. The broad plaster façade of the house, built in 1624 for the electoral chamberlain Hans Georg von Ribbeck, appears in its original state, for although the originally two-storey building was extended upwards in 1803-04, the top section was removed again in 1959 after being damaged in the 2nd World War. The façade features four dormer windows with cambered Renaissance gables. It was one of the first houses in the city with its eaves facing to the road (cf. also picture on p. 11). On the ground floor there are still several rooms with groined vaulting.

Below right: Next to the Ribbeck Haus is the building at 36 Breite Straße, which illustrates the transition from Renaissance to Baroque. This main building of the 'Alter Marstall' (old royal stud) was built by the architect Michael Matthias Smid in 1665-70, using some elements of the previous building on the site, which was destroyed by fire. Following many alterations and severe damage in the War, the façade was restored to its original late Renaissance / early Baroque state during renovation in the years leading up to 1961. It was thus given twin windows, a triple axis risalit with triangular gable and a round arch doorway framed within an aedicula.

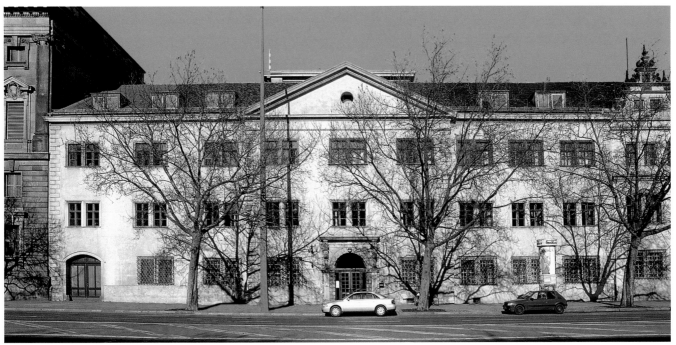

Barock

Geschichte

Durch die Regierungszeit des „Großen Kurfürsten" Friedrich Wilhelm (1640–88) erhielt die Stadt neuen Auftrieb. Er machte sich die Stände gefügig und konnte durch eine geschickte Politik das Territorium seines Kurfürstentums verdoppeln. 1657 wurde Berlin Garnisonstadt für 2000 Soldaten. Von 1658 bis 1683 und somit über einen Zeitraum von 25 Jahren ließ der Kurfürst die Stadt einschließlich Residenz und der ersten Neustadt im Westen, Friedrichswerder, mit einem gewaltigen bastionären Festungsring, bestehend aus 13 vorspringenden Bastionen, mächtigen Wällen und breiten Wassergräben, umgeben. Mit der Errichtung der sternförmigen Wasserfestung war Johann Gregor Memhardt (1607–78) betraut worden. Neue Tore und Straßen entstanden und veränderten das Stadtbild. Bis zu 4000 Bürger der Stadt und Bewohner der umliegenden Dörfer mussten täglich an Gräben, Wällen und Bastionen unentgeltlich Arbeit leisten. Zehn Jahre nach ihrer Fertigstellung wurden die Festungsanlagen als militärisch veraltet und überflüssig abgebrochen.

Zur Deckung der immer höheren Staatsausgaben, bedingt durch das große Militär, gestiegene Verwaltungs- und Baukosten für neue Repräsentationsbauten, wurden der Handel und die Gewerbe gefördert. Dies geschah durch die Gründung von Manufakturen, den Bau des Oder-Spree-Kanals (1662–69) und die Ansiedlung von Einwanderern aus anderen Ländern. Das Toleranzedikt von Potsdam (1685) erlaubte den aus Frankreich vertriebenen Hugenotten die Einwanderung und gewisse Privilegien, sodass fast 6000 Hugenotten nach Berlin kamen und die Wirtschaft belebten. Ihnen folgten als Zuwanderer wenig später pfälzische Protestanten, Böhmen und Holländer. Der Geld- und Fernhandel wurde nach 1677 besonders durch aus Wien vertriebene Juden belebt. Kaufleute, Goldschmiede, Ärzte und viele Handwerkerfamilien errichteten neue Gewerbe und eröffneten Handwerkszweige. Sie legten damit den Grundstein für die sprunghafte wirtschaftliche Entwicklung.

Der „Große Kurfürst" Friedrich Wilhelm, der in Holland studiert und die dortige Kunst schätzen gelernt hatte, verpflichtete Künstler aus den Niederlanden und Flandern, neben dem Festungsarchitekten Memhardt unter anderem den Architek-

Baroque

History

The period of rule by the 'Great Elector' Friedrich Wilhelm (1640-88) gave the city new impetus. He made the people compliant and through skilful politics was able to double the Electorate's territory. In 1657, Berlin became a garrison city for 2,000 soldiers. From 1658 to 1683, a period of 25 years, the Elector had the city, including the electoral residence and the first new town in the west, Friedrichswerder, encircled by a formidable fortified ring made up of 13 projecting bastions, mighty walls and wide moats. Johann Gregor Memhardt (1607-78) was charged with overseeing the construction of this star-shaped, moated fortification. New city gates were built, new roads laid and the whole city landscape changed. Up to 4,000 residents of Berlin and the surrounding villages had to work on the moats, walls and bastions day in, day out, without pay. Yet, ten years after they were finished, the fortifications were considered militarily outdated and superfluous and thus demolished.

To cover the ever-rising demands on the public purse caused by the large army, increased administrative expenses and building costs for new prestige buildings, the activities of merchants and tradesmen were encouraged. This took place through the establishment of factories, the construction of the Oder-Spree canal (1662-69) and by the settlement of immigrants from other countries. The 'Edict of Potsdam' (1685), also known as the 'Edict of Tolerance', allowed Huguenots driven out of France to come to city, and also granted them certain privileges. As a consequence, almost 6,000 came to Berlin and breathed new life into the economy. A short while later, they were followed as immigrants by Protestants from the Palatine, Bohemians and the Dutch. Dealing in money and long-distance trade was given a particular boost after 1677 by Jews driven out of Vienna. Merchants, goldsmiths, doctors and many artisan families set up new trades and crafts-based businesses, thus laying the foundations for vibrant economic development.

Having studied in Holland and gained an appreciation for the country's art, the 'Great Elector' Friedrich Wilhelm recruited the services of many artists from the Netherlands and Flanders. In addition to Memhardt, the architect of the city fortifications, these included the architect Michael Matthias Smid and the portrait painter Willem van Honthorst. They were followed later by Rutger van Langervelt (architect of the new palace in Köpenick) and the painters Jacques

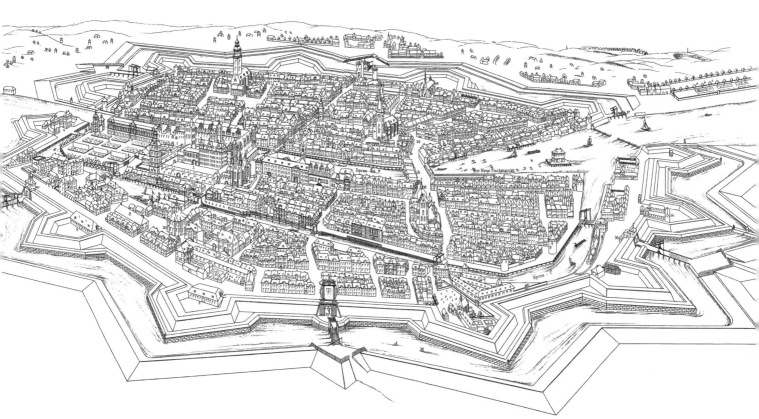

oben: Stadtansicht von Berlin 1688 (Umzeichnung von 1877) mit der von Joh. Gregor Memhard anlegten sternförmigen Festungsanlage
unten: Leipziger Tor (1), repräsentativstes Tor der frühbarocken Festungsanlage, 1738 abgebrochen und von 20 Metern Höhe, mit Graben (3), hölzerner Zugbrücke (2), Dom (5), Nikolaikirche (7), Petrikirche (8), Zeichnung von Johann Stridbeck 1690

Above: View of Berlin in 1688 (new drawing from 1877) with the star-shaped fortifications built by Johann Gregor Memhard.
Below: Leipziger Tor (1), 20-metre-high grand gateway of the early Baroque fortifications, demolished in 1738, with moat (3) and wooden drawbridge (2). Cathedral (5), St. Nicholas' (7) and St. Peter's (8). Drawing by Johann Stridbeck 1690.

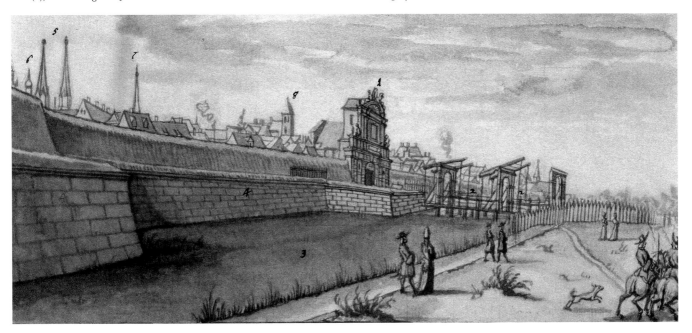

ten Michael Matthias Smid und den Bildnismaler Willem van Honthorst. Ihnen folgten später Rutger van Langervelt (der Architekt des Schlossneubaus in Köpenick) und die Maler Jacques Vaillant sowie Frans de Hamilton. Zudem waren die Italiener Philipp und Ludwig de Chieze in Berlin tätig. 1696 wurde die Preußische Akademie der Künste gegründet.

Friedrich III. (1688–1701 Kurfürst, 1701–13 König Friedrich I.) erhielt durch die guten Beziehungen zum habsburgischen Haus die Zustimmung, das Herzogtum Preußen zum selbständigen Königreich zu erheben. 1701 krönte er sich in Königsberg zum ersten preußischen König.

Um 1700 lebten in der Residenzstadt etwa 37 000 Einwohner. Jeder sechste Bürger sprach französisch, fast jeder dritte war im protestantischen Berlin Katholik oder Hugenotte. Toleranz in Glaubensfragen wurde so zu einer Voraussetzung der Politik. Noch heute künden davon der Französische Dom (die Hugenottenkirche) und die katholische St.-Helenen-Kirche, die heutige Bischofskirche des katholischen Bistums Berlin. Bis 1713 wuchs die Stadt auf bereits 61 000 Einwohner.

Aufgrund des Bevölkerungswachstums ließen die Herrscher mehrere Neustädte außerhalb der (ehemaligen) Befestigungsanlage anlegen. So entstand zunächst ab 1674 auf dem Besitz der Kurfürstin die „Dorotheenstadt" mit der späteren Prachtstraße „Unter den Linden", ab 1688 die „Friedrichstadt" unter Friedrich III. Der Ausbau der Stadt vollzog sich von Jahrzehnt zu Jahrzehnt in immer schnellerem Ausmaß. 1709 wurden die Neustädte, die Vorstädte im Norden und Osten und die Kernstadt zu einer Stadt mit dem Namen Berlin zusammengefasst und erhielten eine durch landesherrliche Eingriffsmöglichkeiten geprägte Ratsverfassung.

Die Stadterweiterungen wurden maßgeblich von den Baumeistern Johann Arnold Nering (1659–95) und Philipp Gerlach (1679–1748) vorangetrieben. Berühmtheit erlangte der Architekt und Bildhauer Andreas Schlüter (um 1659–1714). Er entwarf unter anderem das Zeughaus und erweiterte das Stadtschloss. Mit den Werken Schlüters (Reiterdenkmal Kurfürst Friedrich Wilhelms (heute Schloss Charlottenburg), Kanzel der Marienkirche, Sarkophage im Dom und Bauplastik am Zeughaus) wurde Berlin ein Zentrum der Barockplastik.

Neben dem Ausbau der Residenzstadt förderten die Kurfürsten auch den Erwerb und Bau von Schlössern, wie Monbijou, Friedrichsfelde und Schönhausen. Zum Amt Potsdam hatte zuvor schon Kurfürst Friedrich Wilhelm 1677 das Gut

Vaillant and Frans de Hamilton. The Italians Philippe and Ludwig de Chieze also worked in Berlin. In 1696, the Prussian Academy of the Arts was founded.

By virtue of his good relationship with the House of Hapsburg, Friedrich III (Elector from 1688-1701, King Friedrich I from 1701-13) obtained consent for the Duchy of Prussia to become an autonomous kingdom. In Königsberg in 1701, he crowned himself the first Prussian king.

By around 1700 the city's population numbered some 37,000. Every sixth citizen spoke French and almost one in three in Protestant Berlin was a Catholic or a Huguenot. Tolerance in matters of faith thus became a prerequisite in city politics. Signs of this remain today with the 'Französischer Dom' or French Cathedral (the Huguenots' church) and the Catholic St.-Helenen-Kirche (St. Helen's Church), the present-day bishop's church of Berlin's Catholic diocese. By 1713, the city's population had already grown to 61,000.

Due to the speed in the growth of the population, the rulers had several new towns created outside of the (former) city fortifications. Initially, for instance, 'Dorotheenstadt', with what would become the grand 'Unter den Linden' avenue, was built on land owned by the Elector's wife, and from 1668 under the rule of Friedrich III, 'Friedrichstadt' was erected. Decade by decade, the city developed at an increasingly rapid rate. In 1709, the new towns, peripheral towns to the north and east and the core of the city itself were merged into one entity under the name Berlin and were given a city council constitution that was however characterised by opportunities for the rulers to intervene.

Work on expanding the city was driven largely by the master builders Johann Arnold Nering (1659–95) and Philipp Gerlach (1679–1748). The architect and sculptor Andreas Schlüter (c. 1659–1714) also acquired great fame. His designs included the Zeughaus (Armoury) and the extension to the 'Stadtschloss' (City Palace). Indeed, Schlüter's works (the statue of Elector Friedrich Wilhelm on horseback (now at Schloss Charlottenburg), the Marienkirche's pulpit, the sarcophagus in the cathedral and sculpture work on the Armoury) made Berlin a centre of Baroque sculpture.

As well as promoting the expansion of the city, the electors also encouraged the acquisition and construction of stately palaces, such as Monbijou, Friedrichsfelde and Schönhausen. Elector Friedrich Wilhelm had already bought the Klein Glienicke estate in 1677 for the administrative district of Potsdam and had a summer residence built there for his son. From 1677-81 the new 'Schloss Köpenick' was also built for the Electoral Prince Friedrich III, later King Friedrich I. In the years following the close of the 17th century,

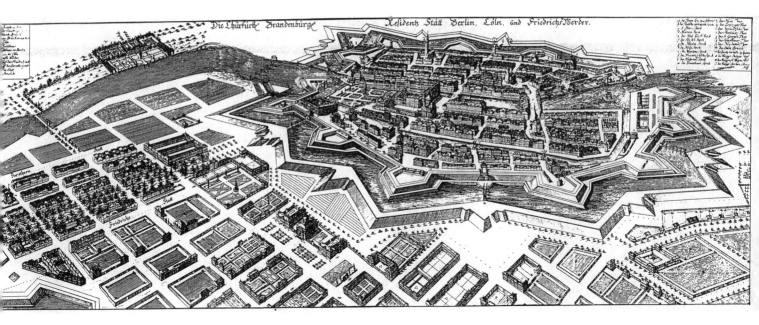

oben: Residenzstadt Berlin-Cölln mit Stadterweiterung nach Westen, Merian-Stich des ausgehenden 17. Jahrhunderts. Der perspektivische Plan Berlins zeigt die großen Festungsanlagen, zusätzlich in der Abbildung links die Dorotheenstadt und darunter die Friedrichstadt.

unten: Über den Festungsgräben entstanden im 18. Jahrhundert steinerne Brücken, auf denen zur Verschönerung der Stadt repräsentative Schauarchitekturen im Auftrag des Königs errichtet wurden. Zu diesen gehörten die Königskolonnaden (Abb. links), 1777–80 von Carl von Gontard erbaut. Sie bildeten Brückenkolonnaden als letzten Abschnitt der in den Alexanderplatz einmündenden Königsstraße (seit 1910/11 Kleistpark, Berlin-Schöneberg). Die Mohrenkolonnaden in der Mohrenstraße von Carl Gotthard Langhans (Abb. rechts) befinden sich dagegen noch an ursprünglicher Stelle. Sie wurden 1787 zur Verschönerung auf der 1742 angelegten Brücke über dem Festungsgraben mit Plastiken von Schadow und Rode erbaut. Als der Graben zugeschüttet wurde, erhielt man die Kolonnaden und bezog sie in die Neubauten mit ein.

Above: The residence city of Berlin-Cölln showing the spread of the city to the west: Engraving by Merian from the late 17th century. The 3-D plan of Berlin shows the extensive fortifications. To the left in the picture you can also see Dorotheenstadt, with Friedrichstadt below it.

Below: During the 18th century, stone bridges began to be built over the moats of the fortifications. To enhance their appearance, the king commissioned splended showpiece structures to be erected on these bridges. These included 'King's Colonnades' (Königskolonnaden, pictured left), built from 1777–80 by Carl von Gontard. They formed bridge colonnades as the final section of Königsstraße, which opens up onto Alexanderplatz (since 1910/11 they have been in Kleistpark in Berlin-Schöneberg). By contrast, Carl Gotthard Langhans' 'Mohrenkolonnaden' on Mohrenstraße (pictured right) are still in their original location. They were built in 1787 to provide embellishment on the bridge over the moat and were adorned with sculptural works by Schadow and Rode. When the moats were filled in, the colonnades were retained and integrated into new buildings.

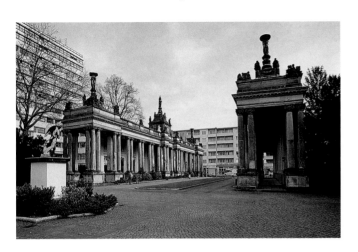

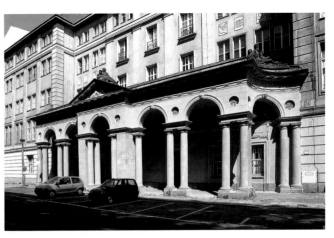

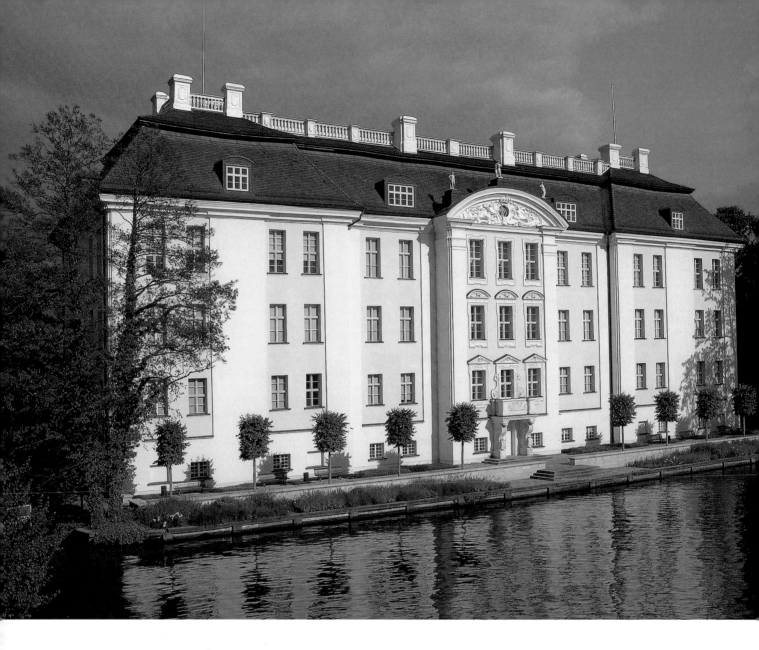

Klein Glienicke gekauft und dort für seinen Sohn ein Lust-
schloss anlegen lassen. Für den Kurprinzen Friedrich III.,
den späteren König Friedrich I., entstand 1677–81 der Neu-
bau von Schloss Köpenick. Als bedeutende Bauaufgabe ent-
wickelte sich seit dem ausgehenden 17. Jahrhundert zudem
die „Litzenburg", die später den Namen Charlottenburg er-
hielt. Charakteristisch für die barocke Stadt- und Landschafts-
gestaltung war dabei unter anderem die Errichtung von ba-
rocken Sichtachsen, die bis heute eine städtebauliche Kom-
ponente des Berliner Stadtbilds ausmachen. Dieses Netz von
Straßen- und Blickachsen verband etwa das Charlottenbur-

*'Litzenburg' palace, later given the name 'Charlottenburg', also
developed into a major building project. Characteristically for
Baroque city and landscape design this included creating straight
lines of sight that still form one of the architectural components of
the Berlin city landscape to this day. This network of road axes and
straight views linked, for instance, Schloss Charlottenburg with the
Stadtschloss (via the extension of 'Unter den Linden') and with the
residential Bismarckstraße/Kaiserdamm.*
*In 1713, the 'Soldier King' Friedrich Wilhelm I (1713-40) came to
power. From that point on, it was no longer the needs of the court
that were the centre of interest, but those of the military. The*

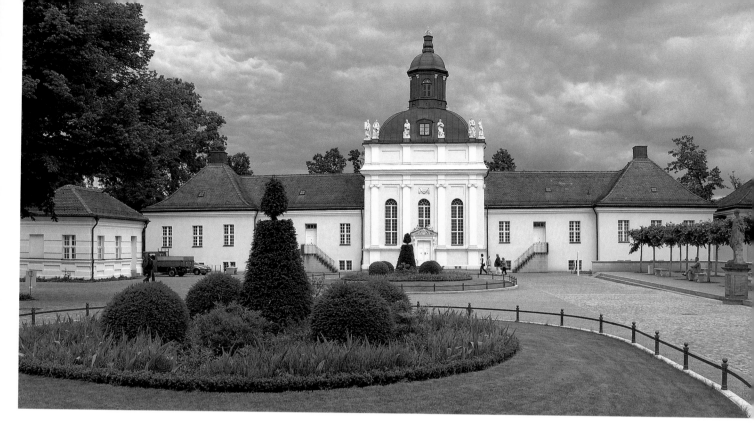

Schloss Köpenick, Fassade über der Dahme (links), Schlosskirche (oben) und Hofseite (unten), Barockanlage von 1677–81 für Kurprinz Friedrich nach Plänen des niederländischen Architekten Rutger van Langevelt. Das Schloss ist der bedeutendste Profanbau der Vor-Schlüter-Zeit in der Mark Brandenburg. Die ehemalige Schlosskapelle wurde 1682–85 von Johann Arnold Nering erbaut.

Schloss Köpenick. Façade above the River Dahme (left), palace church (above) and courtyard side (below). A Baroque property dating from 1677-81, built for the Electoral Prince Friedrich to a design by Dutch architect Rutger van Langevelt. The palace is the most important secular building of the pre-Schlüter period in the Mark of Brandenburg. The former palace chapel was built in 1682-85 by Johann Arnold Nering.

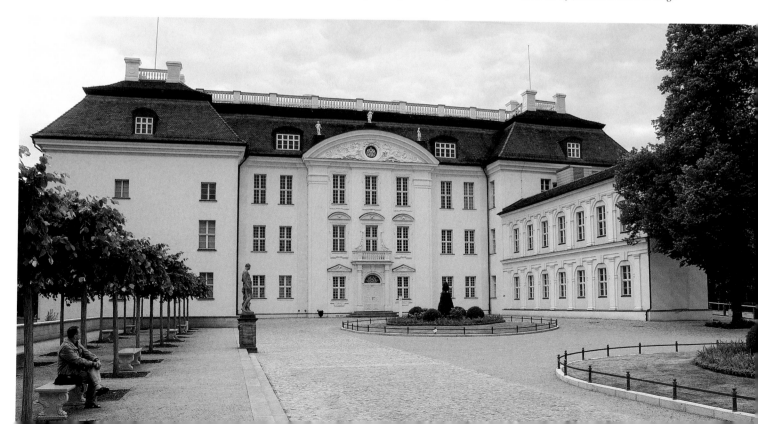

ger Schloss mit dem Stadtschloss durch die Verlängerung der Straße „Unter den Linden" und dem Straßenzug Bismarckstraße/Kaiserdamm.

1713 gelangte der „Soldatenkönig" Friedrich Wilhelm I. (1713–40) an die Regierung. Seitdem standen nicht mehr die Bedürfnisse des Hofs im Mittelpunkt des Interesses, sondern die der Armee. Das preußische Heer wuchs von 40 000 auf 83 000 Mann. Damit machte die Zahl der Militärpersonen über 20 % der Bevölkerung Berlins aus. Entsprechend wurde für die Schlösser nur noch das Nötigste getan. Andererseits entstanden während der Regierungszeit Friedrich Wilhelms I. die Böhmische und die Dreifaltigkeitskirche (beide zerstört) sowie der Turm der Sophienkirche.

Ab 1737 wurde als neue äußere Abgrenzung der Stadt eine Zollmauer errichtet, die das Land von der Stadt trennte und in der auf Lebensmittel eine indirekte Verbrauchssteuer, die bereits seit 1667 bestand, erhoben wurde. Die militärisch unbrauchbar gewordene Befestigung ließ der König schleifen. An den drei wichtigsten Toren ließ der Preußenkönig große geometrische Plätze nach Pariser Vorbildern, die im Sinne des Absolutismus des französischen Königs Ludwigs XIV. entstanden waren, errichten: ein „Quarree" (Pariser Platz) vor dem Brandenburger Tor, das „Rondell" im Süden (Mehringplatz) und den Leipziger Platz als „Octogon".

Im Gegensatz zu seinem nüchtern-strengen Vater förderte der musisch begabte Friedrich II., der Große (1740–68), die Künste. Unter seiner Regierungszeit – geprägt durch seine

Prussian army grew from 40,000 to 83,000 men, with military personnel thus making up over 20% of Berlin's population. Only essential work was therefore still being done on the palaces, while on the other hand the Böhmische Kirche (Bohemian Church) and the Dreifaltigkeitskirche (Trinity Church) - both now destroyed - and the tower of the Sophiekirche (St. Sophie's Church) were all built during Friedrich Wilhelm's rule.

In the years following 1737, a customs wall was erected as the city's new outer border, separating the rural areas from the city, in which an indirect consumer tax had been levied on food since 1667. As they had become militarily unusable, the King had the old fortifications razed, while at the three main gates he had created large, geometric open spaces, following the Parisian examples produced as part of the absolutism of the French King, Louis XIV. These were: A 'Quarree' (Pariser Platz) in front of the Brandenburg Gate, the 'Rondell' in the south (Mehringplatz) and Leipziger Platz as an 'Octagon'.

In contrast to his prosaically strict father, the musically talented Friedrich II, 'Frederick the Great' (1740-68), promoted the arts. During his rule – epitomised by his concept of "enlightened monarchy" and his interest in the French art of his time – buildings and interiors of unique and high quality were produced that art historians created a new term for them: 'Frederician Rococo'. The decorative forms produced by this style were a synthesis of late Baroque, Classicism and French Rococo. Architecture, painting and sculptural elements all corresponded with each other, creating a style that could be characterised as vibrantly ceremonial, worthy and at the same time intimate. By shortly after 1734, Frederick the Great, as

Schloss Köpenick, Portal zum Schlosshof mit Pförtnerhäuschen von Arnold Nering

Schloss Köpenick. Doorway to the palace courtyard with Arnold Nering's small gatehouses.

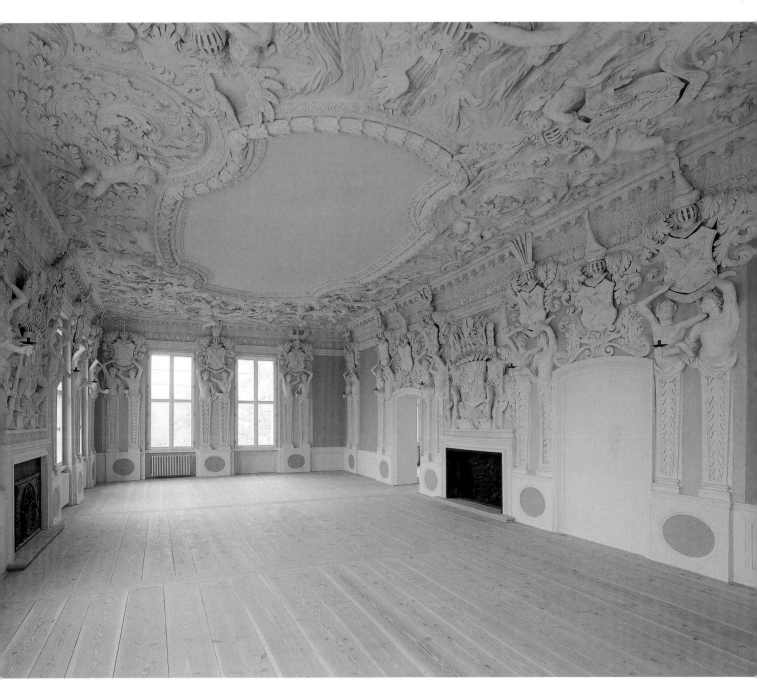

Schloss Köpenick, Wappensaal von 1684–90, Stuck von Giovanni Carove. 29 der 35 Räume des Schlosses besitzen reiche Stuckdecken. Sie entstanden zwischen 1683 und 1690 als Werk Tessiner und Graubündner Stuckateure, von denen nur der aus Bissone am Luganer See stammende Carove namentlich bekannt ist. Die Stuckaturen, die nicht gefasst oder vergoldet, sondern im Ton des Kalkstucks belassen wurden, sind frei an der Decke angetragen, nur Gesichter, Früchte und Blüten sind teilweise gegossen.

Schloss Köpenick. Heraldic hall dating from 1684-90 with stucco by Giovanni Carove.
29 of the palace's 35 rooms have ornate stucco ceilings. They stem from between 1683 and 1690 and are the work of stucco plasterers from Ticino and Graubünden, of whom only Carove, who came from Bissone on Lake Lugano, is known by name. The plasterwork that was not painted or gilded but was left in the colour of the lime stucco was applied freehand to the ceiling – only some of the faces, pieces of fruit and flowers are moulds.

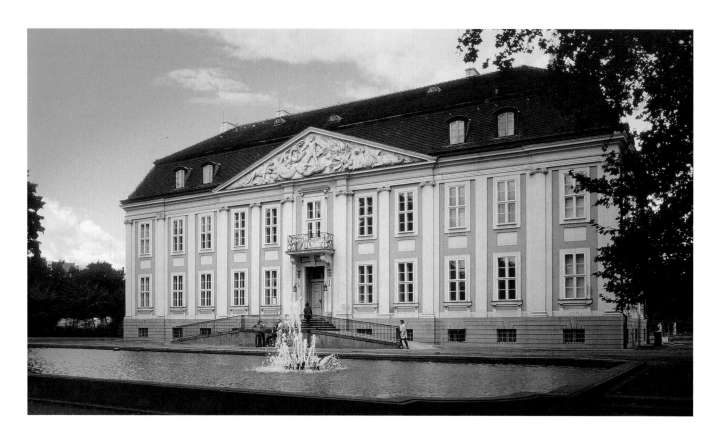

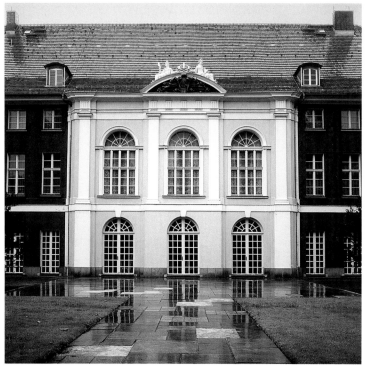

Schloss Friedrichsfelde (Am Tierpark 125) in Berlin-Lichten-berg (heute Teil des Friedrichsfelder Zoos), 1694/95 im hollän-dischen Landhausstil von Johann Arnold Nering für den Nie-derländer Benjamin von Raulé, Generaldirektor der kurfürstli-chen Marine, erbaut. Es bestand zunächst nur aus dem Mittel-teil. Als das Schloss 1698 in königlichen Besitz und 1717 an den Markgrafen Albrecht Friedrich von Brandenburg-Schwedt überging, erhielt der Hofbaumeister Martin Heinrich Böhme 1719 den Auftrag, das Gebäude zu vergrößern. Sein heutiges Aussehen erhielt das Schloss jedoch erst kurz nach 1800, als das Mansarddach und der breite Schmuckgiebel über dem Mittelrisalit errichtet wurden. Die prunkvollen Innenräume, die besichtigt werden können, sind frühklassizistisch und stammen aus der Zeit um 1785.

Above: Schloss Friedrichsfelde (125 Am Tierpark) in the Lichten-berg district of Berlin (now part of Friedrichsfelde Zoo). Built in 1694/95 in the Dutch country house style by Johann Arnold Ne-ring for Dutchman Benjamin von Raulé, Commanding Officer of the Electoral Navy. The palace initially consisted only of the mid-dle section, but after it passed in 1698 into royal ownership and in 1717 to Margrave Albrecht Friedrich von Brandenburg-Schwedt, court master builder Martin Heinrich Böhme was commissioned in 1719 to enlarge the building. However, it did not get its current appearance until shortly after 1800, when the mansard roof was put up, along with the ornate gable over the central risalit. The magnificent rooms inside the palace, which you are able to look around, are in the early Classicist style, dating from around 1785.

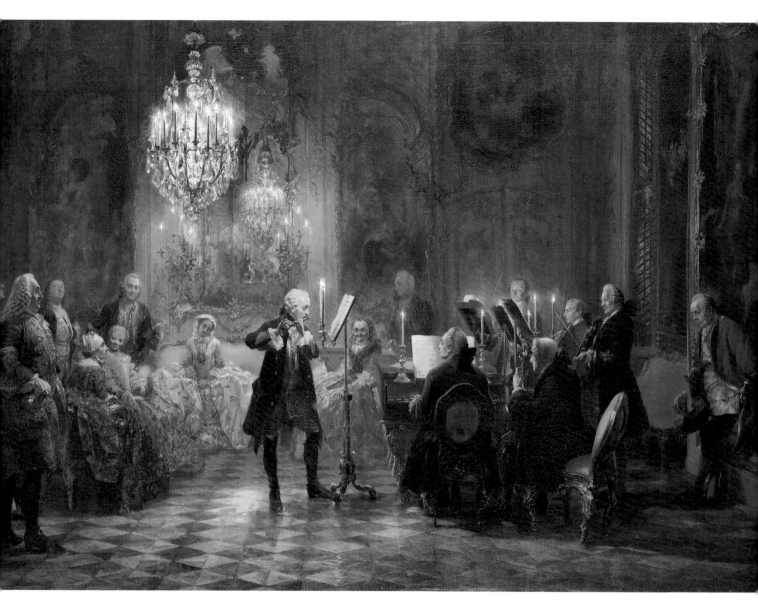

Flötenkonzert Friedrichs des Großen in Sanssouci, Öl auf Lein-
wand, 1850–52, von Adolph Menzel,
142 x 205 cm, Nationalgalerie Berlin.
Das Gemälde schildert eines der privaten Konzerte, bei
denen Friedrich der Große – im preußisch-schlichten
Uniformrock dargestellt – als Soloflötist z. T. mit selbst komponier-
ten Stücken aufzutreten pflegte.

Schloss Niederschönhausen, als Landhaus nach Plänen von
Johann Arnold Nering errichtet und seit 1704 nach Ent-
würfen von Johann Friedrich Eosander zu einer Dreiflügel-
anlage mit Pavillons umgebaut. 1740–97 war das Schloss
Sommersitz der Gemahlin Friedrichs II. und wurde 1763
unter Johann Boumann d. Ä. zum Rechteckbau erweitert.

*Above: 'The Flute Concert of Sanssouci', oil on canvas, 1850-52,
by Adolph Menzel, 142 x 205 cm, Berlin National Gallery.
The painting depicts one of the private concerts at which Frederick
the Great – portrayed in a simple Prussian tunic – was wont to
appear as a solo flautist, sometimes playing pieces he had com-
posed himself.*

*p. 46, bottom: Schloss Niederschönhausen. Built to plans by Johann
Arnold Nering as a country house and from 1704 converted, to a
design by Johann Friedrich Eosander, into a three-winged complex with
pavilions. From 1740-97 the palace was the summer residence of
Frederick the Great's wife and in 1763 was extended under the direc-
tion of Johann Boumann d. Ä. into a rectangular building.*

Vorstellung eines „aufgeklärten Monarchentums" und sein Interesse an der französischen Kultur seiner Zeit – entstanden derartig einzigartige und hochwertige Bauwerke und Innenausstattungen, dass die Kunstgeschichtsschreibung dafür die Bezeichnung „friderizianisches Rokoko" prägte. Die Dekorationsformen – eine Synthese aus spätbarocken und klassizistischen Formen mit dem französischen Rokoko, bei der Architektur, Malerei und Plastik sowie Ornamentik miteinander korrespondieren – können als schwungvoll festlich, würdevoll und zugleich intim charakterisiert werden. Jene feinen Rokoko-Dekorationen ließ Friedrich II. bereits ab 1734 als Kronprinz im Rahmen der Umgestaltung und Ausstattung seiner Residenz Schloss Rheinsberg im nördlichen Brandenburg ausführen. Seinen Höhepunkt erreichte die Ausstattungskunst nach seiner Thronbesteigung im Schloss Charlottenburg in Berlin 1740–43 und in den Stadtschlössern Berlin und Potsdam (1744–52), die beide im 2. Weltkrieg stark beschädigt und während der DDR-Zeit gesprengt wurden.

Genialer Baumeister des Preußenkönigs war Georg Wenzeslaus von Knobelsdorff (1699–1753). König Friedrich II. hatte ihn nach dessen Regierungsantritt 1740 zum Oberintendanten der Schlösser und Gärten sowie aller Bauten der königlichen Provinzen ernannt. Seit 1742 war er zugleich Intendant der Schauspiele und wohl auch der Musik. Knobelsdorff vereinigte in seinen Werken Elemente zeitgenössischer italienischer und französischer Baukunst mit denen des „Palladianismus". Er war veranwortlich für den Umbau von Schloss Rheinsberg (1737–39), dem Bau des Berliner Opernhauses (1741–43) und der Errichtung des Neuen Flügels (1740–43) und dessen Ausstattung sowie der Gartenanlage (1744) von Schloss Charlottenburg. Zudem wirkte er maßgeblich am Entwurf des berühmten Potsdamer Schlosses Sanssouci (1745–47) mit.

Friedrich der Große betätigte sich zudem als Sammler. So liebte er die Gemälde des französischen Rokokomalers Watteau und seiner Nachfolger und erwarb mehrere Gemälde. Er förderte die Berliner Porzellanmanufaktur und sammelte Porzellan (vornehmlich der Meißner Manufaktur). Darüber hinaus erwarb er 1742 den Nachlass Kardinal Polignacs und damit eine herausragende Sammlung von Antiken.

Unter Friedrich II. und seinem Nachfolger Friedrich Wilhelm III. (1786–96) erfolgten keine größeren Stadterweiterungen, obgleich die Bevölkerung rasant auf über 100 000 Einwohner (um 1747) bzw. auf ca. 172 000 (um 1800) wuchs. Am Ende seiner Regierungszeit blickte Friedrich der Große auf

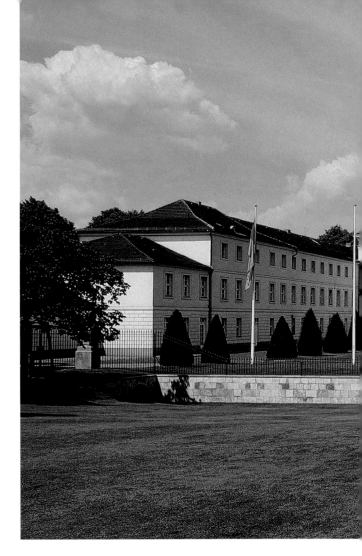

Crown Prince, was already having fine Rococo decorations of this sort produced as part of the redesign and decoration of his palatial residence, Rheinsberg, in the north of Brandenburg. Following his accession to the throne, this form of interior decorative art reached its highpoint in Schloss Charlottenburg in Berlin in 1740-43 and in the city palaces of Berlin and Potsdam in 1744-52. Both of the latter palaces were badly damaged in the Second World War and demolished during the GDR era.

Frederick's extremely talented master builder was Georg Wenzeslaus von Knobelsdorff (1699–1753). After taking power in 1740, the Prussian king had appointed him superintendent of palaces, gardens and of all buildings of the royal provinces. From 1742 he was also in charge of drama and probably also of music. Knobelsdorff united in his work elements of contemporary Italian and French architecture with those of 'Palladianism'. He was responsible for the remodelling of Schloss Rheinsberg (1737-39),

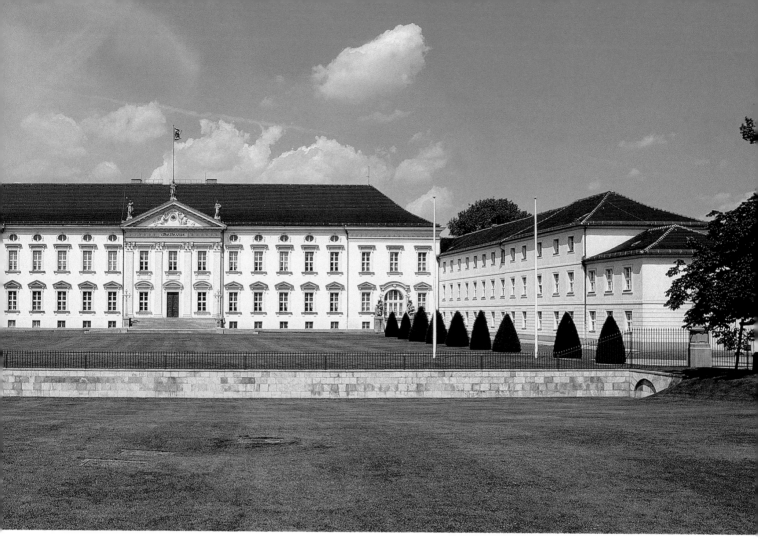

the building of the Berlin Opera House (1741-43) and at Schloss Charlottenburg for the construction and interior decoration of the 'New Wing' (1740-43) and the gardens complex (1744). He also played a key role in drawing up the designs for the famous Potsdam palace of Sanssouci (1745-47).

Frederick the Great was also an active collector. He particularly liked, for example, the paintings of the French Rococo artist Watteau and his successors and bought many of their works. He supported the Berlin porcelain factory and collected many china pieces (predominantly from the factory in Meissen). In 1742, he also acquired an outstanding collection of antiques from the estate of Cardinal Polignac.

Although the population grew rapidly to over 100,000 by around 1747 and c. 172,000 by around 1800, no great extensions to the city were made under the rule of Frederick the Great nor of his successor Friedrich Wilhelm III (1786-96).

1785–90 entstand für Prinz August Ferdinand von Preußen, den jüngsten Bruder Friedrichs des Großen, von Michael Philipp Daniel Boumann das dreiflügelige Schloss Bellevue als Sommersitz an der Spree. Dieses erste klassizistische Schloss in Preußen hatte das 1769–73 von Friedrich Wilhelm v. Erdmannsdorff nach englischen Vorbildern erbaute Schloss Wörlitz als Vorbild. *Auch die Gartenanlage des Hofgärtners Weil folgte dem damals modernen englischen Garten. Wahrscheinlich war an der Planung Johann August Eyserbeck (1762–1801) beteiligt, der Schöpfer des Dessau-Wörlitzer Gartenreichs, des ersten Landschaftsgartens auf dem europäischen Kontinent.*

Designed by Michael Philipp Daniel Boumann, the three-winged Schloss Bellevue was built from 1785-90 as a summer residence on the Spree for Prince August Ferdinand of Prussia, Frederick the Great's youngest brother. This first Classicist stately home in Prussia was modelled on Schloss Wörlitz, built following English examples in 1769-73 by Friedrich Wilhelm v. Erdmannsdorff. Court gardener Weil's garden complex also followed the then modern English garden style. It is probable that another man involved with planning the gardens was Johann August Eyserbeck (1762–1801), the creator of the Dessau-Wörlitz garden empire, the first landscape garden in mainland Europe.

ein Berlin, das zum Zentrum der gewerblichen Wirtschaft geworden war. Hier befand sich die größte deutsche Textilindustrie. Zudem gehörte Preußen neben Österreich, Russland und Frankreich nun zu den europäischen Großmächten mit Berlin als Hauptstadt.

Unabhängig vom königlichen Hof und der Staatsverwaltung wirkte die Berliner Aufklärung um die wissenschaftlich-literarisch interessierten, teils jüdischen Persönlichkeiten wie dem Verleger und Literaturkritiker Friedrich Nicolai (1733–1811) und den Schriftstellern und Philosophen Moses Mendelssohn (1729–86) und Gotthold Ephraim Lessing (1729–81).

Ende des 18. Jahrhunderts wurde der Klassizismus in das Stadtbild Berlins eingeführt. Dafür stehen die Architekten Carl von Gontard (1738–91), der seit 1764 im Dienst Friedrichs des Großen die königliche Bautätigkeit in Potsdam und Berlin leitete und 1781–85 die von Kuppeln bekrönten Turmbauten der Deutschen Kirche und des Französischen Doms entwarf, und Carl Gotthard Langhans (1733–1808), den Friedrich Wilhelm II. 1786 nach Berlin holte und dessen Brandenburger Tor von 1788–91 heute das Wahrzeichen Berlins ist.

unten und rechts: Ehrenhof des Schlosses Charlottenburg nach Plänen Eosanders 1701–1713 unter Verwendung des Ursprungsbaus eines östlich gelegenen Nebengebäudes

By the end of his reign, Frederick the Great could look on a Berlin that had become the centre of the manufacturing economy, with the city by then home to Germany's largest textile industry. Prussia now also belonged alongside Austria, Russia and France as one of the great powers of Europe, with Berlin as its capital.

Independent of the royal court and state administrators, the Enlightenment in Berlin revolved around individuals, some of them Jewish, with an interest in academia and literature, such as the publisher and literary critic Friedrich Nicolai (1733–1811) and the writers and philosophers Moses Mendelssohn (1729–86) and Gotthold Ephraim Lessing (1729–81).

Classicism was introduced to the Berlin cityscape at the end of the 18th century. The architects responsible for this were Carl von Gontard (1738–91) and Carl Gotthard Langhans (1733–1808). From 1764, Carl von Gontard supervised on Frederick the Great's behalf all royal building activity in Potsdam and Berlin and in 1781-85 designed the dome-topped towers of the Deutsche Kirche (German Church) and the Französischer Dom (French Cathedral). Carl Gotthard Langhans was brought to Berlin by Friedrich Wilhelm II in 1786, and his Brandenburg Gate of 1788-91 is now Berlin's trademark.

Below and right: Schloss Charlottenburg's courtyard of honour, constructed to Eosander's design in 1701-13, making use of the original structure of a side building on the east.

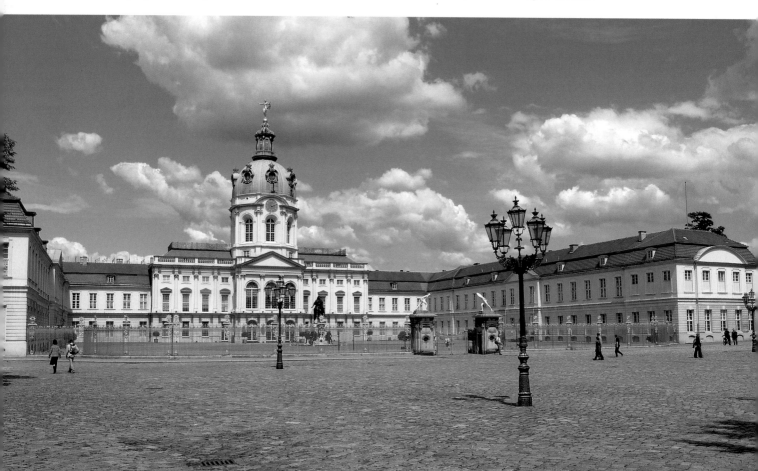

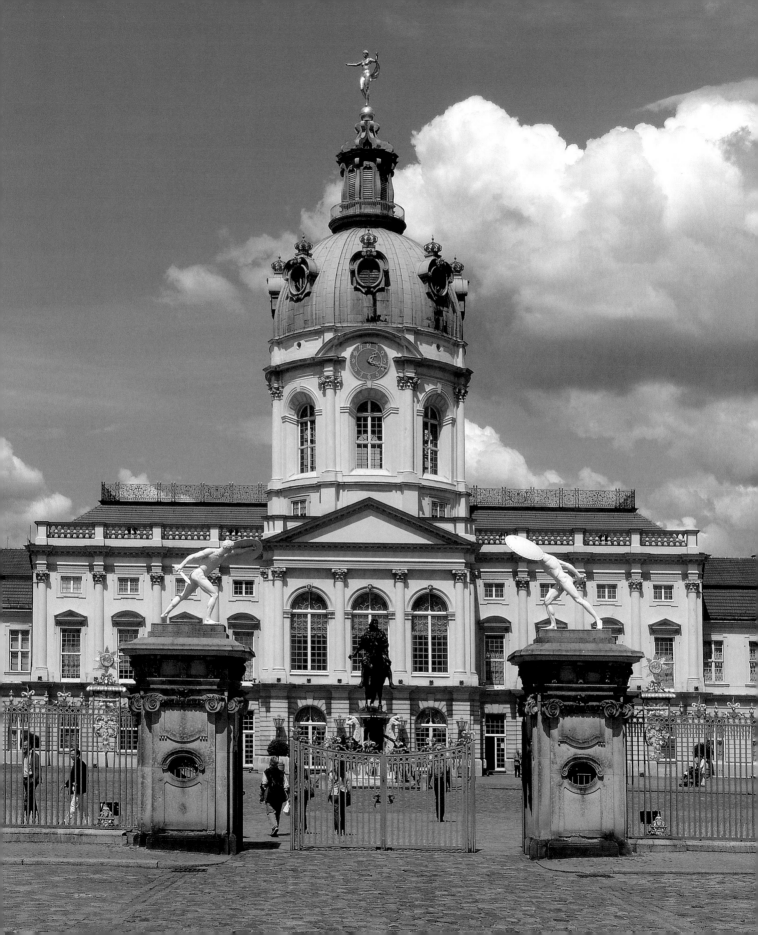

Schloss Charlottenburg

Das Schloss ist nach der Zerstörung des Stadtschlosses neben dem Zeughaus das bedeutendste barocke Bauwerk Berlins. Dabei handelt es sich nicht nur um eine herausragende Architektur. Zur Anlage gehören auch eine Parkanlage und prunkvolle Innenräume. Der erste Bauabschnitt wurde 1695 von Arnold Neringer als elfachsiges Sommerschloss für die Kurfürstin Sophie Charlotte in damals ländlicher und bewaldeter Landschaft begonnen und 1699 unter Martin Grünberg vollendet. Die erste Erweiterung zu einer Dreiflügelanlage erfolgte schon nach der Königskrönung 1701 nach Plänen von Johann Friedrich Eosander. Er fügte bis 1711 auch die 48 Meter hoch aufragende Kuppel, auf die Straßenzüge und Sichtachsen Bezug nehmen, und bis 1713 die 143 Meter lange Orangerie hinzu. Georg Wenzeslaus von Knobelsdorff lieferte die Pläne für den Neuen Flügel von 1740–46 als östliches Pendant zur Orangerie. Als Verlängerung der Orangerie folgte 1787–91 der Bau des Theaters durch Carl Gotthard Langhans.

Schloss Charlottenburg

Since the destruction of the Stadtschloss (City Palace), Schloss Charlottenburg ranks alongside the Zeughaus (Armoury) as the most important Baroque building in Berlin. It is not only a building of outstanding architecture, but a palace that also includes great gardens and grand interiors. The building was begun in 1695 by Arnold Neiger as a summer residence laid out on eleven axes for the Electoral Princess Sophie Charlotte in what was then rural, wooded countryside. This phase was completed in 1699 under the direction of Martin Grünberg. The first extension of the palace into a three-winged complex was carried out to plans by Johann Friedrich Eosander soon after the coronation in 1701. By 1711, he had added the towering dome that rises up 48 metres high and acts as a reference point for the lines of streets and extended vistas. By 1713, he had also added the 143-metre-long orangery. Georg Wenzeslaus von Knobelsdorff provided the plans for the New Wing of 1740-46, designing it as an eastern counterpart to the orangery. In 1787-91, the orangery was then extended by the construction of the theatre designed by Carl Gotthard Langhans.

links: Gegenüber dem Schloss Charlottenburg stehen die ehemaligen Gardekasernen des Regiments „Garde du Corps". 1852–59 nach Plänen von August Stüler erbaut, rahmen die identischen Häuser die Schlossstraße. Sie beherbergen heute unter anderem die Kunstsammlung Berggruen.

rechts: Im Ehrenhof des Schlosses Charlottenburg steht das Reiterdenkmal des Großen Kurfürsten von Andreas Schlüter, ein Meisterwerk der Barockplastik. 1696/97 modelliert, wurde es 1700 gegossen und 1703 beim Stadtschloss auf der Langen Brücke, der heutigen Rathausbrücke in Berlin-Mitte, aufgestellt. Der Sockel ist eine Kopie; das Original befindet sich heute im Bode-Museum.

Left: Opposite Schloss Charlottenburg are the 'Garde du Corps' regiment's former barracks. Built in 1852-59 to plans by August Stüler, the row of identical buildings lines Schlossstraße. Their uses today include housing the Berggruen art collection.

Right: Standing in Schloss Charlottenburg's courtyard of honour is Andreas Schlüter's statue of the Great Elector on horseback, a masterpiece of Baroque sculpture. Modelled in 1696/97, it was cast in 1700 and erected in 1703 on 'Lange Brücke' (Long Bridge), the present-day 'Rathausbrücke' in the Mitte district of Berlin. The plinth is a copy – the original is now kept in the Bode Museum.

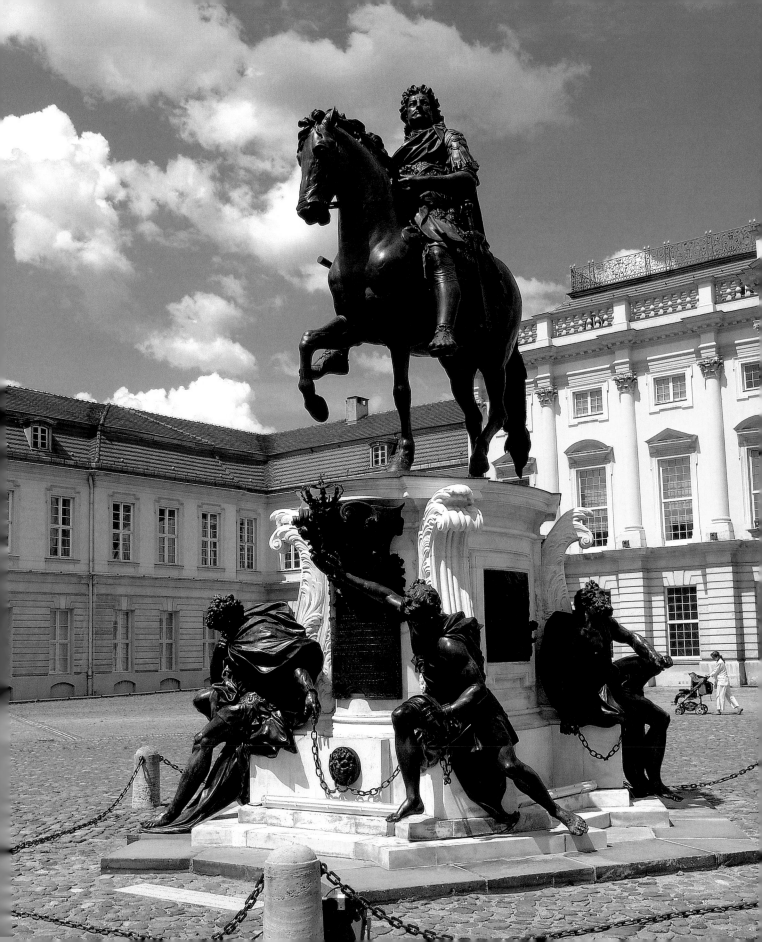

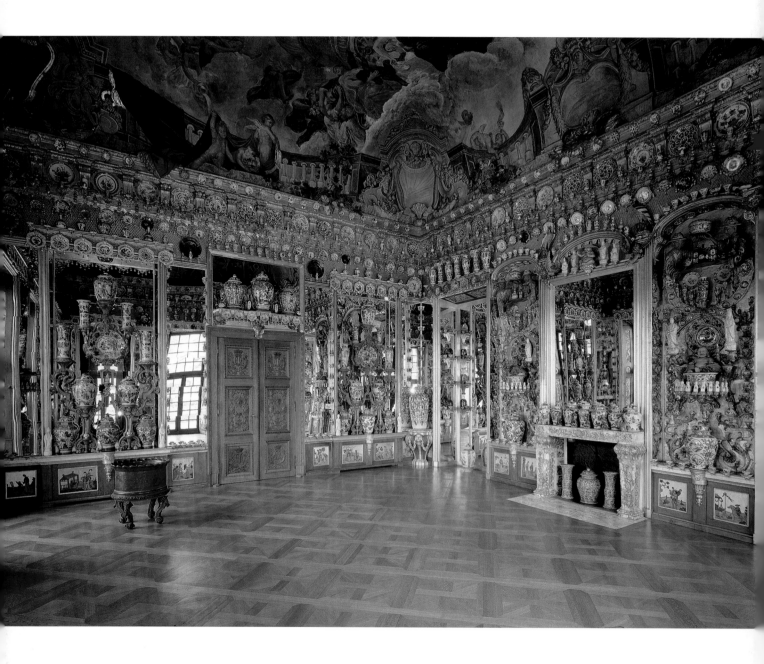

oben: Schloss Charlottenburg, Porzellankabinett, nach dem 2. Welt-krieg rekonstruiert. Friedrich III. holte 1695 Etageren und Porzellan aus Oranienburg in das Lietzenburger (Charlottenburger) Eckkabinett. Spiegel erhöhen die Wirkung der (damals) ausgesprochen kostbaren Porzellane.

rechts: Schloss Charlottenburg, Kapelle mit Krone und Baldachin von Eosander, 1704–08, nach dem 2. Weltkrieg rekonstruiert

Above: Schloss Charlottenburg's 'Porzellankabinett' (Porcelain Room), reconstructed after the 2nd World War. In 1695, Friedrich III moved étagères and porcelain from Oranienburg into this corner room at Lietzenburg (Charlottenburg). Mirrors heighten the impact of the (then) extremely valuable china.

Right: Schloss Charlottenburg. Chapel with Eosander's 1704-08 corona and baldachin, reconstructed after the 2nd World War

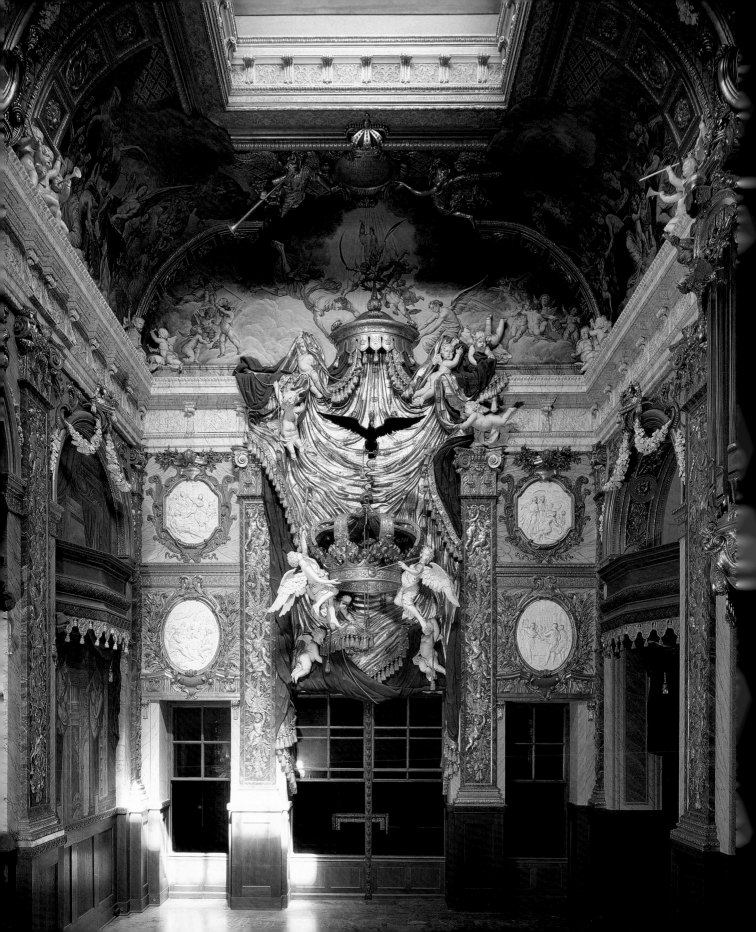

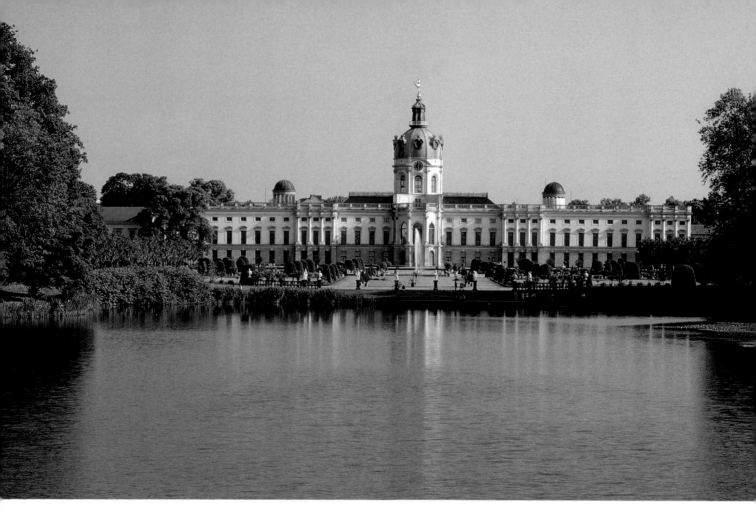

Schloss Charlottenburg, Gartenfront

Zum Schloss Charlottenburg gehört eine große Parkanlage. Den ältesten Teil des Schlosses bildet der elfachsige Mittelbau, der 1701–13 um den 48 m hohen Kuppelturm, die Dreiflügelanlage mit Ehrenhof und die 143 m lange Orangerie (rechte Gartenfront) erweitert wurde.

1	Mittelbau	6	Schinkel-Pavillon
2	Eosanderflügel	7	Mausoleum
3	Knobelsdorff-Flügel	8	Belvedere
4	Theater	9	Sammlung Berggruen
5	Kleine Orangerie	10	Weitere Gardekaserne

Schloss Charlottenburg, garden frontage

The Schloss Charlottenburg complex includes large gardens. The oldest part of the palace is the eleven-axis central building, which was extended in 1701-13 through the addition of the 48-metre domed tower, the three-winged complex with the courtyard of honour and the 143-metre-long orangery (on the right of the garden frontage).

1	*Central building*	*6*	*Schinkel pavilion*
2	*Eosander wing*	*7*	*Mausoleum*
3	*Knobelsdorff wing*	*8*	*Belvedere*
4	*Theatre*	*9*	*Berggrün collection*
5	*Small orangery*	*10*	*More guards' barracks*

rechts: Im nördlichen Teil des Schlossparks von Charlottenburg, der als englischer Landschaftsgarten ausgeführt ist, steht das Belvedere (1789/90), das ehemalige Teehaus mit Aussichtsplattform, ursprünglich auf einer Insel gelegen, von Carl Gotthard Langhans, Architekt des Brandenburger Tors, erbaut. Interessant ist der Grundriss: ein Oval, an das vier Rechtecke angefügt sind. Der sparsame Fassadenschmuck steht für den Übergang vom Barock zum Klassizismus.

unten: Neben der barocken Schlossanlage steht im Südosten der Schinkel-Pavillon („Neuer Pavillon"). Er wurde 1824/25 nach Plänen Karl Friedrich Schinkels als „italienische Villa" (Sommerhaus) für den König Friedrich Wilhelm III. ausgeführt.

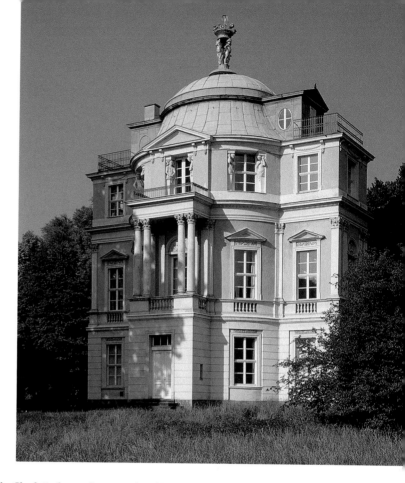

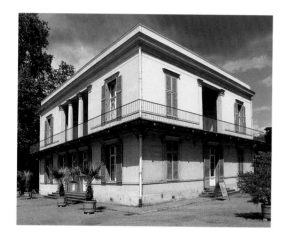

unten: Mausoleum im Schlosspark Charlottenburg nach Plänen von Karl Friedrich Schinkel 1810–12 durch Heinrich Gentz (1766–1811) errichtet, Erweiterungen 1841 und 1889. Im Innern stehen die Sarkophage der Königin Luise und ihres Gemahls, des Königs Friedrich Wilhelm III. Der Kenotaph der Königin wurde 1811–14 von Christian Daniel Rauch geschaffen, der ihres Gemahls nach Rauchs Entwurf von Carlo Baratta 1841. Ihre letzte Ruhestätte fanden hier u. a. auch die zweite Gemahlin Friedrich Wilhelms III., die Fürstin Liegnitz, ferner Kaiser Wilhelm I. und seine Gemahlin, die Kaiserin Augusta.

Above right: Situated in the northern part of the Charlottenburg palace grounds, which are laid out as an English landscape garden, is the Belvedere (1789/90), the former teahouse with viewing platform, originally standing on an island, built by Carl Gotthard Langhans, architect of the Brandenburg Gate. It has an interesting layout, being an oval with four adjoining rectangles. The sparing decoration on the façade denotes the transition from Baroque to Classicism.
Above left: Standing next to the Baroque palace complex in the southeast is the Schinkel Pavilion ('New Pavilion). It was built in 1824/25 to Karl Friedrich Schinkel's design as an 'Italian villa' (summer house) for King Friedrich Wilhelm III.
Below: The mausoleum in the grounds of Schloss Charlottenburg, built by Karl Friedrich Schinkel to plans by Heinrich Gentz (1766–1811) in 1810–12 and extended in 1841 and 1889. Inside are the sarcophagi of Queen Luise and her husband, King Friedrich Wilhelm III. The Queen's cenotaph was created by Christian Daniel Rauch in 1811-14 and that of her husband by Carlo Baratta in 1841 to Rauch's design. Others for whom the mausoleum became their final resting place include Friedrich Wilhelm III's second wife, Princess Liegnitz, Kaiser Wilhelm I and his wife, Empress Augusta.

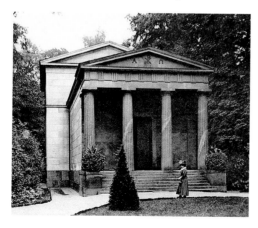

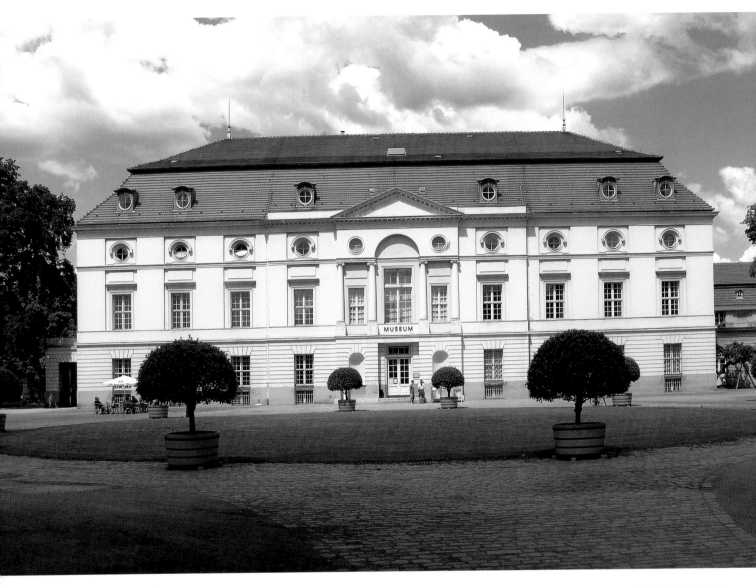

oben: Schloss Charlottenburg, Schlosstheater, 1788–91 von Carl Gott-
hard Langhans erbaut. Durch die Anfügung des Theaterbaus war die
Größe des Schlosses auf eine Länge von 505 Metern angewachsen.

rechts: Das ehemalige Schlosstheater beherbergte bis 2009 das Museum für
Vor- und Frühgeschichte, eines der größten seiner Art in Europa. Seit 2009
wird die Sammlung im Neuen Museum auf der Museumsinsel präsentiert.
Die Abbildung zeigt den sogenannten „Berliner Goldhut", die vollstän-
dig aus Gold bestehende, 74,5 cm hohe und 490 g schwere Tiara eines
Kultherrn aus der späten Bronzezeit (10. Jahrhundert v. Chr.).
Neben dem „Berliner Goldhut" gehören die „Sammlung trojanischer Al-
tertümer", die Heinrich Schliemann 1881 dem Museum vermachte, der
Fund eines Neandertalers von Le Moustier, die Schätze aus früheisenzeit-
lichen Fürstengräbern Sloweniens und reiche Grabbeigaben aus der Me-
rowingerzeit zu den bekanntesten Exponaten des Museums.

*Above: Schloss Charlottenburg's palace theatre, built by Carl Gotthard
Langhans in 1788-91. The addition of the theatre building took the
palace's size to a length of 505 metres.*

*Right: The former palace theatre was housing the 'Museum für Vor- und
Frühgeschichte' (Museum of Early History and the Prehistoric Era) until
2009, one of the largest of its kind in Europe. Since 2009 the collection is
shown in the New Museum on Museum Island.*
*The picture shows the so-called 'Berliner Goldhut' (Berlin's gold hat), the
tiara of a cult god from the late Bronze Age (10th century BC). It is made
completely of gold, is 74.5 cm high and weighs 490 g.*
*In addition to the 'Berliner Goldhut', the museum's other best-known
exhibits include the 'Collection of Trojan Antiquities' bequeathed to the
museum in 1881 by Heinrich Schliemann, Le Moustier's Neanderthal youth,
treasures from the early Iron Age graves of Slovenian princes and opulent
burial objects from the Merowingian Age.*

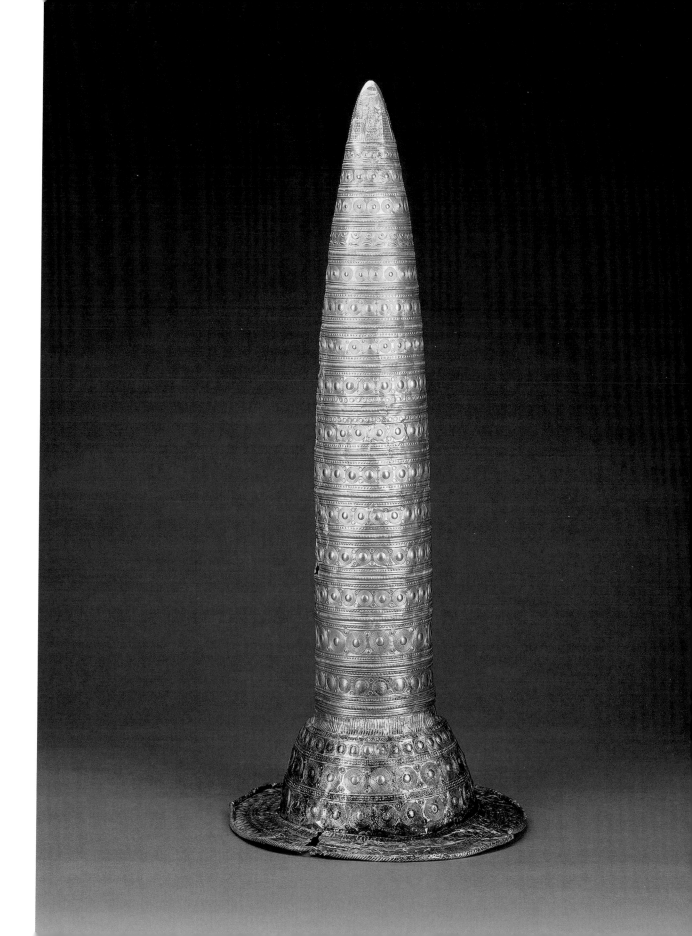

Bürgerhäuser und Kirchen

Während der Barockzeit entstanden nicht nur neue Stadtviertel, sondern es wandelte sich auch das Stadtbild des mittelalterlichen Zentrums durch die Aufstockung der ein- bis zweigeschossigen Häuser zu drei- bis viergeschossigen Gebäuden. Die Fachwerkhäuser wurden verputzt oder durch steinerne Gebäude ersetzt. Von daher bestimmen auch verputzte barocke und klassizistische Fassaden das Bild des nachgebauten Nikolaiviertels (vgl. auch S. 13ff.).

links oben: Villa Kamecke, 1711–12 von Andreas Schlüter für den Staatsminister Ernst Bogislav van Kamecke in der Dorotheenstadt nahe der Spree als vorstädtisches Landhaus im Stil eines Lustgebäudes mit geschweiftem Mittelbau errichtet, nach Kriegsschäden 1943 nach dem Krieg abgebrochen
links unten: Neuer Markt, Radierung von Johann Georg Rosenberg 1785
rechts oben: Stadterweiterungen der Doppelstadt Berlin-Cölln und Neustädte bis zum 18. Jahrhundert
rechts unten: Cöllnischer Fischmarkt mit dem Cöllnischen Rathaus, Kupferstich von Jean Rosenberg, 1785

City housing and churches

During the Baroque era not only were entire new districts created, but the face of the medieval centre of the city was also transformed by the addition of extra floors to the one or two-storey houses to create three to four-storey buildings. Half-timbered houses were also plastered over or replaced with stone-built structures. It is for this reason that plastered Baroque and Classicist façades also define the look of the reproduction Nikolaiviertel (cf. also p. 13ff.).

Above left: Villa Kamecke. Built in Dorotheenstadt near the Spree by Andreas Schlüter in 1711-12 for Minister of State Ernst Bogislav van Kamecke as a suburban country house in the style of a summer residence, with a cambered central structure. It suffered war damage in 1943 and was demolished after the War.
Below left: Neuer Markt (New Market). Etching by Johann Georg Rosenberg, 1785.
Above right: Pre-18th century extensions of the twin city of Berlin-Cölln and new towns.
Below right: Cölln fish market and town hall. Copper etching by Jean Rosenberg, 1785.

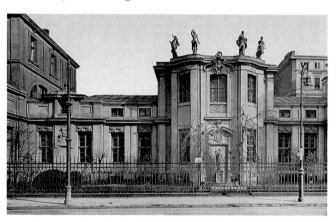

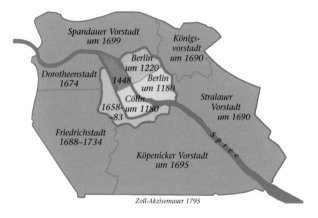

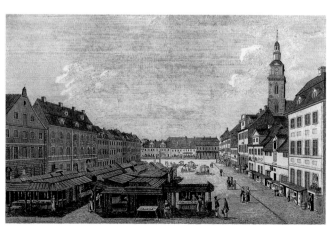

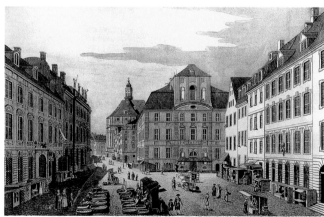

oben: Märkisches Ufer, seit 1680 angelegt, Bebauung 18.–20. Jahrhundert, z. B. Nr. 16 um 1790, Nr. 18 um 1730 (beide heute Museum „Otto-Nagel-Haus") und Nr. 10 (Ermeler-Haus) 1760–63 bzw. 1804 (Fassade) (transloziertes bzw. rekonstruiertes Gebäude, ursprünglich: Breite Straße 11)
rechts: Friedrichsgracht, Uferstraße 1670–82 angelegt, Zeichnung, 1690 von Johann Stridbeck

Above: Märkisches Ufer (embankment). Laid out since 1680, houses built 18th-20th century, e.g. no. 16 c. 1790, no. 18 c. 1730 (now both the 'Otto-Nagel-Haus' Museum) and no. 10 (Ermeler Haus) 1760-63/1804 (façade), a relocated/reconstructed building, originally at 11 Breite Straße).
Right: Friedrichsgracht (canal), Uferstraße. Built 1670–82. Drawing by Johann Stridbeck, 1690.

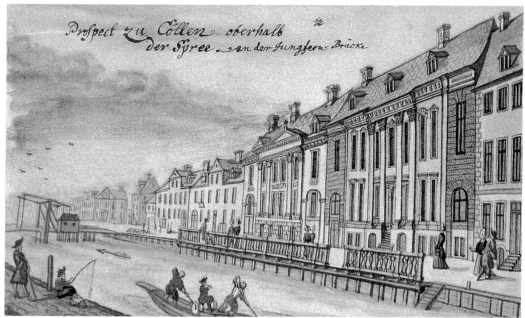

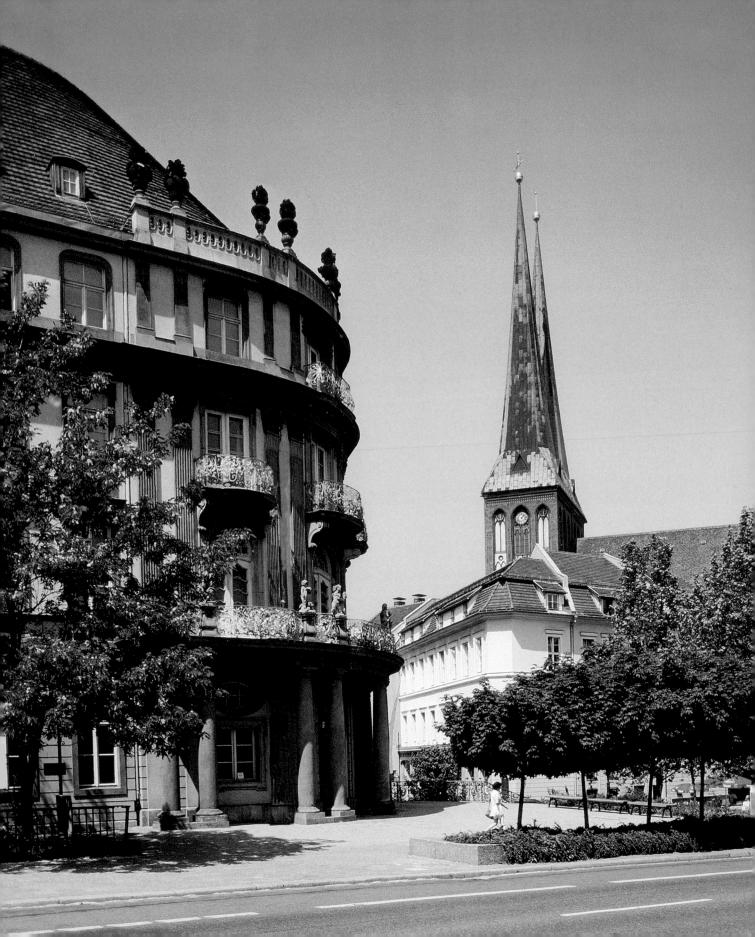

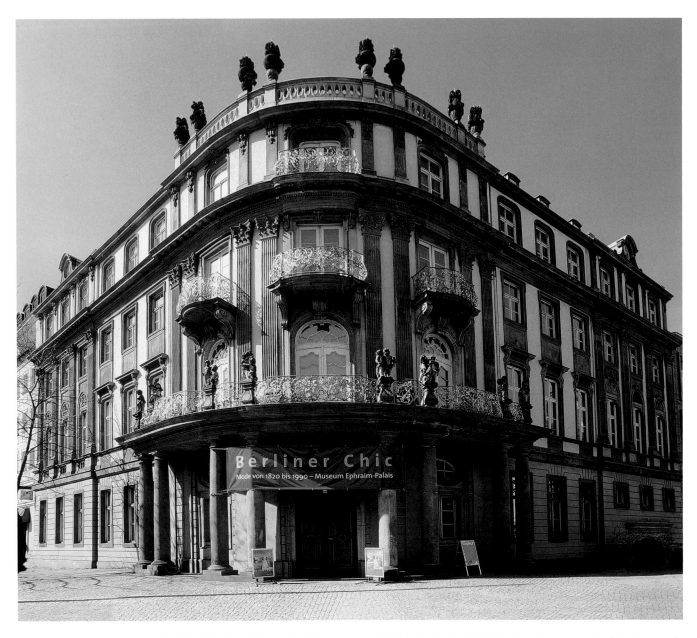

Palais Ephraim im Nikolaiviertel Ecke Mühlendamm/Poststraße 16.
Das 1762–66 nach Entwurf Friedrich Wilhelm Diterichs (1702–82) für
den Hofjuwelier und Münzpächter Friedrichs des Großen, Nathan
Veitel Ephraim, erbaute Palais, das als schönstes der Rokokozeit gilt,
war 1935/36 aufgrund einer Straßenerweiterung abgebrochen worden
und wurde 1985–87 mit originalen Fassadenteilen neu aufgebaut. Die
den Balkon tragenden Säulen und die Gitter sollen ein Geschenk
Friedrichs II. aus seiner Kriegsbeute von 1757 vom Schloss Pförten
sein. Heute ist das Gebäude Teil des Stadtmuseums. Im Innern ist u. a.
die Kopie einer Stuckdecke von 1704 nach Entwürfen Andreas Schlü-
ters aus dem 1889 abgebrochenen Wartenbergschen Palais zu sehen.

*Palais Ephraim in the Nikolaiviertel on the corner of Mühlendamm and
16 Poststraße.*
*This palatial villa was built in 1762-66 to a design by Friedrich Wilhelm
Diterich (1702–82) for court jeweller and Frederick the Great's minter of
coins, Nathan Veitel Ephraim. Considered the most beautiful such villa of
the Rococo period, it was nevertheless demolished for road widening in
1935/36 before being rebuilt using original façade components in 1985-87.
The pillars supporting the balcony and the railings are said to have been a
gift from Frederick the Great out of his spoils of war from Schloss Pförten in
1757. Today, the building is part of the Stadtmuseum (City Museum).
Interior features to be seen include the copy of a 1704 Andreas Schlüter
stucco ceiling from Wartenberg Palais, which was demolished in 1889.*

oben: Palais Schwerin am Molkenmarkt, Mittelteil der Fassade 1704 von Jean de Bodt entworfen. Sie wurde 1935/37 zurückversetzt und um die zwei abgebildeten flankierenden Bauten erweitert.

links: Knoblauchhaus, 1759–61 als Wohnhaus für die Familie des Nadlermeisters Johann Christian Knoblauch errichtet. Die Fassade wurde 1806 klassizistisch umgestaltet. Das Gebäude ist eines der wenigen am ursprünglichen Standort verbliebenen Berliner Bürgerhäuser des 18. Jahrhunderts. Die Familie Knoblauch besaß einen umfangreichen Bestand an Möbeln, Porzellan, Gemälden und Fotografien, der heute in dem als Museum genutzten Gebäude zu sehen ist.

Above: Palais Schwerin on Molkenmarkt. Central part of the façade designed in 1704 by Jean de Bodt. In 1935/37, it was set back and extended through addition of the flanking structures illustrated.

Left: Knoblauchhaus. Built in 1759-61 as a home for the family of master tailor Johann Christian Knoblauch. The façade was remodelled in 1086 in the Classicist style. The building is one of the few 18th century merchants' houses in Berlin still standing in its original location. The Knoblauch family possessed a comprehensive stock of furniture, porcelain, paintings and photographs, now on view in the building, which is today used as a museum.

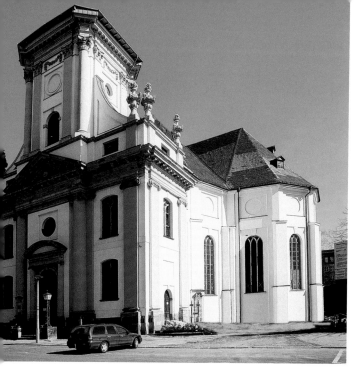

oben und rechts: Parochialkirche in der Klosterstraße, 1695 von Johann Arnold Nering begonnen, von Martin Grünberg, der 1705 die Vorhalle schuf, weitergeführt und nach Entwurf von Jean de Bodt durch Philipp Gerlach mit dem Turm 1713/14 vollendet. Der Zentralbau ist als Vierkonchenanlage (ursprünglich darüber ein Vierungsturm) mit einer Vorhalle ausgeführt. Die Turmobergeschosse wurden seit der Zerstörung im 2. Weltkrieg noch nicht ausgeführt (ursprünglicher Zustand siehe Abbildung unten rechts).

unten links: Palais Podewils, Klosterstraße 68, 1701–04 nach Plänen von Jean de Bodt

unten rechts: Blick in die Klosterstraße mit der Parochialkirche, Radierung, 1785 von Johann Georg Rosenberg

Above and right: Parochialkirche on Klosterstraße. Begun in 1695 by Johann Arnold Nering, continued by Martin Grünberg, who created the vestibule in 1705, and completed to Jean de Bodt's design by Philipp Gerlach with the addition of the tower in 1713-14. The central building is designed as a four-apse structure (originally including a crossing tower above it) with a vestibule. Since being destroyed in the 2nd World War, the tower's upper floors have not yet been rebuilt (the picture below right shows the church's original appearance).

Below left: Palais Podewils, 68 Klosterstraße. Built in 1701–04 to plans by Jean de Bodt.

Below right: View down Klosterstraße including the Parochialkirche. Etching by Johann Georg Rosenberg, 1785.

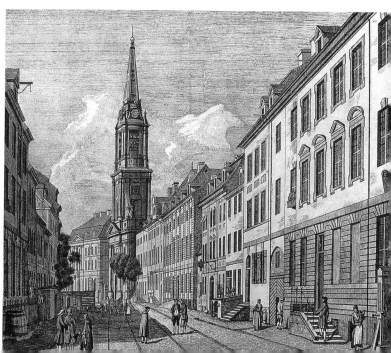

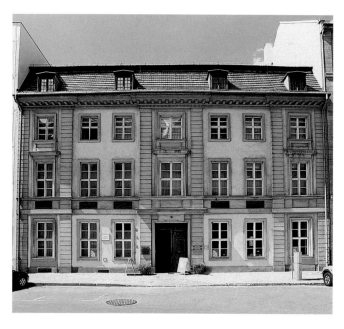

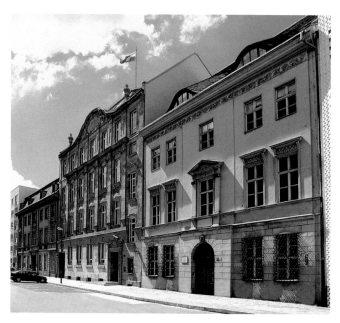

oben links: Nicolai-Haus (heute Stiftung Stadtmuseum), Brüderstraße 13, 1674 auf zwei mittelalterlichen Grundstücken erbaut. In dem Gebäude richtete der Schriftsteller und Verleger Christoph Friedrich Nicolai (1733–1811) 1787 seine Buchhandlung ein und ließ das Gebäude durch den Maurermeister und späteren Direktor der Berliner Singakademie Karl Friedrich Zelter umbauen.
oben rechts: Brüderstraße 10–13. Das Haus Brüderstraße 10 (sog. Galgenhaus, da 1735 vor dem Haus eine Dienstmagd zu Unrecht öffentlich gehängt worden war) wurde um 1688 für den Kammerrat von Happe errichtet und 1805 klassizistisch verändert (heute Fotografische Sammlung des Stadtmuseums). Das Gebäude Brüdergasse 11–12 errichteten die Architekten Reimer & Körte 1905 im Stil des Neobarock.

Above left: Nicolai Haus (today City Museum Foundation), 13 Brüderstraße. Built in 1674 on two medieval plots. In 1787, the author and publisher Christoph Friedrich Nicolai (1733-1811) set up his bookshop in the building and had it remodelled by master mason Karl Friedrich Zelter, who later became Director of the Berlin Academy of Song.
Above right: 10-13 Brüderstraße. The house at 10 Brüderstraße (called the 'Galgenhaus' or gallows house, as the unjust public hanging of a housemaid took place in front of it in 1735) was built in 1688 for Chamber Councillor von Happe and altered in 1805 in Classicist style (now houses the City Museum's photographic collection). The building at 11-12 Brüderstraße was built in the Neo-Baroque style by the architects Reimer & Körte in 1905.

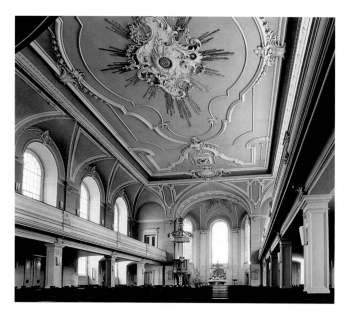

links und rechts: Sophienkirche, als Pfarrkirche der Spandauer Vorstadt 1712–13 wohl nach Plänen von Philipp Gerlach als Stiftung der Königin Sophie Luise – Gemahlin Friedrichs I. – errichtet. Die Kirche erhielt 1732–34 unter Johann Friedrich Grael in Anlehnung an Schlüters Münzturm und die Potsdamer Garnisonkirche einen fast 70 Meter hohen Turm, den einzigen original erhaltenen Barockturm Berlins. 1892–95 gestaltete man den Kirchenraum neobarock zur Langhauskirche um. Auf dem Kirchhof befinden sich die Gräber des Komponisten Carl Friedrich Zelter (1758–1832) und des Historikers Leopold v. Ranke (1795–1886). Wenige Meter südlich liegt der 1672 angelegte, 1827 geschlossene, 1943 eingeebnete und 1945 zur Parkanlage umgestaltete Jüdische Friedhof.

Left and right: Sophienkirche. Built in 1712-13 as the parish church of the Spandauer Vorstadt district probably to plans by Philipp Gerlach as a gift of Queen Sophie Luise, the wife of Friedrich I. In 1732-34, under the direction of Johann Friedrich Grael and drawing on Schlüter's 'Münzturm' (Mint Tower) and Potsdam's Garnisonkirche, the church was given an almost 70-metre tower, the only Baroque tower in Berlin still preserved in its original form. In 1892-95, the body of the church was converted in Neo-Baroque style into a nave church. In the churchyard are the graves of the composer Carl Friedrich Zelter (1758-1832) and the historian Leopold v. Ranke (1795–1886). A few metres to the south is the Jewish cemetery, built in 1627, closed in 1827, levelled in 1943 and converted into a park in 1945.

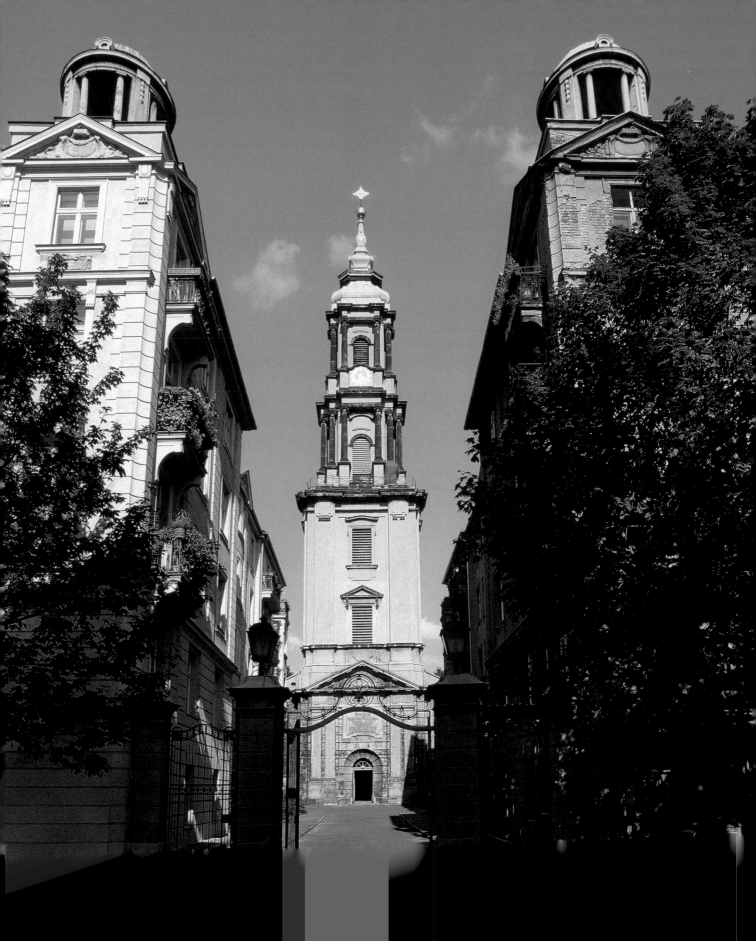

unten: Zwei der ursprünglich drei Pfarrhäuser von 1738/39 der zerstörten Dreifaltigkeitskirche (Taubenstraße/Ecke Glinkastraße). Sie sind die einzigen erhaltenen barocken Wohnhäuser der Friedrichstadt und wurden nach Plänen des Baumeisters der Dreifaltigkeitskirche, Titus Favre, erbaut.

Below: Two of the destroyed Trinity Church's original three manse houses dating from 1738-39 (corner of Taubenstraße and Glinkastraße). They are the only Baroque houses from Friedrichstadt remaining and were built to plans by Titus Favre, architect of the 'Dreifaltigkeitskirche' (Trinity Church).

oben: Neue Schönhauser Straße 8, zwischen 1785 und 1794 wohl von Georg Christian Unger, Direktor der Immediatbaukommission Friedrichs II., erbaut; Pflanzengirlanden mit Schlusssteinköpfen in Form von weiblichen Büsten wahrscheinlich aus der Werkstatt Jean Pierre Antoine Tassaerts, dem Hofbildhauer Friedrichs II. Das Gebäude steht in der Spandauer Vorstadt, dem einzigen gut erhaltenen historischen Viertel Berlins mit Zeugnissen barocker, klassizistischer und historistischer Wohnhausarchitektur. Hier lebten vor 1900 vor allem kleine Handwerker und Arbeiter der Woll- und Seidenmanufakturen, ab 1671 auch „Schutzjuden", die gegen Zahlung hoher Steuern unter dem Schutz des preußischen Königs standen und geduldet wurden. Noch um 1900 besaß das Viertel ein besonderes Flair, das von geringerem Einkommen und unterschiedlichen Glaubensrichtungen geprägt war. Heute beleben Kunsthandwerker, Künstler, Galerien, Cafés und Restaurants die malerischen Hinterhöfe, von denen die Hackeschen und die Sophie-Gips-Höfe am bekanntesten sind.

Above: No. 8 Neue Schönhauser Straße. Built between 1785 and 1794, probably by Georg Christian Unger, Friedrich II's Director of the 'Palatial Buildings Commission'. It features floral garlands with keystone heads in the form of female busts probably from the workshop of Jean Pierre Antoine Tassaert, Friedrich II's court sculptor. The building is in Spandauer Vorstadt, the only well-preserved historical district of Berlin, with examples of Baroque, Classicist and other historical residential architecture. The people living here prior to 1900 were predominantly modest craftsmen and workers from the wool and silk factories, while from 1671 they also included 'protected Jews', who in return for paying high taxes were protected by the Prussian king and tolerated. Even by around 1900, the quarter still had a special flair, characterised by modest incomes and a variety of religious beliefs. Today, workers in arts and crafts, artists, galleries, cafés and restaurants bring life to the picturesque rear courtyards, the best known of which are the Hackeschen Höfe and the Sophie Gips Höfe.

oben: Magnushaus, Am Kupfergraben 7, gegenüber dem Pergamonmuseum, 1756–61 von Georg Friedrich Boumann und August Gotthilf Naumann für den Geheimen Kriegsrat Johann Friedrich Westphal erbaut, eines der wenigen erhaltenen barocken herrschaftlichen Häuser Berlins. 1840 erwarb der Physiker Heinrich Gustav Magnus das Gebäude und richtete einen Hörsaal und ein Laboratorium ein.

Above: Magnushaus, no. 7 Am Kupfergraben, opposite the Pergamon Museum. Built in 1756-61 by Georg Friedrich Boumann and August Gotthilf Naumann for Privy Councillor of War Johann Friedrich Westphal, it is one of the few preserved Baroque aristocratic houses in Berlin. The building was bought in 1840 by the physicist Heinrich Gustav Magnus, who installed a lecture theatre and laboratory.

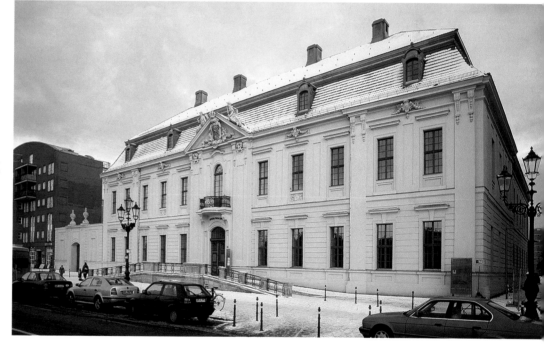

Mitte und unten: Altbau des Jüdischen Museums, ehem. Kollegienhaus, später Kammergericht, Lindenstraße 14, 1733–35 von Philipp Gerlach als anspruchsvolles Stadtpalais erbaut, Fassade (Mitte) und Gartenseite (unten). Das 1945 schwer zerstörte Barockgebäude ist eine zweigeschossige Dreiflügelanlage mit Mansarddach und Dreiecksgiebel mit den Allegorien Justitia und Prudentia wahrscheinlich aus der Werkstatt Johann Georg Glumes. Es ist der einzige erhaltene Barockpalast der Friedrichstadt.

Centre and below: The Jewish Museum's old building, 14 Lindenstraße, a former council chamber and later superior court of justice. Built in 1733-35 by Philipp Gerlach as a sophisticated city palace. Façade (centre) and garden side (below). The Baroque building, which was badly damaged in 1945, is a two-storey, three-winged complex with a mansard roof and triangular gable that includes the allegories of Justice and Prudence, probably from the workshop of Johann Georg Glume. It is the only remaining Baroque palace from Friedrichstadt.

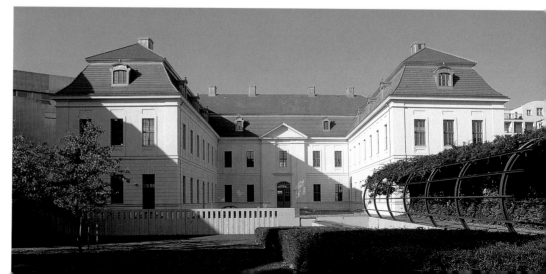

Unter den Linden

Der Prachtboulevard mit Ausrichtung auf das Brandenburger Tor ist das Pendant zur Pariser Avenue des Champs-Elysées mit dem Arc de Triomphe. Der 1573 angelegte Reitweg, der vom Schloss zum königlichen Jagdrevier im Tiergarten führte, wurde 1647 als 1,2 km lange und 60 m breite, mit Linden bepflanzte Straße angelegt. Ihre repräsentative Gestalt erhielt sie erst im Zuge der barocken Stadterweiterung im 18. Jahrhundert unter Friedrich I. und Friedrich dem Großen, der das Forum Fridericianum, nach Planungen von Knobelsdorff, zum kulturellen Mittelpunkt bestimmte. Im östlichen Teil vom Adelspalais flankiert, entstanden in Richtung Brandenburger Tor bürgerliche Wohn- und Geschäftshäuser. Seit der Gründung des Kaiserreiches 1871 wandelten sich die „Linden" zur Luxusstraße mit Cafés, großen Bankhäusern und Hotelbauten. Nach der Zerstörung im 2. Weltkrieg wurden bedeutende historische Bauten rekonstruiert und große Verwaltungsgebäude errichtet. Seit 1989 bemüht man sich um eine Wiederbelebung als Flanierboulevard.

Unter den Linden

This grand boulevard leading up to the Brandenburg Gate is the counterpart of the Champs-Elysée and the Arc de Triomphe in Paris. Initially laid out in 1573 as a bridal path from the Schloss to the royal hunting grounds in the Tiergarten, it was turned into an avenue lined with linden trees, 60 metres wide and 1.2 kilometres long, in 1647. It was first given its look of pomp and grandeur in the course of the Baroque expansion of the city in the 18th century under Friedrich I and Frederick the Great, who determined that the Forum Fridericianum, designed to plans by Knobelsdorff, should be the city's cultural focal point. Flanked to the east by the aristocracy's palace, middle-class housing and business premises were built towards the Brandenburg Gate. Following the foundation of the empire in 1871, 'Unter den Linden' transformed itself into a luxury street with cafés, major bank buildings and grand hotels. After being destroyed in the Second World War, many significant historic structures have since been rebuilt and large administrative buildings erected. Since 1989, the city has been making great efforts to revive the street as a grand promenade.

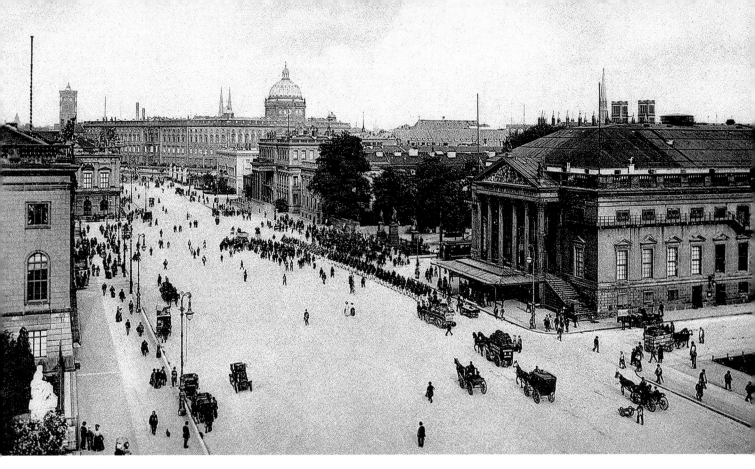

oben: Unter den Linden um 1900, Blick vom Westflügel des Universitäts-
gebäudes über das Zeughaus zum Stadtschloss, rechts Kommandantur,
Kronprinzenpalais, Prinzessinnenpalais und Opernhaus
unten: Unter den Linden im frühen 21. Jahrhundert, Blick vom Berliner
Dom zur Kommandantur, zum Kronprinzenpalais, Prinzessinnenpalais,
Opernhaus (links davon die St.-Hedwigs-Kathedrale) und Zeughaus

*Above: Unter den Linden c. 1900. View from the west wing of the university building
past the Armoury (Zeughaus) to the City Palace, with the military headquarters, the
Crown Prince's palace, the Princess's palace and the Opera House on the right.
Below: Unter den Linden in the early 21st century. View from Berlin Cathedral to the
military headquarters building, the Crown Prince's palace, Princess's palace, Opera
House (with St. Hedwig's Cathedral to the left) and the Armoury.*

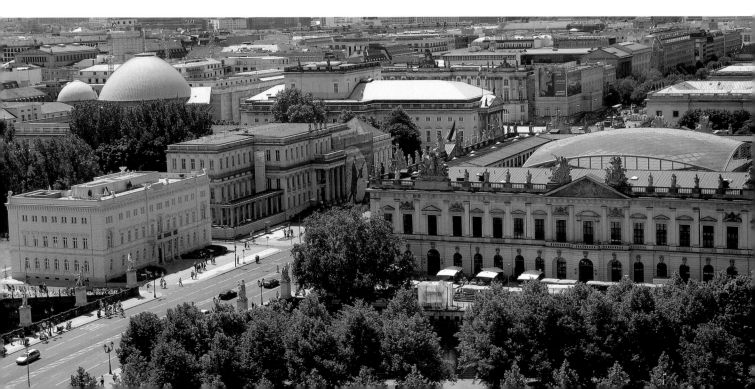

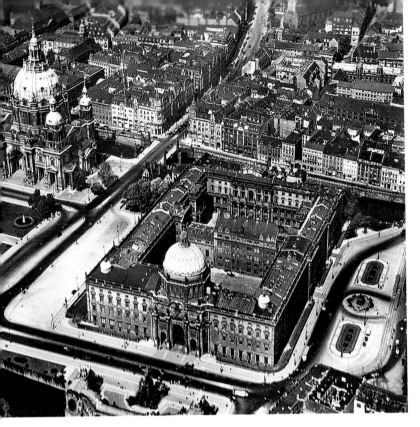

oben und unten: Stadtschloss, nach Kriegsschäden 1950/51 gesprengt. Das monumentale Schloss war bis 1918 die Residenz der hohenzollernschen Kurfürsten, Könige und Kaiser. Ihren Ursprung hat die Anlage in der von 1443 bis 1451 errichteten Burg, die unter Joachim II. ab 1538 zu einem prächtigen Renaissanceschloss und von 1698 bis 1716 unter Leitung von Andreas Schlüter und Johann Friedrich Eosander v. Göthe ihre einheitliche Form im Stil des Barock erhielt. Das Stadtschloss besaß eine Ausdehnung von fast 200 m Länge, 117 m Breite und war 30 m hoch. Den Westflügel krönte eine Kuppel von beinahe 70 m Höhe.

Above and below: Stadtschloss, blown up in 1950/51 after being damaged in the War. Until 1918, this monumental palace was the residence of the Hohenzollern electors, kings and Kaisers. The complex had its origins in the castle built from 1443 to 1451, which was converted from 1538 under Joachim II into a magnificent Renaissance palace. From 1698 to 1716, under the direction of Andreas Schlüter and Johann Friedrich Eosander v. Göthe, it was given its uniform Baroque appearance. The Stadtschloss, or City Palace, was almost 200 metres long, 117 metres wide and 30 metres high. On the west wing sat a dome of almost 70 metres in height.

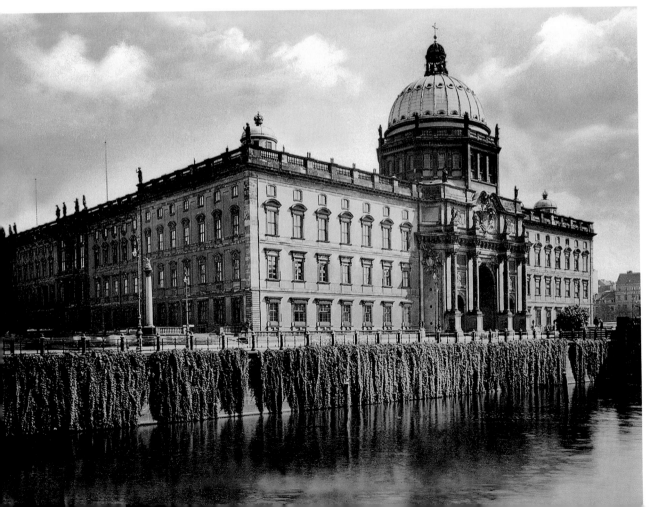

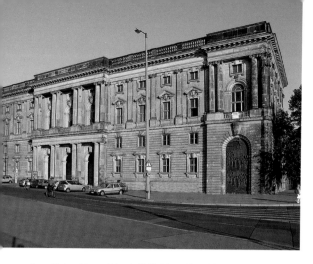

oben links: Neuer Marstall (Schlossplatz 7, ursprünglich gegenüber dem Stadtschloss gelegen), 1896–1901, von Ernst von Ihne im Stil des Stadtschlosses neubarock erbaut zur Unterbringung von Kutschen und 300 kaiserlichen Pferden.

oben rechts: Ehemaliges Staatsratsgebäude der DDR (Schlossplatz 1), 1962–64, von Roland Korn und Hans-Erich Bogatzky. Der Eingangsbereich ist eine Kopie des Stadtschloss-Nordflügelportals von J. F. Eosander v. Göthe (um 1710, Bauplastik von Permoser). Am 9.11.1918 rief Karl Liebknecht von jenem Balkon des Stadtschlosses eine „Freie sozialistische Republik" aus.

unten: Kommandantur, Zeughaus und Schlossbrücke, 1822–24 von Karl Friedrich Schinkel

Above left: Neuer Marstall (New Stables, 7 Schlossplatz, originally located opposite the City Palace). Built in 1896-1901 by Ernst von Ihne in Neo-Baroque form, reflecting the style of the City Palace, to accommodate 300 imperial horses and carriages.

Above right: The GDR's former state council building (no. 1 Schlossplatz), built 1962-64, designed by Roland Korn und Hans-Erich Bogatzky. The entrance area is a copy of J. F. Eosander v. Göthe's doorway to the north wing of the City Palace (c. 1710, sculptural work by Permoser). It was from that balcony of the palace that Karl Liebknecht had proclaimed a 'Free Socialist Republic' on 9th November 1918.

Below: Military headquarters, Armoury and Schlossbrücke (Palace Bridge), 1822-24, by Karl Friedrich Schinkel.

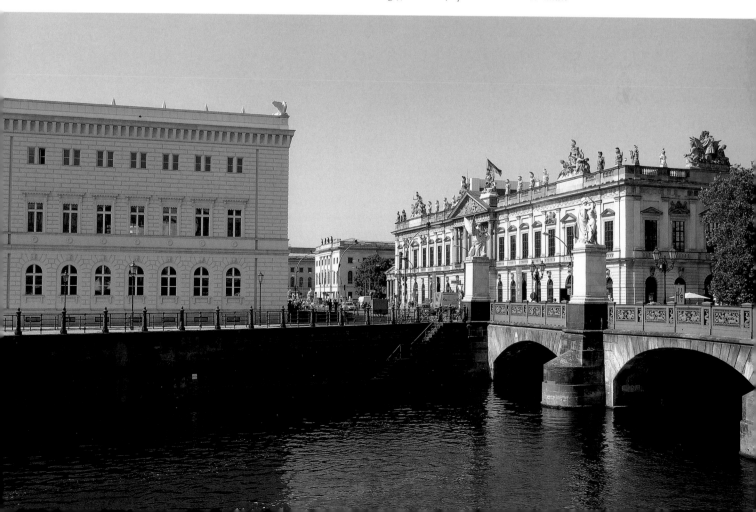

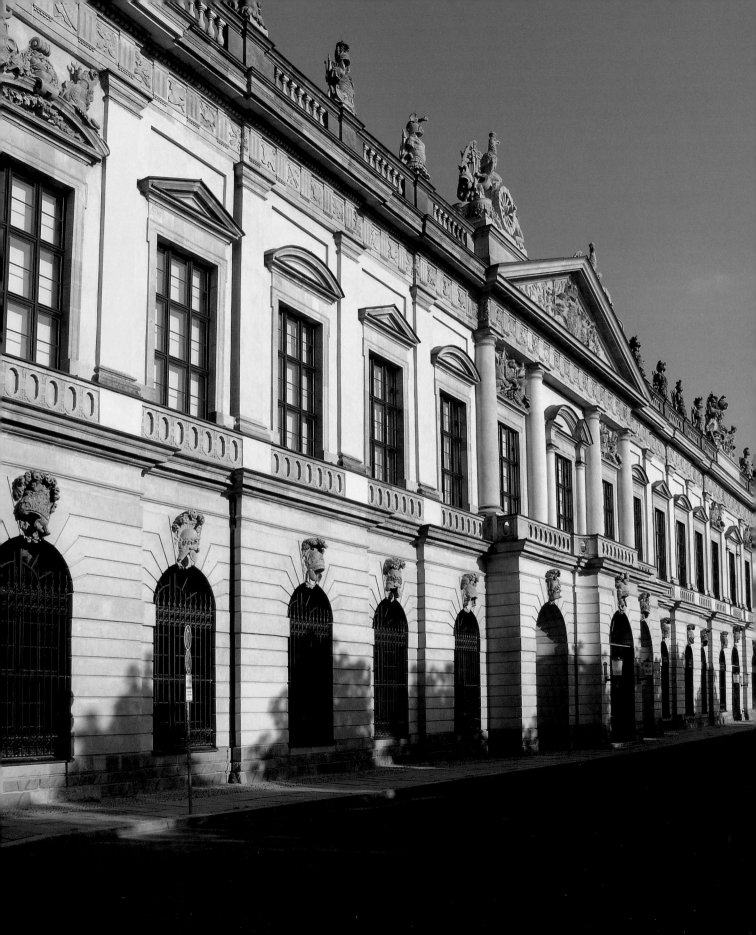

Andreas Schlüter

Schlüter (1659 Danzig – 1714 St. Petersburg) ist der bedeutendste Baukünstler Berlins vor Schinkel und führte die Berliner Baukunst und Plastik zu internationalem Ruhm. In Danzig im Betrieb des Vaters zum Bildhauer ausgebildet, schuf er 1689–93 in Warschau die Giebelreliefs des Krasinski-Palais. 1694 konnte ihn Kurfürst Friedrich III., der spätere König Friedrich I. von Preußen, für Berlin gewinnen. Dort führte Schlüter 1696 die plastisch ausgestalteten Schlusssteine des Zeughauses aus und entwarf das bronzene Reiterstandbild des Großen Kurfürsten (Abb. S. 53), ein Hauptwerk barocker Plastik. 1698 wurde er Nachfolger Nerings als Architekt des Zeughauses und schuf die berühmten Masken der sterbenden Krieger im Lichthof und die Trophäen auf der Dachbalustrade. Als Schlossbaudirektor entwarf er den nach ihm benannten Schlüterhof, der 1950 wie das übrige Stadtschloss gesprengt wurde. Zum Verhängnis wurde Schlüter die Errichtung des von ihm entworfenen Münzturms an der nordwestlichen Ecke des Schlosses. Der drohende Einsturz des Turms, der das Wahrzeichen der Residenzstadt werden sollte, wurde 1706 durch Teilabriss verhindert. Schlüter fiel dadurch in Ungnade und wurde 1707 aus dem Hofdienst entlassen. Nach dem Tod Friedrichs I. schuf Schlüter dessen Prunksarg aus Zinn. Die Villa Kamecke (Abb. S. 60) von 1711–12 war sein letzter Bau in Berlin. 1713 zog er nach St. Petersburg, wo er jedoch nur ein Jahr nach seiner Ankunft verstarb.

Andreas Schlüter

Schlüter (born 1659 in Danzig, died 1714 in St. Petersburg) is Berlin's most significant architect prior to Schinkel. He took architecture and sculpture to heights of international fame. Having trained in Danzig as the son of a sculptor, he created the gable reliefs of the Krasinski Palace in Warsaw in 1689-93. In 1694, Elector Friedrich III, later King Friedrich I of Prussia, succeeded in bringing him to Berlin, where Schlüter produced the vividly shaped keystones of the Zeughaus (Armoury) and designed the bronze statue of the Great Elector on horseback (pictured on p. 53), a major work of Baroque sculpture. In 1698 he succeeded Nering as the Armoury's architect and created the famous masks of the dying warriors in the inner courtyard, plus the trophies on the roof balustrade. As director of palace construction he designed the Schlüterhof, which carried his name and which, along with the rest of the Stadtschloss, was blown

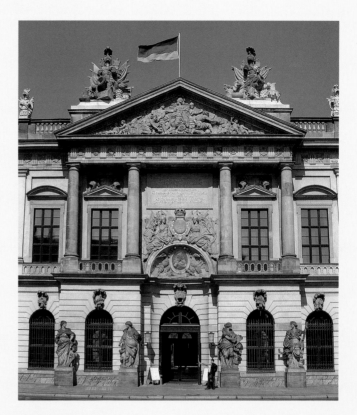

links und oben: Zeughaus, heute Deutsches Historisches Museum, 1695 wohl nach Plänen des Pariser Akademiedirektors Nicolas François Blondel von Johann Arnold Nering begonnen und bis 1706 von Martin Grünberg, Andreas Schlüter und Jean de Bodt fertig gestellt, 1730–1875 Waffenarsenal und Kriegsmagazin, danach Armeemuseum, 1952–1990 Museum für deutsche Geschichte der DDR

Left and above: Zeughaus (Armoury), today the Deutsches Historisches Museum. Begun in 1695 by Johann Arnold Nering, probably to plans by the director of the Paris Academy, Nicolas François Blondel, and completed in the years up to 1706 by Martin Grünberg, Andreas Schlüter and Jean de Bodt. From 1730-1875 a weapons arsenal and war munitions store, then an army museum and from 1952-1990 the GDR's Museum of German History.

up in 1950. The erection of the Münzturm (Mint Tower) on the northwest corner of the palace turned out to be fateful for Schlüter. In 1706, the threatened collapse of the tower, which was supposed to be a symbolic landmark for the city, could only be averted by partially pulling it down. This led to Schlüter falling out of favour, and in 1707 he was dismissed from court service. Following Friedrich I's death, however, he created the latter's ceremonial tin coffin, while his final building in Berlin was the Villa Kamecke (pictured on p. 60) from 1711-12. In 1713, he moved to St. Petersburg, where he died just a year after his arrival.

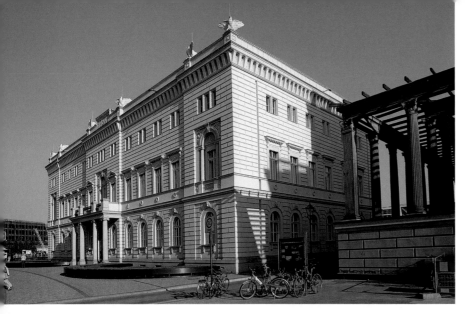

oben: Das Gebäude der Kommandantur (Unter den Linden 1) geht auf das Wohnhaus des kurfürstlichen Architekten J. G. Memhardt zurück, der sich das Gebäude 1653/54 als ersten Bau entlang der neu angelegten Allee Unter den Linden erbaute. Seit 1799 Sitz des Stadtkommandanten Berlins und 1802 klassizistisch erneuert, erhielt das Gebäude seine heutige Außenerscheinung 1873/74, als man den Bau um ein Geschoss erhöhte und durch seine Rustikafassadengliederung bereicherte. Im 2. Weltkrieg ausgebrannt und wenig später abgebrochen, wurde das Gebäude 2001–03 als Firmenrepräsentanz durch das Büro Stuhlemmer & Stuhlemmer rekonstruiert. Den Innenausbau und die moderne rückwärtige Glasfront entwarf das Kölner Büro van den Valentyn.

Mitte und unten: 1961 als Kriegsruine abgerissen und 1968/69 rekonstruiert zeigt das Palais Unter den Linden (im mittleren Foto das linke Gebäude) den Zustand mit Attikageschoss, Mittelrisalit und Portikus, den es 1857/58 durch Johann Heinrich Strack erhielt. Das Palais war 1663 von J. A. Nering errichtet, 1732 von P. Gerlach zum Kronprinzenpalais umgebaut und 1810 als Stadtpalais des Königs mit dem Prinzessinnenpalais verbunden worden.
Neben dem Palais steht das Operncafé (im Foto rechts und Abb. unten) auf dem Gelände der seit 1690 geschleiften Festungswälle. 1733 nach Entwürfen von Friedrich Wilhelm Dieterichs unter Verwendung zweier Wohnhäuser erbaut, wurde der Barockbau 1810/11 nach Entwurf von Johann Heinrich Gentz durch einen Kopfbau ergänzt und nach Kriegszerstörung 1962/63 rekonstruiert.

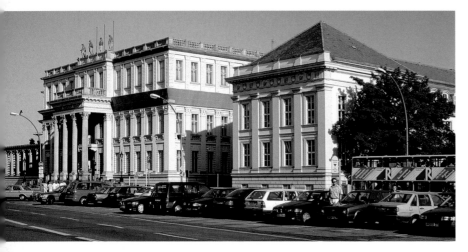

Above: The military headquarters building (no. 1 Unter den Linden) goes back to the house of the electoral architect J. G. Memhardt, who erected the building for himself in 1653/54 as the first building on the newly created Unter den Linden. From 1799 the seat of the City Commander of Berlin and remodelled in Classicist style in 1802, the building was given its current external appearance in 1873/74, when an extra floor was added and it was embellished through the addition of a façade outline in rustic masonry. Gutted by fire in the 2nd World War and demolished a short while later, it was reconstructed by the architects firm of Stuhlemmer & Stuhlemmer in 2001-03 as a showcase company headquarters buildings. The interior and the modern, reverse glass frontage were designed by Cologne architects van den Valentyn.

*Centre and below: Demolished as a war ruin in 1961 and reconstructed in 1968/69, the Palais Unter den Linden (the building on the left in the middle photo) now has the appearance it was given in 1857/58 by Johann Heinrich Strack, with attic floor, central risalit and portico. The palace had been built in 1663 by J. A. Nering, converted into the Crown Prince's palace in 1732 by P. Gerlach and combined with the Princess' palace to form the Stadtschloss in 1810.
Next to the Palais, on the site of fortified walls razed in 1690, stands the Opera House Café (on the right in the photo and pictured below). Built in 1733 to designs by Friedrich Wilhelm Dieterich and making use of two residential houses, the Baroque building had a top structure added in 1810/11 to a design by Johann Heinrich Gentz. After being destroyed in the War, it was reconstructed in 1962/63.*

oben und Mitte: Die Neue Wache wurde 1816–18 nach Plänen Schinkels mit Bauplastik von Gottfried Schadow und August Kiß (Giebel mit Allegorien auf Kampf und Sieg, Flucht und Niederlage von 1842–46) erbaut. 1931 zum Gefallenendenkmal und 1960 zum Mahnmal für die Opfer des Faschismus und Militarismus erklärt, ist die Neue Wache seit 1993 die Zentrale Gedenkstätte der Bundesrepublik Deutschland. Im Innenraum steht die vergrößerte Kopie einer „Pieta" von Käthe Kollwitz.

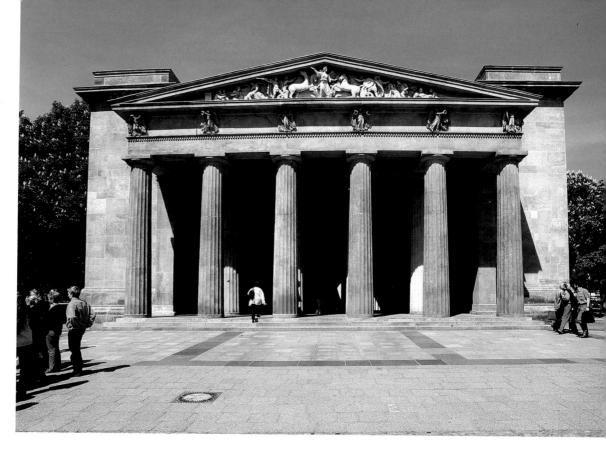

unten links: Das Maxim Gorki Theater (Am Festungsgraben) wurde 1824–27 von Karl Theodor Ottmer unter Verwendung von Entwürfen Schinkels von 1821 für die 1792 von Karl Friedrich Fasch gegründete Singakademie auf Anregung des damaligen Leiters und Goethe-Freundes Karl Friedrich Zelter erbaut.

unten rechts: Neben dem Maxim Gorki Theater steht das Palais am Festungsgraben. 1751–53 von Christian Feldmann für den Kammerdiener und Unternehmer Donner errichtet, war es seit 1787 Sitz des Preußischen Finanzministers, 1804–09 Wohnung des Freiherrn vom Stein. 1861–63 erhielt es durch Heinrich Bürdes seine heutige Fassade im Stil der italienischen Renaissance.

Above and centre: The 'Neue Wache' (New Guardhouse) was built in 1816-18 to plans by Schinkel, using architectural sculptural work by Gottfried Schadow and August Kiß (gable with allegories to battle and victory, flight and defeat, dating from 1842-46). Declared a monument to the fallen soldier in 1931 and a memorial to the victims of fascism and militarism in 1960, the Neue Wache has been the Federal Republic of Germany's central site of remembrance since 1993. Inside there is an enlarged copy of a 'pietà' by Käthe Kollwitz.

Below left: The Maxim Gorki Theatre on 'Am Festungsgraben' was built in 1824-27 by Karl Theodor Ottmer using Schinkel's designs of 1821 for the Singakademie (Academy of Song), which was founded in 1792 by Karl Friedrich Fasch at the prompting of its then leader and friend of Goethe, Karl Friedrich Zelter.

Below right: Next to the Maxim Gorki Theatre is the 'Palais am Festungsgraben' (Palace by the Moat). Built in 1751-53 by Christian Feldmann for the valet and businessman Donner, it was the Prussian Finance Minister's official residence from 1787 and home to Baron vom Stein from 1804-09. It was given its current Italian Renaissance façade by Heinrich Bürdes 1861-63.

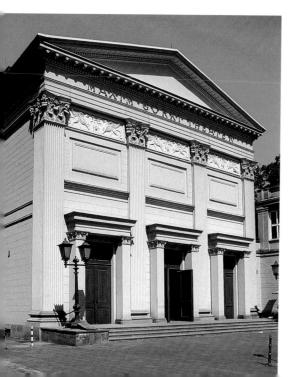

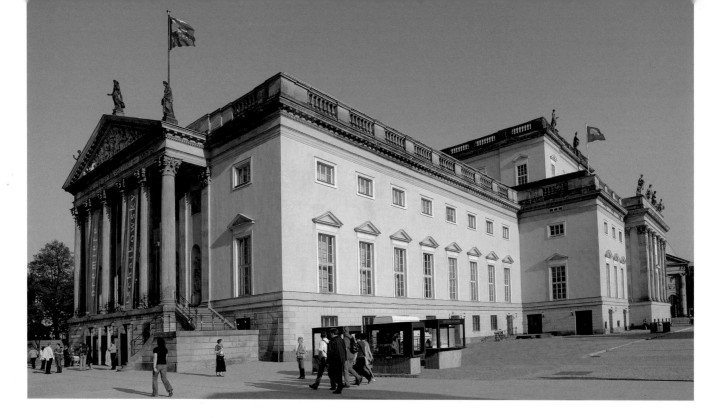

An der Prachtstraße „Unter den Linden" liegt das Forum Fridericianum, dessen Planung mit dem Regierungsantritt Friedrichs II. 1740 begann. Es umfasst den heutigen Bebelplatz mit seinen Gebäuden und die heutige Humboldt-Universität, die als ehemaliges Stadtpalais des Prinzen Heinrich 1748–53 als nördlicher Abschluss errichtet worden war. Die östliche Begrenzung bildet die Deutsche Staatsoper (1741–43) des Architekten Georg Wenzeslaus von Knobelsdorff. Es handelt sich um den ersten selbständigen Theaterbau Deutschlands, d. h. erstmals war eine räumliche und funktionale Trennung von Schloss und Hofoper als allseitig frei stehendes Gebäude mit

On either side of the grand 'Unter den Linden' boulevard lies the Forum Fridericianum, the planning of which began with the start of Frederick the Great's rule in 1740. It embraces the present-day Bebelplatz and its buildings, plus the Humboldt University, which as the former city residence of Prince Heinrich was built in 1748-53 as the structure to enclose the Forum to the north. The eastern border is formed by the German National Opera House (Deutsche Staatsoper, 1741-43), designed by architect Georg Wenzeslaus von Knobelsdorff. The opera house was Germany's first self-contained theatre building, i.e. for the first time ever the building was designed separated in terms of structure and func-

oben: Deutsche Staatsoper, 1741–43
unten: Forum Fridericianum mit St.-Hedwigs-Kathedrale und Dresdner Bank, Behrenstraße 37/39, von 1887/89 nach Entwurf Ludwig Heims

Above: German State Opera, 1741-43
Below: Forum Fridericianum with St. Hedwig's Cathedral and Dresdner Bank, 37/39 Behrenstraße, designed by Ludwig Heim, 1887/89.

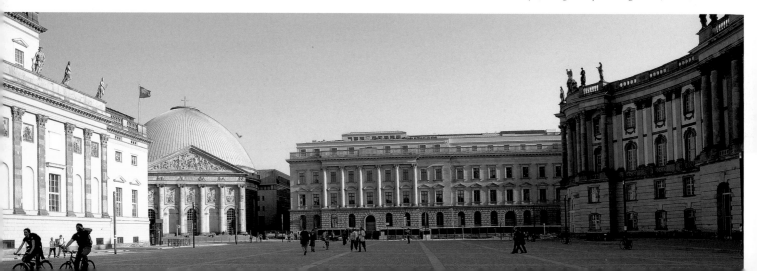

St.-Hedwigs-Kathedrale, 1747–73, von Johann Boumann d. Ä.

St. Hedwig's Cathedral, 1747–73, by Johann Boumann d. Ä.

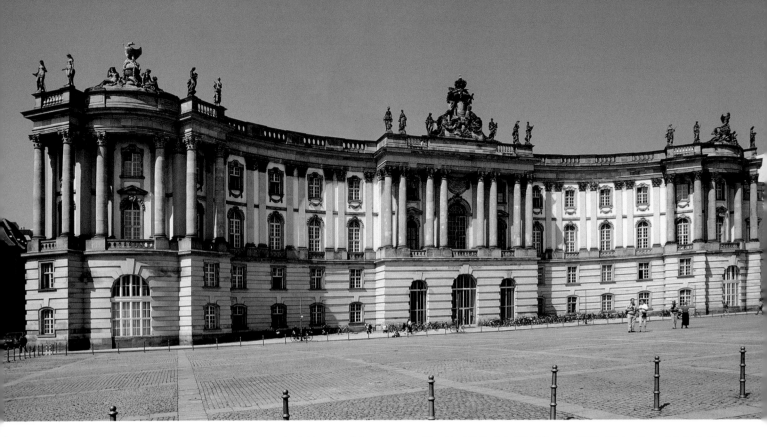

Die Alte Bibliothek (1775–80) von Georg Friedrich Unger und Georg Friedrich Boumann d. J. ist eine verkleinerte Nachahmung des Michaelertrakts der Wiener Hofburg, die 1723–30 von Fischer von Erlach begonnen, aber – später als die Berliner Nachbildung – erst 1889–93 vollendet wurde.

The Alte Bibliothek (Old Library, 1775–80) by Georg Friedrich Unger and Georg Friedrich Boumann the Younger is a smaller copy of the 'Michaelertrakt' at Hofburg Palace in Vienna, which was begun by Fischer von Erlach in 1723–30, but not completed until 1889–93, later than the copy in Berlin.

drei Haupträumen (Apollosaal, Zuschauerraum mit drei Logenrängen und Bühnenraum) vorgenommen worden. Im Theater wurden unter anderem 1821 Webers „Freischütz" und 1925 Bergs „Wozzeck" uraufgeführt.

Die katholische Bischofskirche des Bistums Berlin St. Hedwig im Südosten des Forum Fridericianums wurde nach Skizzen Friedrichs des Großen 1747–73 von Johann Boumann d. Ä. als kreisförmiger Zentralbau nach dem Vorbild des römischen Pantheons mit hoher Kuppel, angefügter Rundkapelle und Säulenportikus mit Giebel errichtet. Die Reliefs über den Rundbogenportalen schuf 1837 Theodor Wilhelm Achtermann. Sie zeigen die Verkündigung, Christus am Ölberg, die Kreuzabnahme und Auferstehung sowie Christi Himmelfahrt. Den Fries ziert die mit Putten geschmückte Weiheinschrift. Im Giebelfeld

unten: St.-Hedwigs-Kathedrale, 1747–73, Grundriss

Below: St. Hedwig's Cathedral, 1747–73, floor plan

tion from the palace and court opera house as a free-standing building on all sides, with three main interior areas (the Apollo Hall, the auditorium, with three tiers of boxes, and the stage area). World premieres performed here have included Weber's 'Freischütz' in 1821 and Berg's 'Wozzeck' in 1925. The Catholic bishop's church of Berlin's St. Hedwig diocese on the southeast side of the Forum Fridericianum was built from 1747-73 by Johann Boumann d. Ä., based on sketches by Frederick the Great. It was built as a geometric circular structure in the style of the Pantheon in Rome, with a high dome, adjoining round chapel and colonnaded, gable-topped portico. The reliefs above the round arched portals were created in 1837 by Theodor Wilhelm Achtermann. They show the Annunciation, Christ on the Mount of Olives, the Deposition from the Cross, the Resurrection and the Ascension.

oben links: Denkmal Wilhelm von Humboldts, 1883 von Martin Paul Otto. Der große Wissenschaftler und Gründer der Universität Wilhelm von Humboldt (1767–1835) ist auf einem antikisierenden Thron sitzend mit aufgeschlagenem Buch dargestellt.

oben rechts und unten: Die Humboldt-Universität (1748–53) von Johann Boumann d. Ä. war ursprünglich das Stadtpalais Prinz Heinrichs, des Bruders Friedrichs d. Großen. Auf Betreiben Wilhelm von Humboldts, dessen Denkmal vor dem Eingang steht, wurde 1810 das Gebäude für die 1809 gegründete Universität freigegeben und 1913–20 unter Ludwig Hoffmann erweitert.

Above left: Martin Paul Otto's 1883 monument to Wilhelm von Humboldt (1767–1835). The great academic and founder of the Wilhelm von Humboldt University is shown with an open book sitting on a throne reminiscent of the classical era.

Above right and below: The Humboldt University (1748-53), designed by Johann Boumann d. Ä., was originally the city palace of Prince Heinrich, the brother of Frederick the Great. At the instigation of Wilhelm von Humboldt, a monument to whom stands in front of the main entrance, the building was released in 1810 for the university, which had been founded a year earlier. In 1913-20, it was extended under the direction of Ludwig Hoffman.

erscheint die Anbetung der Könige, von Achtermann entworfen, jedoch erst 1897 in neobarocken Formen von Nicolaus Geiger vollendet. Nach Kriegszerstörungen wurde 1952–63 der Innenraum von Hans Schwippert neu gestaltet. Die 1943 zerstörte Kuppel, die 1886–87 von Max Hasak eine Kupfereindeckung mit neobarocker Laterne und Aufsätzen erhalten hatte, wurde als Betonschalenkonstruktion in Anlehnung an die ursprüngliche, am Pantheon angelehnte Form wiederhergestellt.

Der Bebelplatz wird im Westen von der Alten Bibliothek von 1775–80 begrenzt, an die sich das klassizistische Alte Palais, 1834–37 von Carl Ferdinand Langhans, anschließt. Davor steht das 13,5 m hohe Reiterdenkmal Friedrichs II. des Großen – 1836/40 von Christian Daniel Rauch entworfen und 1851 als Bronzeguss aufgestellt. Die Sockelreliefs zeigen Zeitgenossen des Königs (vorwiegend Offiziere und Generäle, jedoch auch Künstler, Philosophen, Dichter und Gelehrte) und darüber Szenen aus dem Leben des Königs.

The frieze is adorned by devotional inscriptions decorated with putti. The gable panel shows the Adoration of the Magi, designed by Achtermann but only completed, in Neo-Gothic style, by Nicolaus Geiger in 1897. After being badly damaged in the War, the interior was remodelled from 1952-63 by Hans Schwippert. Destroyed in 1943, the dome, which had been given a copper lining with Neo-Baroque lanterns and attachments by Max Hasak in 1886-87, was recreated as a concrete shell construction drawing on the original, Pantheon-based form.

Bebelplatz is bordered on the west by the Old Library (Alte Bibliothek) dating from 1775-80, which is adjoined by the classicist Alte Palais (1834-37), designed by Carl Ferdinand Langhans. In front of it stands the 13.5-metre-high statue of Frederick the Great on horseback, designed in 1836/40 by Christian Daniel Rauch and erected as a cast-bronze statue in 1851. The reliefs on the plinth show contemporaries of the King (predominantly officers and generals, but also a number of artists, philosophers and academics) below scenes from his life.

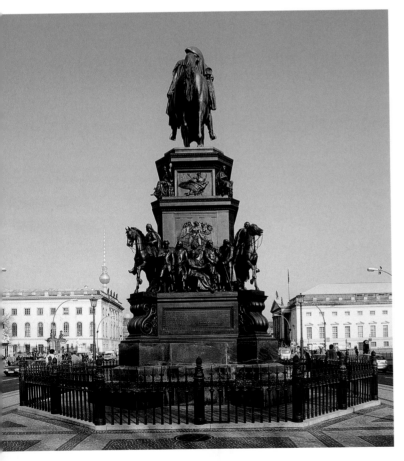

links und rechts: Unter den Linden, Reiterdenkmal König Friedrichs II. von Preußen, 1836–1851 von Christian Daniel Rauch

unten rechts: Neben der Humboldt-Universität steht die Staatsbibliothek (Unter den Linden 8). 1661 als „Churfürstliche Bibliothek" gegründet, war seit 1780 in der Alten Bibliothek untergebracht, bis sie in diesen neobarocken Repräsentationsbau (1903–1914) von Ernst von Ihne zog. Der Baublock von 106 x 170 Metern besitzt sechs Innenhöfe.

Left and right: Unter den Linden. Statue of Frederick the Great on horseback, 1836–1851, by Christian Daniel Rauch.
Below right: Next to the Humboldt University is the 'Staatsbibliothek' (National Library, at 8 Unter den Linden). Set up in 1661 as the 'Electoral Library', it was housed from 1780 in the 'Alte Bibliothek' until it moved into this showcase Neo-Baroque building (1903-14), designed by Ernst von Ihne. The entire block measures 106 by 170 metres and has six inner courtyards.

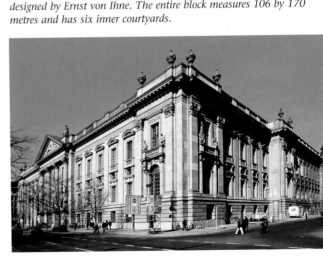

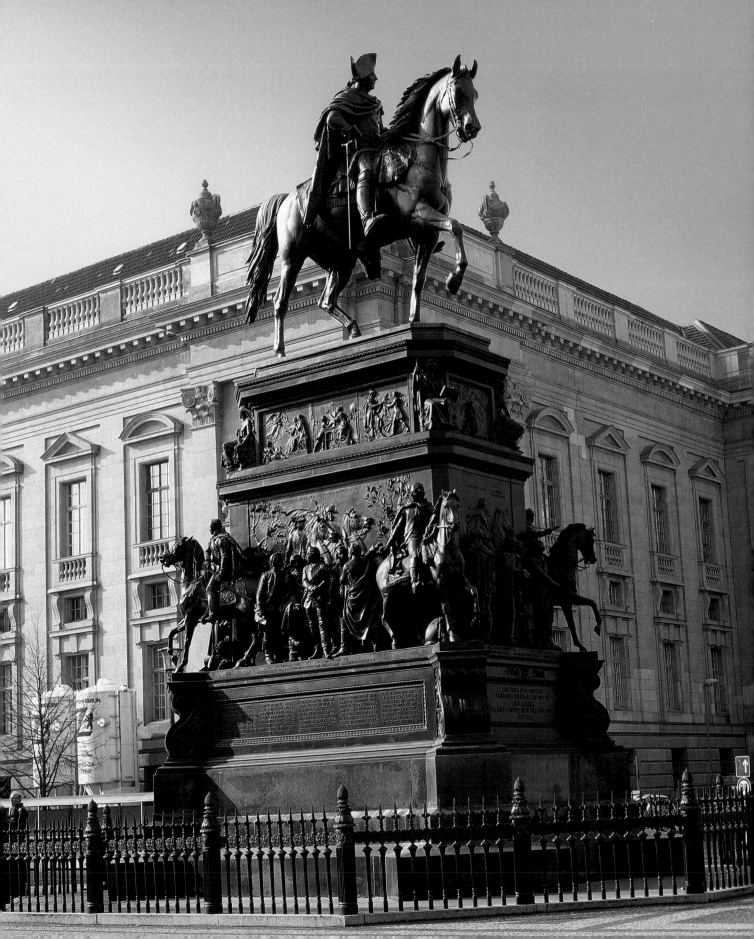

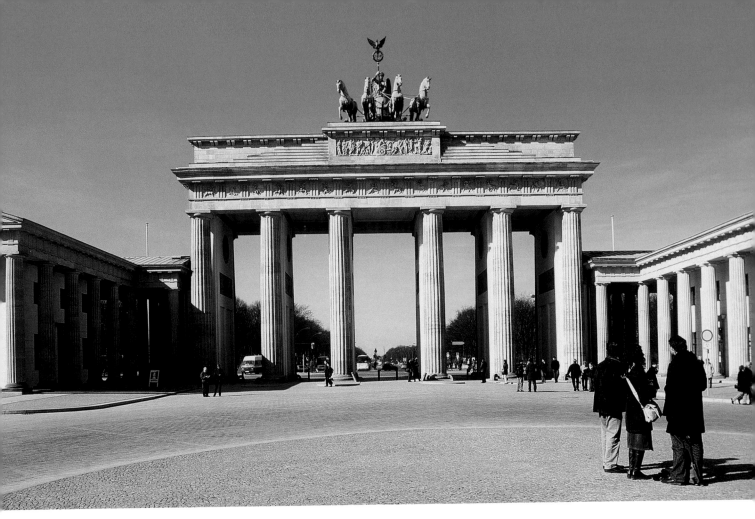

oben: Brandenburger Tor, 1789–93 von Carl Gotthard Langhans

Above: Brandenburg Gate, 1789–93, designed by Carl Gotthard Langhans

unten links: Luftbild mit Blick auf den Pariser Platz und Unter den Linden, 1930er -Jahre

Below left: 1930s aerial picture showing Pariser Platz and Unter den Linden

unten rechts: Brandenburger Tor, Anfang 20. Jahrhundert

Below right: Brandenburg Gate, at the start of the 20th century

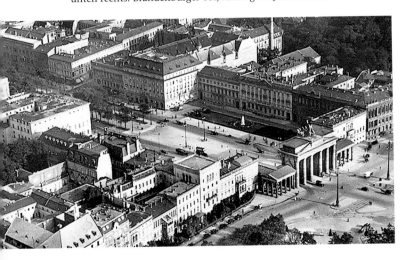

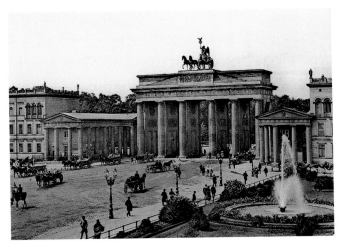

Pariser Platz

Der 1732–34 angelegte Platz erhielt seinen Namen nach der alliierten Eroberung von Paris 1814. Denn 1806 war auf Befehl Napoleons nach der Niederlage Preußens die Quadriga nach Paris gebracht worden. Sie kehrte 1814 in einem Triumphzug nach Berlin zurück.

Das Brandenburger Tor bildet den westlichen Abschluss der Prachtstraße Unter den Linden. Von 1961 bis 1989 Symbol der geteilten Stadt, wurde es mit dem Fall der Mauer am 9. November 1989 zum Sinnbild des wiedervereinigten Deutschland. Kunsthistorisch betrachtet ist es einer der frühesten und bedeutendsten Torbauten des Klassizismus, das früheste

Pariser Platz

After Prussia's defeat in 1806, Napoleon had ordered the 'Quadriga' be taken to Paris. Eight years later, in 1814 when Paris was taken by the allies, it returned in triumphal procession to Berlin, and this square, originally laid out in 1732-43, was given its name, 'Pariser Platz'.

The Brandenburg Gate forms the western end of the grand avenue 'Unter den Linden'. From 1961 to 1989 a symbol of the divided city, when the Wall came down on 9th November 1989 it became an emblem of the reunited Germany. Looked at in terms of art history, it is one of the earliest and most important gateway structures of the Classicist period, the earliest Classicist

Brandenburger Tor, 1789–93 von Carl Gotthard Langhans mit Quadriga, Ansicht von Nordwesten (Reichstagsgebäude)

Carl Gotthard Langhans' Brandenburg Gate, 1789–93, with Quadriga. View from the northwest (Reichstag building).

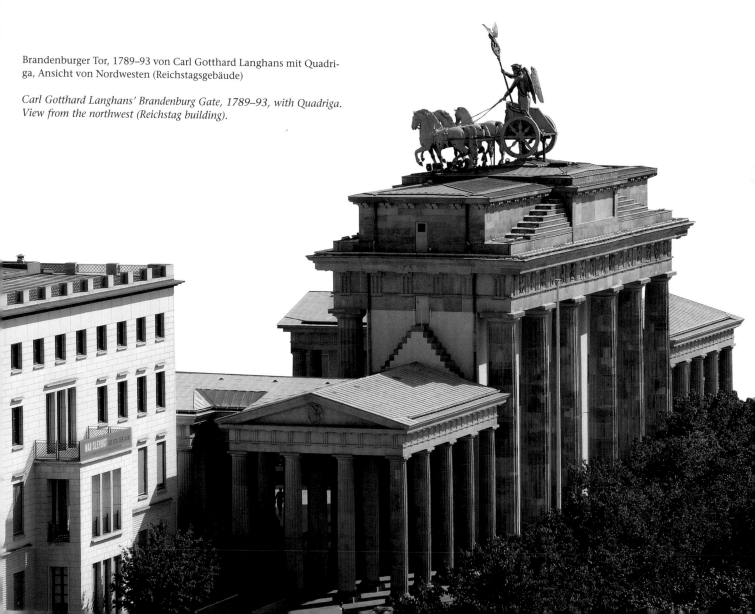

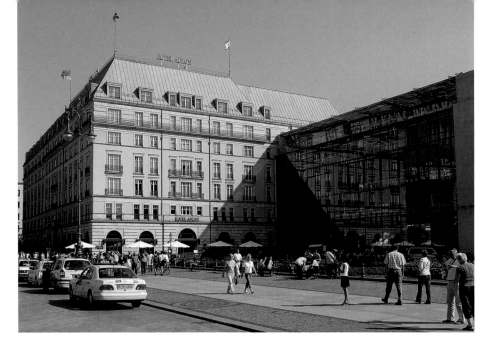

oben: Pariser Platz, Hotel Adlon, 1907 eingeweiht. Im 2. Weltkrieg beschädigt, wurde das legendäre Luxushotel später gesprengt. Der heutige Bau (1995–97) von Patzschke, Klotz & Partner greift in seiner Gebäudekubatur mit Walmdach und in seiner konservativen Fassadengestaltung den Vorgängerbau auf. Rechts schließt sich die Akademie der Künste von 2001–04 mit ihrer Glasfassade nach Plänen von Günter Behnisch an.

unten: Pariser Platz, Französische Botschaft (2001–02 von Christian de Portzamparc) und Wohn- und Geschäftshaus Unter den Linden 80 (1999–2000 von Laurids und Manfred Ortner). Die Neubebauung des Pariser Platzes nach 1989 orientiert sich an den Proportionen der Vorkriegsarchitektur.

Above: Pariser Platz, Hotel Adlon. This legendary luxury hotel was officially opened in 1907. Badly damaged in the 2ⁿᵈ World War, it was later demolished. The current building (1995-97), designed by Patzschke, Klotz & Partners, harks back to its predecessor with the cubature of its structure, its hipped roof and conservative façade. Adjoining on the right is the Academy of the Arts with its glass façade, built in 2001-04 to plans by Günter Behnisch.

Below: Pariser Platz, French Embassy (2001-02, designed by Christian de Portzamparc) and the residential and business building at no. 80 Unter den Linden (1999-2000, by Laurids and Manfred Ortner). The redevelopment of Pariser Platz since 1989 has been based on the proportions of the pre-War architecture.

Bauwerk des Klassizismus in Berlin und die einzige erhaltene Toranlage der Stadt. Carl Gotthard Langhans entwarf das Brandenburger Tor 1788 nach dem Vorbild der Propyläen auf der Akropolis in Athen und als Ersatz für einen Vorgängerbau von 1735. Die Toranlage mit fünf Durchfahrten wurde 1789–91 ausgeführt und wurde 1793 durch Gottfried Schadows (Entwurf) und Emanuel Jurys (Ausführung des Kupfergusses) sechs Meter hohe Quadriga – der Siegesgöttin mit einem Viergespann – vollendet. Die ursprünglich als Wache und Steuerhaus genutzten seitlichen Bauten waren mit der alten Zollmauer verbunden und wurden nach deren Abbruch durch Heinrich Strack 1867–68 mit offenen Säulen im Westen zur Tiergartenseite umgestaltet.

structure in Berlin and the only one of the city's gateway complexes still standing. Carl Gotthard Langhans designed the Brandenburg Gate in 1788 in the style of the Propylaea at the Acropolis in Athens as a replacement for an earlier structure dating from 1735. The gateway complex with its five thoroughfares was built from 1789-91 and completed in 1793 with the addition of the Quadriga, the seven-metre-high goddess of victory with carriage and four, designed by Gottfried Schadow and cast in copper by Emanuel Jury. The side-buildings, originally used as a sentry post and tax house, used to be linked to the old customs wall. After this was demolished, they were remodelled by Heinrich Strack in 1867-68, with open columns added on the west side facing the Tiergarten.

Gendarmenmarkt

Der Gendarmenmarkt war der einstige Hauptmarkt der unter dem Kurfürsten Friedrich III. 1688 angelegten und ab 1695 unter der Leitung von Johann Arnold Nering erbauten Friedrichstadt. Die Bauten des Platzes aus der Zeit des Barock und Klassizismus bilden noch heute ein gelungenes, großartiges Architekturensemble. Die Bebauung des Gendarmenmarktes begann mit der Errichtung des Französischen und des Deutschen Doms im nördlichen bzw. südlichen Teil des Platzes. Der von Louis Gayard entworfene Französische

Gendarmenmarkt

The 'Gendarmenmarkt' was the erstwhile main market of Friedrichstadt, planned in 1688 on instruction of Elector Friedrich III and built from 1695 under the direction of Johann Arnold Nering. The square's buildings, dating from the Baroque and Classicist periods, still create today a successful, impressive architectural ensemble. The first buildings to be built around Gendarmenmarkt were the French and German cathedrals on the square's north and south sides respectively. Designed by Louis Gayard, the French Cathedral (Französischer Dom, 1701-05)

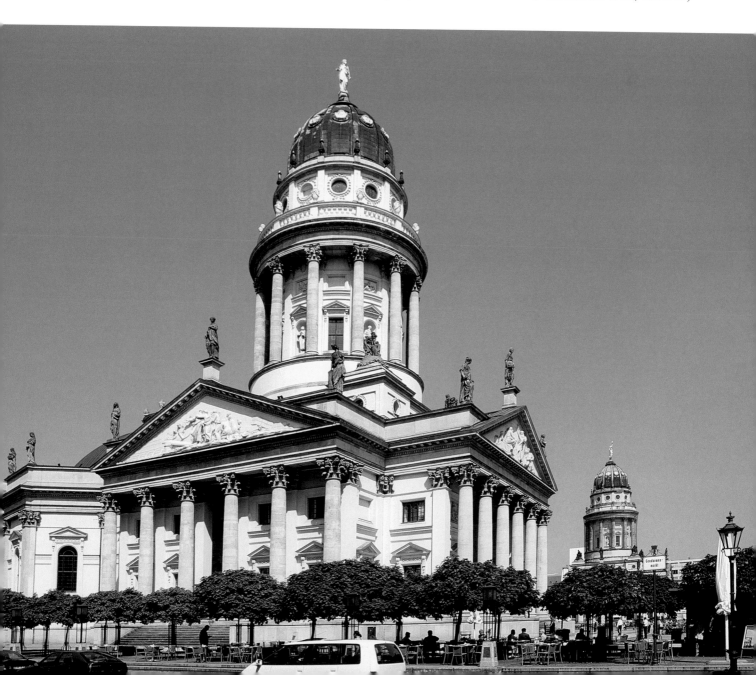

Dom (1701–05) wurde für die Hugenottengemeinde als quer-ovaler Saalraum nach dem Vorbild der 1624 erbauten und 1688 zerstörten Hugenottenhauptkirche in Charenton er-richtet. Den mächtigen Kuppelturm, in dem sich heute das Hugenottenmuseum befindet, fügte man nach Entwürfen Carl von Gontards 1780–85 an. Den Kircheninnenraum ge-staltete Otto March 1905 neobarock um. Der Deutsche Dom entstand 1701–08 nach Plänen von Martin Grünberg als fünfseitiger Zentralbau mit fünf inneren Konchen als Weiter-entwicklung des Grundrisstyps der Berliner Parochialkirche (vgl. S. 67). Die Kirche erhielt gleichfalls ab 1780 von Carl von Gontard ihren markanten Kuppelturm. Den ursprüng-lichen Kirchenbau ersetzten 1881/82 Hermann von der Hu-de und Julius Hennicke durch einen Neubau auf identischem Grundriss.

Im Zentrum des Platzes steht das Schauspielhaus (1818–21) von Karl Friedrich Schinkel, ein Hauptwerk des Klassizismus. Mauerreste und die sechs Portikussäulen stammen vom ab-gebrannten Vorgängerbau (1802) des Architekten Carl Gott-hard Langhans. Die einst verputzte Fassade wurde 1883/84 mit

was built for the Huguenot community as a transverse oval hall, modelled on the Huguenot church in Charenton, built in 1624 and destroyed in 1688. The mighty domed tower, today home to the Huguenot museum, was added in 1780-85 to plans by Carl von Gontard. Otto March remodelled the interior of the cathedral in Neo-Baroque style in 1905. The German Cathedral (Deutscher Dom) was built in 1701-08 to plans by Martin Grünberg as a geometric, pentagonal structure with five inner apses as an extension of the layout style of Berlin's Parochialkirche (cf. p. 65). In the years after 1780, this cathedral too was given its striking domed tower by Carl von Gontard. The original cathedral building was replaced with a new one on exactly the same footprint by Hermann von der Hude and Julius Hennicke in 1881/82.

In the centre of the square is Karl Friedrich Schinkel's 'Schauspielhaus' (theatre, 1818-21), a major work of the Classicist period. Remnants of the walls and the six portico columns come from the previous building (1802), which was designed by the architect Carl Gotthard Langhans and later destroyed by fire. The once plastered façade was clad with sand-

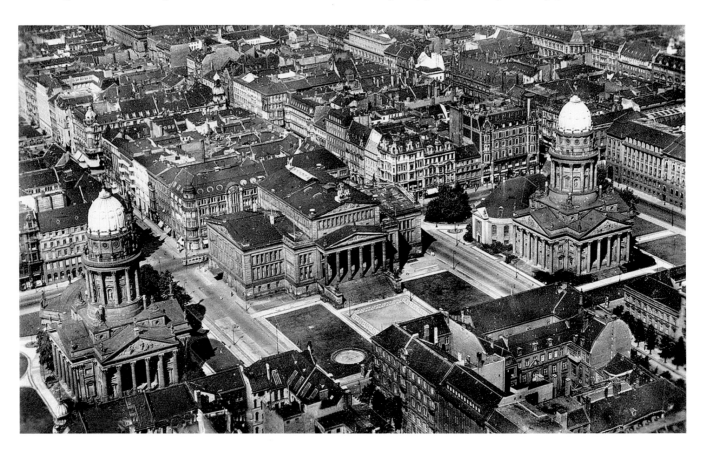

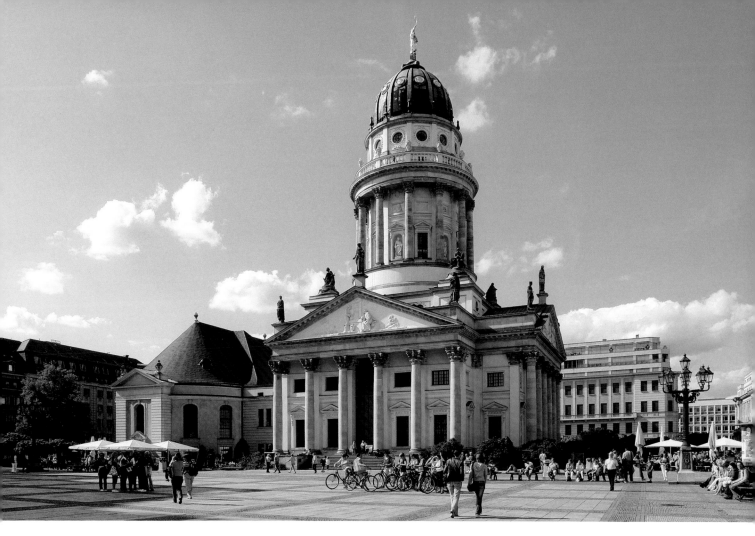

oben und rechts: Gendarmenmarkt, Französischer Dom, 1701–05 von Louis Cayard und Abraham Quesnays (Kirchenbau), 1780–85 von Carl von Gontard (Kuppelbau)

links: Gendarmenmarkt, Luftaufnahme 1930er-Jahre

Above and right: Gendarmenmarkt, Französischer Dom (French Cathedral). Cathedral, designed by Louis Cayard and Abraham Quesnays, built 1701–05, dome, by Carl von Gontard, 1780–85.

Left: Gendarmenmarkt, 1930s aerial photograph

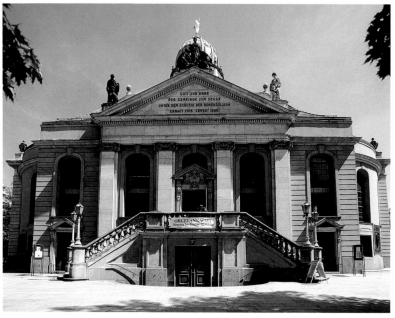

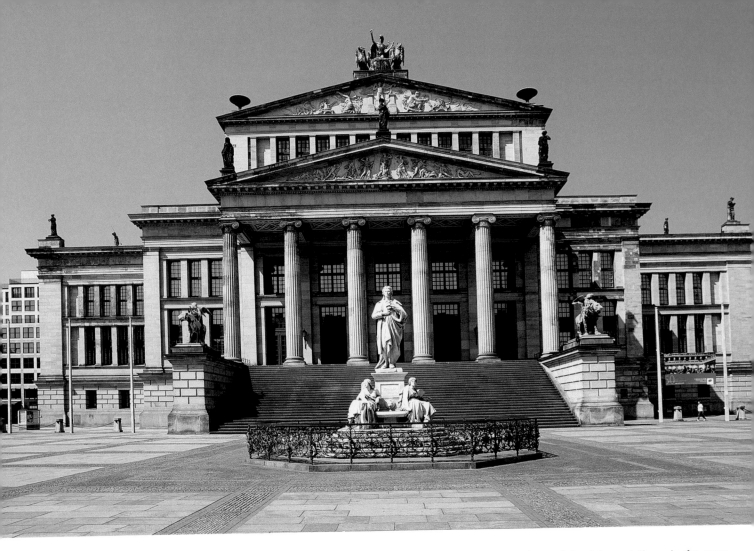

Sandstein verkleidet. Vor dem Schauspielhaus steht das sechs Meter hohe Schiller-Denkmal aus Marmor, ein Frühwerk des Bildhauers Reinhold Begas von 1864–69.

stone in 1883/84. In front of the Schauspielhaus is the seven-metre-high, marble Schiller memorial, an early work of the sculptor Reinhold Begas, dating from 1864-69.

oben: Gendarmenmarkt, Schauspielhaus, 1818–21 von Karl Friedrich Schinkel, und Schillerdenkmal, 1864–69 von Reinhold Begas

links: Gendarmenmarkt mit dem Deutschen Dom und dem 1802 erbauten und 1817 durch Brand zerstörten Nationaltheater von Carl Gotthard Langhans, von dem die Portikussäulen für den Nachfolgebau Schinkels übernommen wurden, Stich um 1805 nach F. Calau

Above: Gendarmenmarkt. Schauspielhaus (theatre), built 1818–21, designed by Karl Friedrich Schinkel, and Reinhold Begas' Schiller monument, erected 1864–69.

Left: Gendarmenmarkt with the German Cathedral and Carl Gotthard Langhans' National Theatre, built in 1802 and destroyed by fire in 1817, from the which the portico pillars were used for the replacement building, designed by Schinkel. Etching c. 1805, based on a work by F. Calau.

19. Jahrhundert

Geschichte

Mit dem Bau der königlichen Eisengießerei 1804 vor dem Neuen Tor deutet sich eine neue Epoche an, die industrielle Revolution. Sie ist vor allem mit den Maschinenbauanstalten von Borsig und Egell verbunden. Besonders der Ausbau des Eisenbahnnetzes im Zeitraum von 1838 bis 1845 sorgte für einen wirtschaftlichen Aufschwung. Atemberaubend verlief auch die Bevölkerungsentwicklung Berlins. Waren es um 1816 200 000 Einwohner, so lebten um 1840 bereits über 400 000 Menschen in der Stadt. Um 1860 hatte Berlin 600 000 und 1871 bereits 827 000 Einwohner. Für das Jahr 1912 sind 2,08 Mio. belegt.

Der Wohnungsbau konnte mit dieser Entwicklung nicht mithalten. Gab es um 1800 im Süden noch einen großen Anteil landwirtschaftlich genutzter Flächen innerhalb der Zollmauer, waren wenig später die letzten größeren Flächen innerhalb der Zollmauer bebaut. Zudem blieben für weite Bevölkerungskreise nur Keller- oder Dachwohnungen. 1861 vergrößerte man durch Eingemeindung die Stadtfläche von etwa 15 auf 60 qkm. Dabei gelangten die

19th century

History

The construction in 1804 of the royal iron foundry just outside of the city's New Gate (Neues Tor) heralded the start of a new era, the industrial revolution. This period is associated above all with the mechanical engineering establishments of Borsig and Egell. The expansion of the railway network in the years from 1838 to 1845 provided a particular boost for the economy, and Berlin's population grew at this time at a breathtaking rate. While around 1800 it had numbered 200,000, by 1840 this had already risen to over 400,000, by 1860 to 600,000 and by 1871 to 827,000. For the year 1912, 2.08 million is recorded as the figure.

The construction of housing could not keep pace with these changes. While around 1800 there was a large proportion of land within the customs wall still in agricultural use, a short time later every major piece of land inside the wall had been developed. And yet, broad swathes of the population had to live in basements or lofts. In 1861, the size of the city was increased from around 15 to 60 square kilometres by incorporating outlying communities. The districts of Moabit, Wedding,

links: Schadowhaus, 1805, um 1851 erhöht, Schadowstraße 10/11, Wohnhaus des Bildhauers Johann Gottfried Schadow mit Reliefs von Schadow, Schievelbein und Tieck
rechts: Grabmal von August Borsig (gest. 1854), Industrieller und Begründer der gleichnamigen Maschinen- und Lokomotivfabrik, Grabmal auf dem Friedhof Chausseestraße 126/127 nach Entwurf von Johann Heinrich Strack 1857, bronzene Büste von Christian Daniel Rauch 1855. Das Bildnismedaillon zeigt die Ehefrau (gest. 1887)

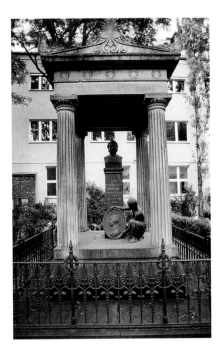

Left: Schadowhaus, 1805, extended upward 1851. 10/11 Schadowstraße, home of the sculptor Johann Gottfried Schadow, with reliefs by Schadow, Schievelbein and Tieck. Right: August Borsig's tomb. Borsig (d. 1854) was an industrialist and founder of the engineering and locomotive factory of the same name. The tomb, designed by Johann Heinrich Strack in 1857, is in the cemetery at 126/127 Chausseestraße. The 1855 bronze bust is by Christian Daniel Rauch. The medallion pictures his wife (d. 1887).

Stadtbezirke Moabit, Wedding, Gesundbrunnen, Prenzlauer Berg sowie die Parkanlagen Friedrichshain und Kreuzberg nach Berlin. Die Zollmauer hatte damit ihre Bedeutung verloren und wurde aufgegeben.

Im Verlauf der ersten Hälfte des 19. Jahrhunderts wandelte sich daher Berlin von einer Residenzstadt zu einer bürgerlichen Industrie-Großstadt. Der Ausbau der Bahn für den Personenverkehr wurde vorangetrieben, um das Berliner Umland, wo die Grundstückspreise niedriger waren, besser an die Stadt anzubinden.

Auch durch den Machtzuwachs Preußens stieg im Laufe des 19. Jahrhunderts die Bedeutung Berlins als politisches und kulturelles Zentrum Deutschlands. Berlin wurde zur Bundeshauptstadt des 1867 unter preußischer Führung gegründeten Norddeutschen Bundes.

Nach dem siegreichen Krieg 1870/71 gegen Frankreich wurde am 18. Januar 1871 in Versailles das Deutsche Reich proklamiert. König Wilhelm I. ließ sich zum deutschen Kaiser krönen. Berlin wurde dadurch Hauptstadt des neuen Nationalstaates und Residenz des Deutschen Kaisers. Die von Frankreich gezahlten 5 Mrd. Francs Kriegsentschädigung und der Wegfall der Zollschranken führten zu einem Wirtschaftsboom. Berlin wurde herausragender Börsen- und Bankplatz, Zentrum der Elektroindustrie, des Maschinenbaus und der Zeitungsherstellung.

Im 19. Jahrhundert war Berlin ein Kunstzentrum von internationaler Bedeutung. Einflüsse der sog. Schinkelschule – vor allem in der Architektur und im Kunstgewerbe – wirkten in ganz Mittel-, Nord- und Osteuropa. Aber auch der Gartenarchitekt Peter Joseph Lenné (1789 Bonn – 1866 Potsdam), die Bildhauer Johann Gottfried Schadow (1764 Berlin – 1850 Berlin), der 1795–97 das berühmte Doppelstandbild der Prinzessinnen Luise und Friederike von Preußen schuf, und Christian Daniel Rauch (1777 Arolsen – 1857 Dresden), Entwerfer des Reiterdenkmals für Friedrich den Großen (S. 82–83), gelangten ebenso wie der Maler und Graphiker Adolf Menzel (1815 Breslau – 1905 Berlin) zu Weltruhm. Menzel machte Berlin zu einem Zentrum der realistischen Malerei und Graphik (s. Abb. S. 47). Gegen Ende des 19. Jahrhunderts wirkten in Berlin die bedeutendsten Vertreter des deutschen Impressionismus: Max Liebermann (1847 Berlin – 1935 Berlin), Lovis Corinth (1858 Tapiau/ Ostpreußen – 1925 Zandvoort/Holland) und Max Slevogt (1868 Landshut – 1932 Neukastel/Pfalz).

Gesundbrunnen and Prenzlauer Berg and the parklands of Friedrichshain and Kreuzberg thus became part of Berlin. The customs wall consequently became meaningless and fell into disrepair.

In the course of the first half of the 19th century, Berlin thus transformed itself from royal residence into a major middle-class industrial city. Development of the railways for passenger transport was pushed forward, which, due to the low building costs and good transport links, in turn encouraged the development of the surrounding areas of Berlin.

Prussia's increasing power during the 19th century also saw a rise in Berlin's significance as one of Germany's political and cultural centres. The city became the capital of the North German Confederation, in the formation of which in 1867 Prussia played the leading role.

Following the victorious war against France in 1870/71, the German Empire (Deutsches Reich) was proclaimed on 18th January 1871 at Versailles. King Wilhelm I had himself crowned German Emperor (Kaiser). Berlin became the capital of the new nation state and the Kaiser's seat of residence. The 5 billion francs in war reparations paid by France and the abolition of customs barriers led to an economic boom. Berlin became an outstanding stock market and banking centre and the heart of the electronics, engineering and newspaper industries.

In the 19th century, Berlin was an internationally important centre of the arts. Influences of the so-called 'Schinkel School' – above all in architecture and the applied arts – were felt all over Central, Northern and Eastern Europe. Others, too, achieved world fame. These included: the garden designer Peter Joseph Lenné (born 1789 in Bonn, died 1866 in Potsdam); the sculptor Johann Gottfried Schadow (b. 1764 in Berlin, d. 1850 in Berlin), who in 1795-97 created the famous double statue of the Princesses Luise and Friederike of Prussia; Christian Daniel Rauch (b. 1777 in Arolsen, d. 1857 in Dresden), designer of the statue of Frederick the Great on horseback (pp. 82-83); and the painter, drawer and engraver Adolf Menzel (b. 1815 in Breslau, d. 1905 in Berlin). The last of these, Menzel, made Berlin a centre of realistic painting and graphic art (see section on p. 47). Towards the end of the 19th century, the key representatives of German Impressionism also worked in Berlin, i.e. Max Liebermann (b. 1847 in Berlin, d. 1935 in Berlin), Lovis Corinth (b. 1858 in Tapiau, East Prussia, d. 1925 in Zandvoort, Holland) and Max Slevogt (b. 1868 in Landshut, d. 1932 in Neukastel, Palatinate).

Karl Friedrich Schinkel

Schinkel – 1781 in Neuruppin geboren und 1841 in Berlin gestorben – war der bedeutendste Architekt des 19. Jahrhunderts in Deutschland. Er war ein universeller Künstler, der sich nicht nur als Architekt, Maler (vgl. Gemälde S. 114) und Denkmalpfleger betätigte, sondern auch Schriften verfasste und Entwürfe zu Bühnenbildern, Bauplastik, Glas- und Wandmalerei, Möbeln und Stoffen lieferte. Sein umfangreiches Werk zeichnet sich durch großen Ideenreichtum und Vielseitigkeit aus. Er rezipierte das Erbe der Antike, der Romanik und Gotik sowie der ländlichen, traditionellen Holzbauweise und verband diese mit funktionalen Aspekten und neuen Bautechniken, wie z. B. dem Eisenguss. Auf Schinkel gehen die Wiederbelebung des Sicht-Backsteinbaus, der Entwurf malerischer Gebäudegruppierungen (unter englischem Einfluss) und des im 19. Jahrhundert beliebten Schweizerstils mit Zierbrettern und „technischem" Fachwerk zurück.

Karl Friedrich Schinkel

Schinkel – born 1781 in Neuruppin, died 1841 in Berlin – was the most significant architect of the 19th century in Germany. He was an artist in every sense, working not only as an architect, painter (cf. painting p. 114) and preserver of artistic heritage, but also composing written works and producing designs for stage scenery, structural sculptures, stained glass, murals, furniture and fabrics. His extensive range of work featured a huge richness of ideas and diversity. He absorbed the heritage of antiquity, the Romanesque and Gothic movements plus the rural, traditional style of timber construction and combined these with functional aspects and new building techniques, such as the use of cast iron. The revival of building with exposed brick, the creation of picturesque groups of buildings (influenced from England) and the Swiss style of building popular in the 19th century using decorative panels and 'technical' half-timbering all go back to Schinkel.

unten links: Bauakademie, 1832–36 von Schinkel, nach Kriegsschäden 1961 abgerissen, Rekonstruktion
unten rechts: Standbild Schinkels von Johann Friedrich Drake, 1867/68

Below left: Schinkel's Bauakademie (Academy of Architecture). Reconstruction. Original built 1832-36, demolished 1961.
Below right: Schinkel's statue by Johann Friedrich Drake, 1867/68

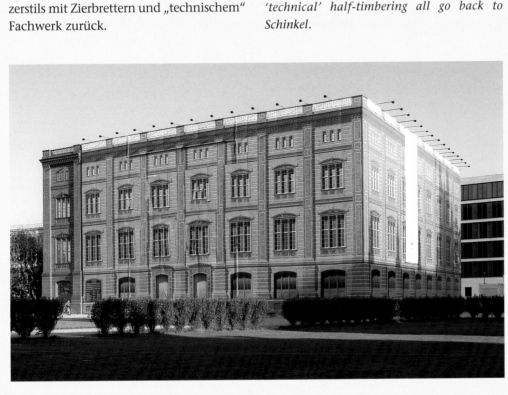

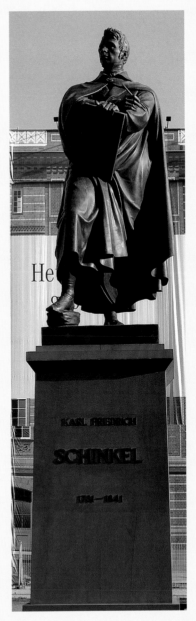

Schlossbrücke, 1822–24 von Schinkel, Figurengruppen – antike Göttinnen mit jungen Kriegern – und Reliefs mit antikisierenden Kriegern und preußischem Adler von Schinkel projektiert, 1842–57 in Carrara-Marmor von Bildhauern der Schadow- und Rauch-Schule ausgeführt. Die Skulpturen ergänzen das Bildprogramm der gleichfalls von Schinkel entworfenen Neuen Wache als Denkmal für die siegreiche Beendigung der Befreiungskriege.

Schinkel's 1822-24 Schlossbrücke (Palace Bridge), with groups of figures – ancient goddesses with young warriors – and reliefs with classical warriors and the Prussian eagle, conceived by Schinkel and made in 1842-57 in Carrara marble by sculptors of the Schadow and Rauch school. The sculptures complement the imagery of the Neue Wache, also designed by Schinkel as a monument to the victorious conclusion of the Wars of Liberation.

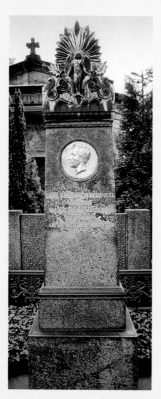

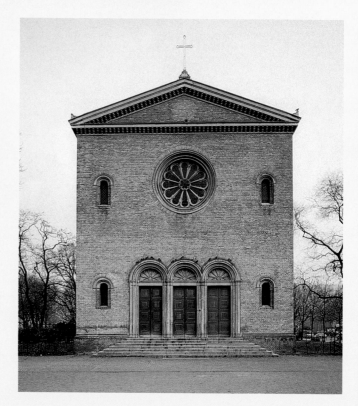

links: Schinkels Grabmal von August Kiß auf dem Friedhof Chausseestraße 126/127
rechts: Nazarethkirche am Leopoldplatz, 1835 von Schinkel. Für Berlins Vorstädte entwarf Schinkel vier Kirchengebäude, einschiffige Saalbauten ohne Turm mit halbrunder Apsis und Emporen. Für die Nazarethkirche rezipierte er Formen der oberitalienischen Romanik und kombinierte sie mit klassizistischen Elementen wie dem Dreiecksgiebel.

Left: Schinkel's tomb designed by August Kiß in the cemetery at 126/127 Chausseestraße
Right: Schinkel's 1835 'Nazarethkirche' on Leopoldplatz. Schinkel designed four church buildings for Berlin's suburbs. These were single-aisle hall-style buildings, with semicircular apse, galleries and no tower. For the Nazarethkirche he absorbed elements of northern Italian Romanesque and combined these with Classicist elements, such as the triangular gable.

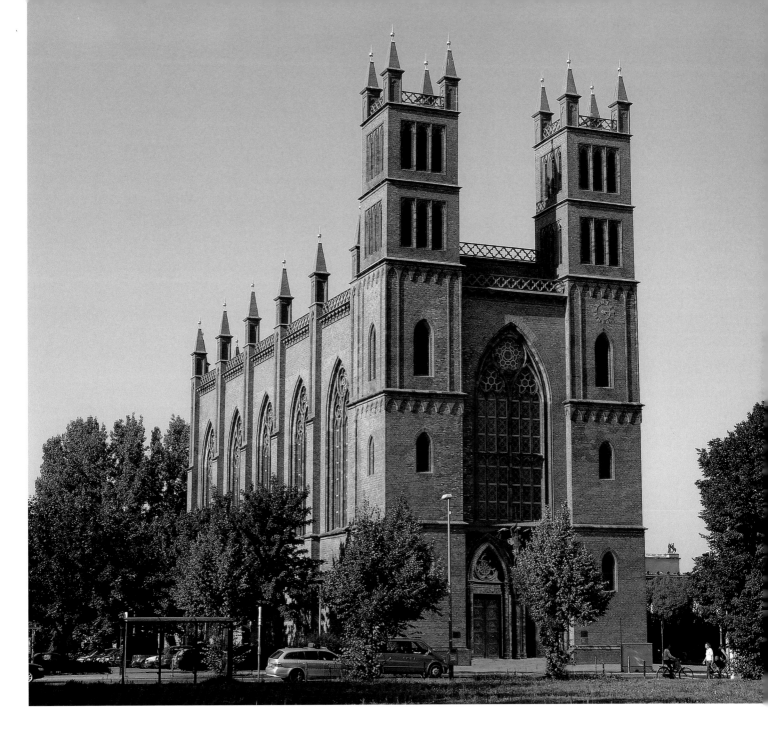

Friedrichwerdersche Kirche

Anstelle eines barocken Vorgängers 1824–30 errichtet und ursprünglich dicht von Häusern umbaut, war die von Karl Friedrich Schinkel 1821–22 entworfene Kirche nicht nur der erste neugotische Sakralbau Berlins, sondern auch der erste

Friedrichwerdersche Kirche

Designed by Karl Friedrich Schinkel in 1821-22 and built in 1824-40 in place of a previous Baroque building, this church, originally surrounded by dense housing, was not only Berlin's first Neo-Gothic ecclesiastical building, but also the first showcase building since the Middle

Repräsentationsbau seit dem Mittelalter mit unverputzter Backsteinfassade. Erstmals wurde auch der gesamte bauplastische Schmuck – Formsteine, Kapitelle, Reliefplatten, Terrakotten – aus gebranntem Ton gefertigt. Schinkel machte mit diesem Kirchenbau den unverputzten Backsteinbau „hoffähig", sodass er zahlreiche Nachfolger fand, wie Schinkels Bauakademie (S. 93), die Nazarethkirche (S. 94), das Berliner Rathaus (S. 117), die St.-Matthäus-Kirche (S. 118), das Postfuhramt (S. 118), die Neue Synagoge (S. 119) oder den Martin-Gropius-Bau (S. 121). Mit der helmlosen Doppelturmfassade, dem Verzicht auf ein hohes Langhausdach und dem großen Maßwerkfenster der Fassade nahm Schinkel den gotischen bzw. neugotischen Kirchenbau in England und in den Details die gotische Architektur in Norddeutschland zum Vorbild.

Ages to have an unplastered brick façade. It was also the first time that all of a building's ornate sculptural items – shaped stones, capitals, relief panels and terracotta pieces – were made of fired clay. With this church building Schinkel made unplastered brick construction 'fit for a king', and many other buildings consequently followed its lead. These included: Schinkel's 'Bauakademie' (Academy of Architecture, p. 93); the 'Nazarethkirche' (p.94); the Berlin 'Rathaus' (town hall, p. 116); the 'St.-Matthäus-Kirche' (St. Matthew's, p. 117); the 'Postfuhramt' (post office, p. 118); the New Synagogue (p. 119); and the Martin-Gropius-Bau (p. 121). In producing a spireless twin-tower façade with large tracery windows and in refraining from giving the church a high nave roof, Schinkel was drawing on the example of Gothic and Neo-Gothic church architecture in England, while for detail work he drew on Gothic architecture from northern Germany.

S. 95: Friedrichwerdersche Kirche am Werderschen Markt, 1824–31 von Karl Friedrich Schinkel. Nach Kriegszerstörung wurde die Kirche 1982–1987 in der von Schinkel ausgeführten Form ohne die späteren Ergänzungen wiederhergestellt.

links: Friedrichwerdersche Kirche, gusseiserne Flügeltüren des Hauptportals mit „Engel"-Tondi von Friedrich Tieck

rechts: Friedrichwerdersche Kirche, Innenraum. Der Kirchenraum zeigt eine Sandsteinquader-Imitationsmalerei auf den verputzten Wandflächen, eine Ziegelimitationsmalerei auf den Gewölbekappen und neugotische holzsichtige Emporeneinbauten mit Vierpassmaßwerk auf der Brüstung. Als Dépendence der Nationalgalerie beherbergt die Kirche heute eine Ausstellung zur Skulptur des frühen 19. Jahrhunderts, die durch eine Dokumentation zu Leben und Werk Schinkels ergänzt wird.

p. 95: Façade of the Friedrichwerder Church on Werderscher Markt, built 1824-31 to plans by Karl Friedrich Schinkel. After being destroyed in the War, the church was rebuilt in 1982-87 to Schinkel's design, without the later additions.

Left: Friedrichwerder Church. The main doorway's cast-iron wing doors with Friedrich Tieck's angel tondi.

Right: Friedrichwerder Church, interior. The church interior shows imitation sandstone squares painted on the plastered walls, imitation tiles painted on the vaulted canopies and Neo-Gothic exposed wood gallery installations with four-lobed tracery on the balustrade. Today, the church houses the National Gallery's permanent 'Sculpture of the 19th Century' exhibition.

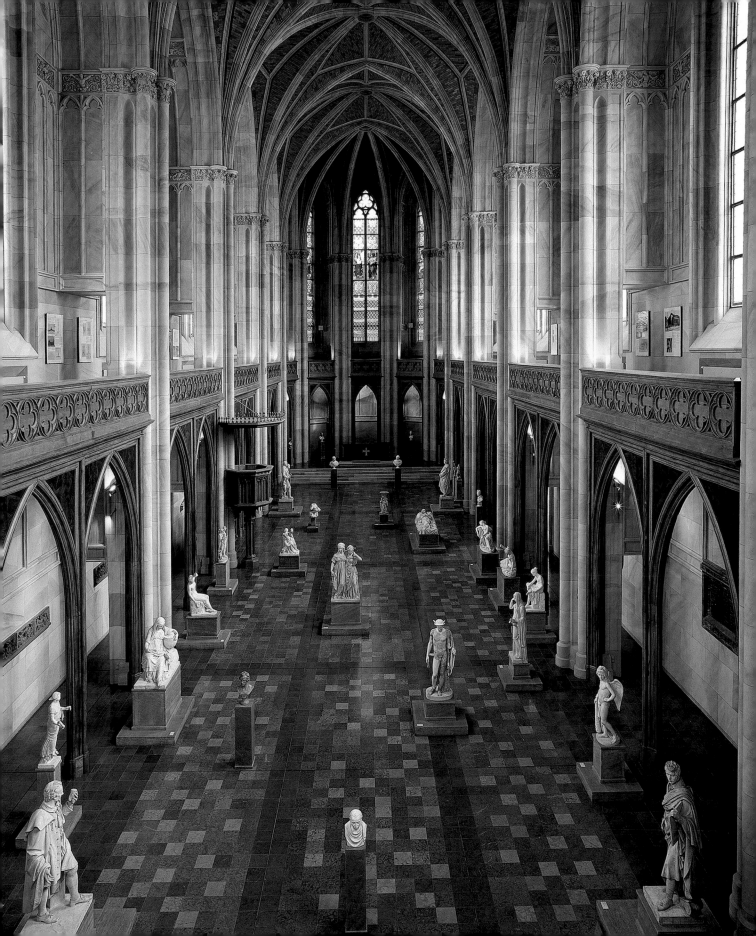

Pfaueninsel und Glienicke

Erst gegen Ende des 18. Jahrhunderts erwarb Friedrich Wilhelm II. die 1,5 km lange und 500 m breite Pfaueninsel am südwestlichsten Rand Berlins. Sie diente der Erweiterung des Neuen Gartens in Potsdam und als romantisch-paradiesisches Refugium. Daher entstand eine Ansammlung von Gebäuden innerhalb eines Landschaftsparks, in dem der Adel Zuflucht vor der Konvention der Etikette in Form von „Landleben" und Ungezwungenheit in einer Scheinwelt als Theaterkulisse fand. So entstand 1794–97 ein ungewöhnliches, malerisches Lustschloss als künstliche Ruine, die der Hofzimmermeister Johann Gottlieb Brendel aus Holz erbaute. Die repräsentative Ausstattung wurde maßgeblich durch Gräfin Lichtenau, der ehemaligen Mätresse des Königs, geprägt. Daher gibt es neben dem Festsaal, der als Konzertzimmer diente, ein „Otaheitisches Kabinett" mit illusionistischer Wand- und Deckenmalerei, die eine Bambushütte nachahmt. In der Meierei, als gotische Klosterruine zeitgleich am anderen Ende der Insel erbaut, wurden Kühe gehalten, um ein einfaches, ursprüngliches Leben in unberührter Natur nachzuleben. Das Kavalierhaus in der Inselmitte erhielt 1824–26 von Schinkel eine spätgotische Fassade, die mit einem ursprünglich aus Danzig stammenden Haus (Original wieder in Danzig) kombiniert ist.

Seinen Traum von antiker italienischer Architektur erfüllte sich Prinz Carl von Preußen mit dem Erwerb und Ausbau von Schloss Glienicke vor den Toren Potsdams unweit der Pfaueninsel ab 1824 durch Neu- und Umbauten Karl Friedrich Schinkels. Den Landschaftsgarten gestaltete Peter Joseph Lenné.

Pfaueninsel and Glienicke

It was not until towards the end of the 18th century that Friedrich Wilhelm II acquired 'Pfaueninsel' (Peacock Island), an island 1.5km long and 500m wide on the southwestern edge of Berlin. It helped with the extension of the 'Neues Garten' (New Gardens) in Potsdam and served as a romantic refuge paradise. A collection of buildings thus grew up within a landscaped park, in which the aristocracy found sanctuary from the conventions of etiquette in the form of 'rural life' and informality in a make-believe world acting as a theatrical backdrop. In 1794-97, for instance, an unusual, picturesque summer residence was built as an artificial ruin, constructed of wood by the court master joiner Johann Gottlieb Brendel. The grand interior was predominantly dictated by Duchess Lichtenau, the King's former mistress. In addition to the ballroom, which used to serve as a venue for concerts, there is therefore also a 'Tahitian Gallery' resembling a bamboo hut with wall and ceiling murals that play tricks on the eye. On the dairy farm, built at the same time at the other end of the island as Gothic monastery ruins, cows used to be kept in order to imitate a simple, primal style of life in untouched nature. In the middle of the island is the 'Kavalierhaus', which in 1824-26 Schinkel gave a late Gothic façade. This façade links to the adjacent house, originally from Danzig (to which the original has since returned). Having acquired 'Schloss Glienicke', not far from 'Pfaueninsel' just outside of Potsdam, Prince Carl of Prussia fulfilled his dream of ancient Italian architecture by developing this in the years following 1824 with new buildings and conversions designed by Karl Friedrich Schinkel and landscaped gardens by Peter Joseph Lenné.

Schloss Glienicke (unten links), Meierei (unten rechts) und Lustschloss (S. 101) auf der Pfaueninsel

Schloss Glienicke (below left), dairy farm (below right) and summer residence (p. 99) on Pfaueninsel (Peacock Island)

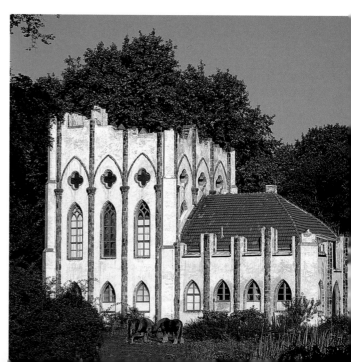

Museumsinsel

Der nördliche Teil der Spreeinsel im Zentrum Berlins besteht aus einem einzigartigen Ensemble von fünf bedeutenden Museumsbauten, die zum Weltkulturerbe gehören. Der Wunsch nach einem Museumsbau entstand, als man 1815 die von den Franzosen unter Napoleon geraubten Kunstwerke nach ihrer Rückführung in einer öffentlichen Ausstellung zeigte. Auch beabsichtigte Friedrich Wilhelm III., seine 1815 bzw. 1821 erworbenen Sammlungen Giustiniani und Solly sowie seine Kunstwerke aus den verschiedenen Schlössern der Hohenzollern der Öffentlichkeit zugänglich zu machen. Realisiert wurden die Museumsplanungen Schinkels aus dem Jahr 1822–23, der die Nordseite des Lustgartens gegenüber dem Schloss durch das Verfüllen des dortigen alten Kanals zwi-

Museum Island

The northern section of this island on the Spree in the centre of Berlin is made up of a unique ensemble of five major museum buildings, today recognised as a World Heritage Site. The desire for a museum building arose in 1815 when the works of art robbed from the French under Napoleon were brought back to Berlin and put on public display. Friedrich Wilhelm III also wanted to give the public access to his Giustiniani and Solly collections, acquired in 1815 and 1821 respectively, and his works of art from the Hohenzollern's various palaces. The plans used to achieve this were produced in 1822 by Schinkel, who proposed the north side of the 'Lustgarten' (Pleasure

S. 100: Altes Museum, 1825–30 von Schinkel; oben links: Blick vom Berliner Dom; oben rechts: Blick in die Säulenhalle
S. 101: Blick in die Rotunde

p. 100: Altes Museum, 1825–30 by Schinkel
Above left: view from the cathedral of Berlin
Above right: the portico
p. 101: the rotunda

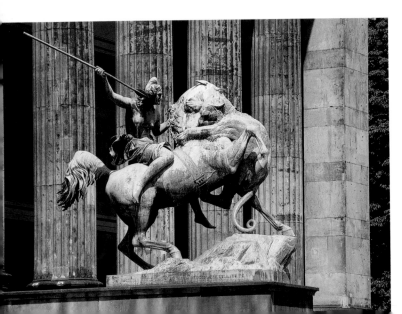

links: Amazone, August Kiß, 1842
rechts: Grundriss

Left: Amazone by August Kiß, 1842
Right: ground plan

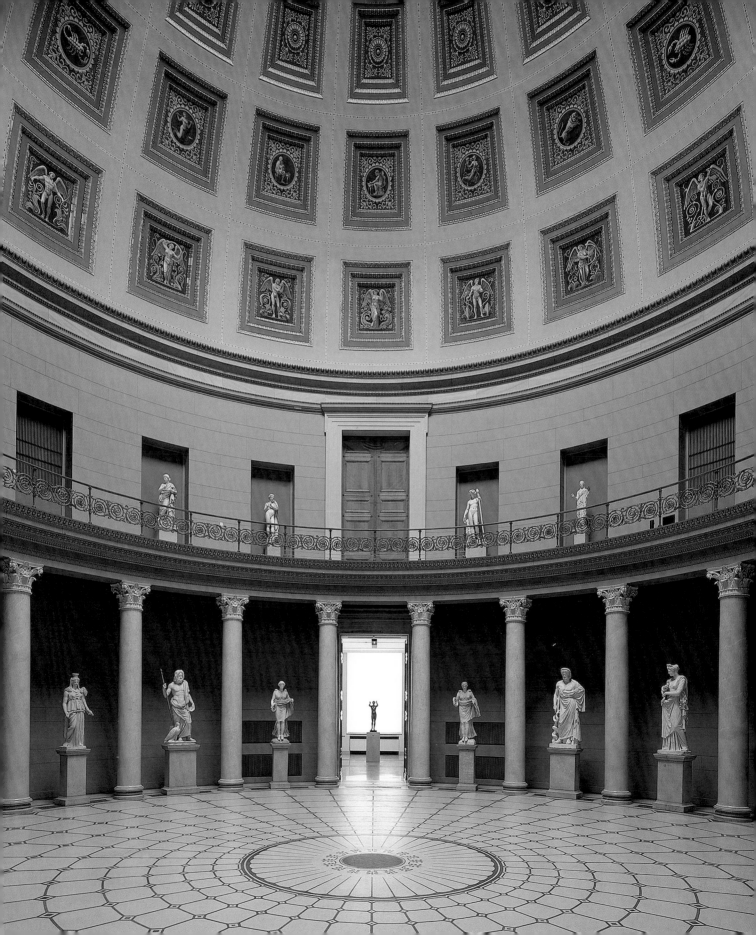

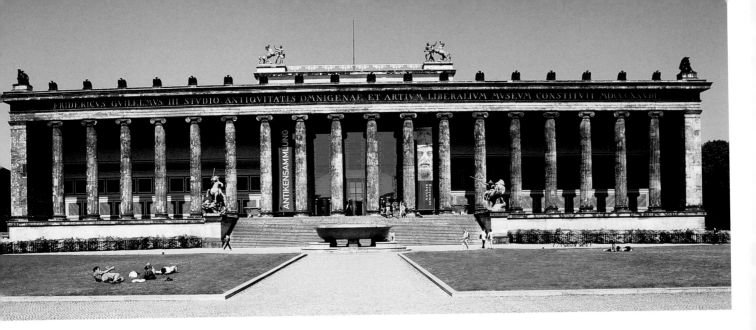

schen Spree und Kupfergraben als Bauplatz vorschlug. Hier entstand zwischen 1825 und 1830 das Alte Museum, das diesen Namen erhielt, nachdem das Neue Museum 1843–55 entstanden war. Das Alte Museum, ein Hauptwerk des Klassizismus, ist der drittälteste Museumsbau Deutschlands – nach dem Fridericianum in Kassel und der Münchner Glyptothek. Die Vierflügelanlage besitzt eine von 18 Säulen getragene Vorhalle und zwei Innenhöfe beidseitig einer Rotunde in Anlehnung an das römische Pantheon. Vor dem Eingang steht eine 1828 aus einem Findling geschliffene Granitschale (Durchmesser 6,9 m) von Christian Gottlieb Cantian (1834), die eigentlich für die Rotunde vorgesehen war.

Das Konzept für eine Ansammlung von Museen geht auf König Friedrich Wilhelm IV. zurück, der 1841 in einem Erlass die Absicht äußerte, „die ganze Spree-Insel hinter dem (Alten) Museum zu einer Freistätte für Kunst und Wissenschaft umzuschaffen." Die Entwicklung zur Museumsinsel begann 1830 mit der Eröffnung des Alten Museums und setzte sich mit dem Neuen Museum 1843–55 von Friedrich August Stüler fort, der auch die Alte Nationalgalerie entwarf (1866–76 von Johann Heinrich Strack ausgeführt). Das Bodemuseum entstand 1897–1904. 1909–30 folgte nach Entwürfen von Alfred Messel unter Ludwig Hoffmann der Bau des Pergamonmuseums als erstes Architekturmuseum der Welt. Um den Anforderungen einer modernen Museumslandschaft zu entsprechen, werden die Gebäude nach einem Masterplan des Londoner Architekten David Chipperfield gegenwärtig unterirdisch miteinander verbunden und um einen Eingangsneubau erweitert.

Gardens) opposite the palace as the building site, to be created by filling in the old canal there between the Spree and the 'Kupfergraben' canal. It was here that the 'Altes Museum' (Old Museum) was built between 1825 and 1830, being given its name following the construction of the 'Neues Museum' (New Museum) in 1843-55. The Old Museum, a major work of the Classicist period, is the third-oldest museum building in Germany – after the 'Fridericianum' in Kassel and the 'Glyptothek' in Munich. The four-wing complex has a front hall supported by 18 pillars and two inner courtyards either side of a rotunda in the style of the Pantheon in Rome. In front of the entrance is a granite bowl hewn out of a glacial boulder. The work, measuring 6.9m in diameter, is by Christian Gottlieb Cantian (1834) and was actually intended for the rotunda.

The concept of having a cluster of museums together goes back to King Friedrich Wilhelm IV who stated in an edict of 1841 the intention "to convert the whole of the Spree island behind the (old) museum into a sanctuary for art and learning." The transformation of the area into 'Museuminsel' (Museum Island) began in 1830 with the opening of the Old Museum and continued in 1843-45 with the New Museum designed by Friedrich August Stüler, who also drew up the plans for the 'Alte Nationalgalerie' (Old National Gallery), executed from 1866-76 by Johann Heinrich Strack. The Bodemuseum was built from 1897-1904. To plans by Alfred Mesel and under the direction of Ludwig Hoffmann, the construction then followed in 1909-30 of the Pergamon Museum, the world's first museum of architecture. To meet the requirements of a modern museum complex, the buildings are currently being linked underground to a master plan by London architect David Chipperfield. A new entrance building is also being built.

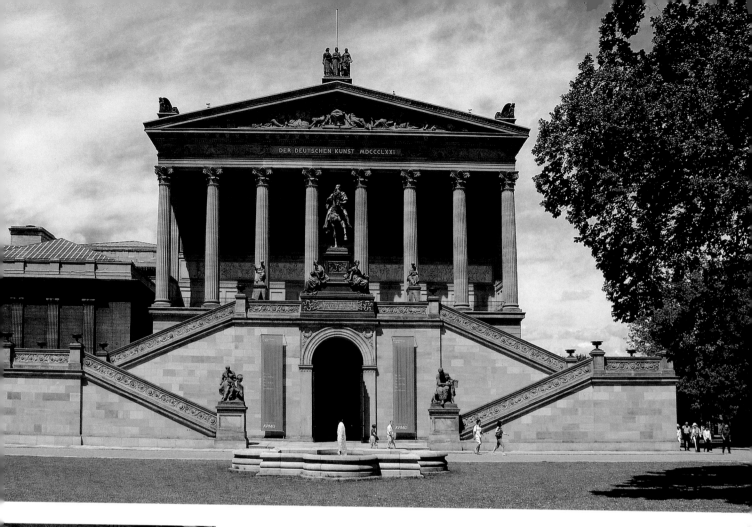

S. 102: Altes Museum, 1825–30 von Schinkel

S. 103: Alte Nationalgalerie, 1866–76 von Friedrich August Stüler (Entwurf) und Johann Heinrich Strack (Ausführung) mit Reiterstandbild Friedrich Wilhelms IV., 1886 von Alexander Calandrelli

p. 102: Schinkel's 'Altes Museum', 1825-30

p. 103: Alte Nationalgalerie. Designed by Friedrich August Stüler and built from 1866-76 by Johann Heinrich Strack. 1886 statue of Friedrich Wilhelm IV on horseback created by Alexander Calandrelli.

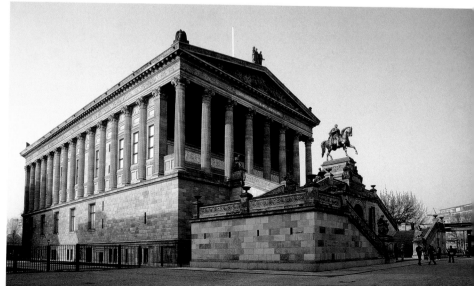

unten: Malerisch zwischen Spree und Kupfergraben gelegen, erhebt sich auf dreieckigem, der Inselspitze angepasstem Grundriss das Bode-Museum (früher: Kaiser-Friedrich-Museum), ein Neobarockbau von 1897–1904 des Architekten Ernst von Ihne. Die Kuppel markiert das große Treppenhaus (Abb. S. 105). In den Innenräumen beherbergt es die Skulpturengalerie der Staatlichen Museen zu Berlin.
rechts: Pergamonmuseum, 1909–30, das erste Architekturmuseum der Welt, nach Plänen von Alfred Messel und ausgeführt von Ludwig Hoffmann. Nach Plänen von Oswald Mathias Ungers wird das Pergamonmuseum seit 2008 saniert und wird einen neuen Verbindungsbau erhalten.

Below: Positioned picturesquely between the Spree and the Kupfergraben canal, the Bode Museum rises up on a triangular footprint adapted to the tip of the island. Formerly the Kaiser Friedrich Museum, it is an 1897-1904 Neo-Baroque building by architect Ernst von Ihne. The dome marks the position of the great stairwell (picture on p. 105). The interior houses the State Museums of Berlin's sculpture gallery.
Right: Pergamon Museum. The world's first-ever museum of architecture, designed by Alfred Messel and built from 1909-30 by Ludwig Hoffman. Now the museum is under recontruction and a new adjoining building to plans by Oswald Mathias Ungers will be added in 2011.

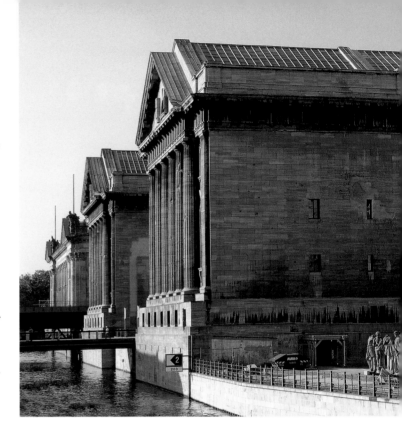

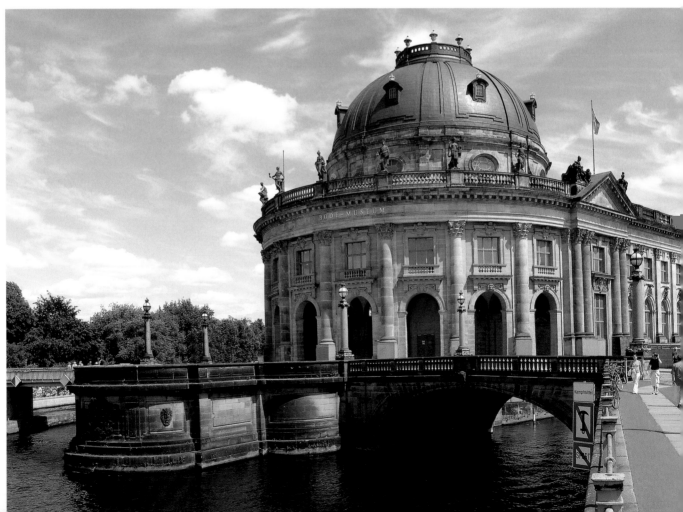

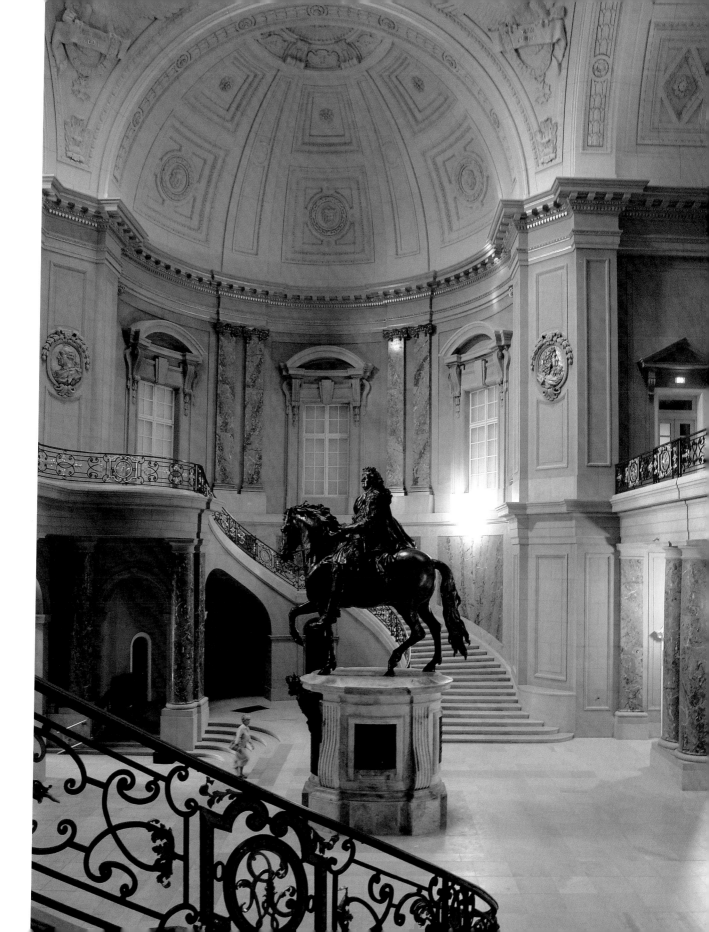

Die Museumsinsel beherbergt eine der umfangreichsten und qualitätvollsten Kunstsammlungen der Welt. Herausragend sind die Bestände zur ägyptischen, vorderasiatischen, antiken, islamischen und europäischen Kunst.

rechts: Modellbüste der Königin Nofretete, Bildhauerwerkstatt des Thutmosis aus Amarna, Kalkstein und Gips, Höhe 48 cm, um 1340 v. Chr., Ägyptisches Museum, Museumsinsel. Die weltberühmte Büste steht wie die Goldmaske des Tutanchamun für die Schönheit und Perfektion altägyptischer Kunst. Die Königin trägt einen breiten Blütenhalskragen und als Kopfschmuck eine Haube (die sog. Nofrete-Haube) mit Diademband und Uräusschlange über der Stirn. Die ausgewogen in den Proportionen und symmetrisch gestaltete Büste wurde 1911 bei Ausgrabungen der Deutschen Orientgesellschaft in der Werkstatt des Thutmosis gefunden. Sie diente als Vorlage zur Herstellung von Statuen der Königin. Da es sich nur um eine Werkstattvorlage handelt, besitzt die Büste nur eine Augeneinlage. Ansonsten wurde die Farbigkeit fast vollständig ausgeführt.
unten: Säulenhof der Ägyptischen Sammlung im Neuen Museum, Entwurf von Friedrich August Stüler, Lithografie nach einem Aquarell von Eduard Gaertner, 1853. Die Darstellung zeigt die Ausgestaltung der Ausstellungsräume für die ägyptische Sammlung im 19. Jahrhundert.

oben: Zweigeschossige Fassade des römischen Nordtores zum Staatsmarkt der kleinasiatischen Stadt Milet, kurz vor 129 n. Chr., Pergamonmuseum
rechts: Ischtar-Tor, Südmesopotamien (Babylon), 6. Jh. v. Chr., aus Original-Bruchstücken in Berlin wiedererrichtet, Vorderasiatisches Museum

Above: Two-storey façade of the Roman north gate to the state marketplace of the city of Milet in Asia Minor, shortly before 129 AD. Pergamon Museum.
Right: Ischtar Gate, southern Mesopotamia (Babylon), 6 BC, rebuilt in Berlin from original quarry stones. Vorderasiatisches Museum.

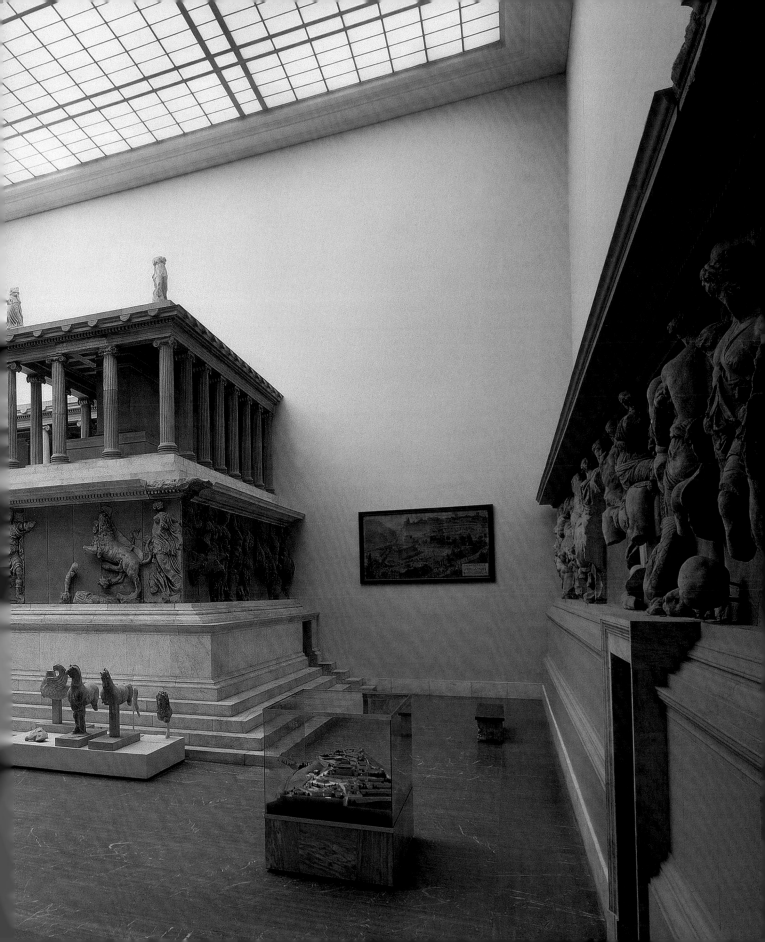

„Im Wintergarten" von Edouard Manet, Öl auf Leinwand, 115 x 150 cm, 1878/79, Staatliche Museen zu Berlin – Preußischer Kulturbesitz, Nationalgalerie.

Als 1896 der Berliner Maler Max Liebermann und der neue Direktor der Nationalgalerie Hugo von Tschudi die Kunstmetropole Paris besuchten, erwarben sie die ersten Impressionisten für die Berliner Galerie, darunter das bedeutendste Werk „Im Wintergarten" von Edouard Manet (1832–83), aber auch die Ölgemälde „Die Unterhaltung" von Edgar Degas, „Ansicht von Vétheuil" von Claude Monet und das bereits 1866 entstandene Werk „Das Mühlwehr" von Courbet. Das Gemälde Manets galt selbst um 1900 noch als erotisch anzüglich und damit unsittlich, da es mit seinen südlich üppigen Pflanzen eine erotische Atmosphäre wiedergibt. Dargestellt ist das mit Manet befreundete Ehepaar Guillemet, das ein Modegeschäft betrieb. Manet malte das Paar im Atelier des Malers Georg von Rosen, das als Treibhaus ausgestaltet und von Manet zu dieser Zeit genutzt wurde.

'In the Conservatory' by Edouard Manet, oil on canvas, 115 x 150 cm, 1878/79, National Gallery, Museum Island.

When the Berlin painter Max Liebermann and the new director of the National Gallery, Hugo von Tschudi, visited the art metropolis of Paris of 1896, they purchased the first Impressionist works for the Berlin gallery. These included the most important work, 'In the Conservatory' by Edouard Manet (1832-83), plus the Edgar Degas oil painting 'Conversation', 'View of Vétheuil' by Claude Monet and the 'Locks on the Loue' by Courbet, produced as far back as 1866. Even around 1900, Manet's painting was considered erotically suggestive and thus immoral, as with its tropically lush plants it evoked an erotic atmosphere. The couple portrayed are friends of Manet's, a married couple called Guillemet, who ran a clothes store. Manet painted them in painter Georg von Rosen's studio, which was fitted out as a greenhouse and used by Manet at this time.

Karl Friedrich Schinkel, Mittelalterliche Stadt an einem Fluss, 1815,
Öl auf Leinwand, 95 x 140 cm, Staatliche Museen zu Berlin – Preußi-
scher Kulturbesitz, Nationalgalerie
Das Gemälde des berühmten Architekten Schinkel (s. S. 93, 94) aus
dem Jahr 1815 wird als Allegorie auf die Napoleonischen Kriege ver-
standen. Das Unwetter der französischen Besatzung ist verzogen, der
Regenbogen symbolisiert die Hoffnung auf eine bessere Zukunft. Das
neue Deutschland ist, wie die gotische Kathedrale des Gemäldes, noch
im Bau, der Kaiser reitet in seine Stadt ein. Eine entsprechende Symbo-
lik verband sich mit dem Weiterbau des Kölner Doms, für den sich
auch Schinkel einsetzte.

Karl Friedrich Schinkel, 'Medieval City on a River', 1815,
oil on canvas, 95 x 140cm, Berlin, State Museums of Prussian
Cultural Heritage, National Gallery.
This painting of 1815 by the famous architect Schinkel (see pp. 93-94)
is seen as an allegory of the Napoleonic War. The storm of French
occupation is withdrawn, while the rainbow symbolises hope for a bet-
ter future. As the Kaiser rides into his city, the new Germany, like the
Gothic cathedral in the painting, is still being built. The symbolism
thus linked to the continued construction of Cologne Cathedral, which
Schinkel also supported.

Caspar David Friedrich, Mondaufgang am Meer, 1822, Öl auf Leinwand, 55 x 71 cm, Staatliche Museen zu Berlin – Preußischer Kulturbesitz, Nationalgalerie

Caspar David Friedrich (1774 Greifswald – 1840 Dresden) ist der bedeutendste Künstler der Romantik in Deutschland. Die Berliner Nationalgalerie besitzt 17 Gemälde des Malers. Das Bild besitzt eine für die Gemälde Friedrichs typisch schwermütig-mystisch-romantische Stimmung. Drei Gestalten am Ufer, auf einem Felsgestein sitzend, blicken in die Tiefe und Ungewissheit zum Mondaufgang am Meer. Der Mond ist ein Zeichen der Hoffnung, die heimkehrenden Schiffe geben gleichfalls Hoffnung zu einer positiven Lebensreise.

Caspar David Friedrich, 'Moonrise over the Sea', 1822, oil on canvas, 55 x 71 cm, Berlin, State Museums of Prussian Cultural Heritage, National Gallery.
Caspar David Friedrich (b. 1774 in Greifswald – d. 1840 in Dresden) is the most significant artist of the Romantic Movement in Germany. The Berlin National Gallery has 17 of his paintings. Typical of Friedrich's works, this picture has a melancholic, mystical and romantic air. Three figures on the shore, sitting on a rock, look into the distant uncertainty towards the moonrise over the sea. The moon is a symbol of hope. The ships making their way home also provide hope of a positive journey through life.

Repräsentationsbauten

Im Zuge der stetig steigenden Einwohnerzahlen entstanden neue Verwaltungsgebäude, Industrie- und Geschäftsbauten, Bahnhöfe, Kirchen und Synagogen in immer größeren Ausmaßen. Mitte des Jahrhunderts war der Sicht-Ziegelsteinbau beliebt, nach 1880 bei Repräsentationsbauten die Sandsteinfassade. Noch bis in die 1870er-Jahre bestimmte die sog. Schinkelschule vom Rundbogenstil bis zur italienischen Renaissance die Stilentwicklung. Es folgte die Rezeption der deutschen Renaissance und schließlich um 1900 des Barock. Im Profanbau war bis etwa 1870 die Neugotik bestimmend, nach 1900 die Neoromanik.

Das Berliner Rathaus (seit 1991 Senatskanzlei und Sitz des Oberbürgermeisters) wurde 1861–69 in der Stadtmitte nach Plänen von Hermann Friedrich Waesemann mit einem 97 m hohen Turm aus rotem Ziegel (daher auch „Rotes Rathaus") im Rundbogenstil erbaut. Es besitzt einen um das Gebäude laufenden Fries aus Terrakotta-Reliefs von 1876–79 mit Szenen aus der Geschichte Berlins. Formen des Rundbogenstils und der italienischen Renaissance zeigt der ehem. Hamburger Bahnhof (Invalidenstraße 50), der heute als Museum für Gegenwart der Staatlichen Museen Berlins genutzt wird. 1845–47 von Friedrich Neuhaus begonnen, wurde die Anlage später mehrfach erweitert. Er war einer der ältesten Kopfbahnhöfe Deutschlands und wurde 1884 wieder geschlossen.

oben: Berliner Rathaus, 1861–69 von Hermann Friedrich Waesemann
unten: Ehem. Hamburger Bahnhof (Invalidenstraße 50), heute Museum für Gegenwart der Staatlichen Museen Berlins, 1845–47
S. 117 links: St.-Matthäus-Kirche am Kulturforum, 1844–46 von Friedrich August Stüler im Stil der Neoromanik bzw. im Rundbogenstil erbaut

Above: Berlin Town Hall, 1861-69, designed by Hermann Friedrich Waesemann.
Below: Former 'Hamburger Bahnhof' (1845-47, no. 50 Invalidenstraße), now Berlin State Museums' 'Museum for the Present'.
p. 117 left: St. Matthew's Church on the 'Kulturforum', 1844-46, built by Friedrich August Stüler in the Neo-Romanesque/Romanesque style.

S. 117 rechts: Die Siegessäule im „Großen Stern" gab Wilhelm I. als Symbol des siegreichen Preußen nach dem Feldzug gegen Dänemark 1864 an Johann Heinrich Strack in Auftrag. Da erst 1873 fertiggestellt, wurde die Säule zum Symbol für die Siege gegen Österreich 1866 und Frankreich 1870/71.

p. 117 right: Wilhelm I commissioned Johann Heinrich Strack to create the Victory Column in the 'Großer Stern' (Great Star) as a symbol of Prussian victory following the campaign against Denmark in 1864. As it was not finished until 1873, the column became a symbol for the victories over Austria in 1866 and France in 1870/71.

Grand showcase buildings

As the population figures constantly grew, new administrative buildings, industrial and commercial properties, railway stations, churches and synagogues were built in ever larger proportions. In the middle of the century, exposed brick construction was popular, while for showcase buildings post 1880 it was sandstone façades. On into the 1870s, the so-called 'Schinkel School' continued to define the evolution in style, from Romanesque to Italian Renaissance. Then came the adoption of German Renaissance and finally, around 1900, of Baroque. In secular architecture Neo-Gothic was the defining style until around 1870, while after 1900 it was Neo-Romanesque.

The Berlin 'Rathaus' (the town hall, since 1991 housing the offices of the Senate and the Mayor) was built in the city centre in 1861-69. It was constructed in Romanesque style to plans by Hermann Friedrich Waesemann, with a 97-metre-high, red brick tower (which is why it is also known as the 'Rotes Rathaus', the 'Red Town Hall'). It has a frieze running around the building made up of terracota reliefs from 1876-79 with scenes from Berlin's history. Elements of the Romanesque style and of Italian Renaissance are shown by the former Hamburger Bahnhof (Hamburg station, 50 Invalidenstraße), which is now used as the Berlin State Museums' 'Museum for the Present' (Museum für Gegenwart). Begun in 1845-47 by Friedrich Neuhaus, the property was later repeatedly extended. Closed again in 1884, it was one of Germany's oldest terminal stations.

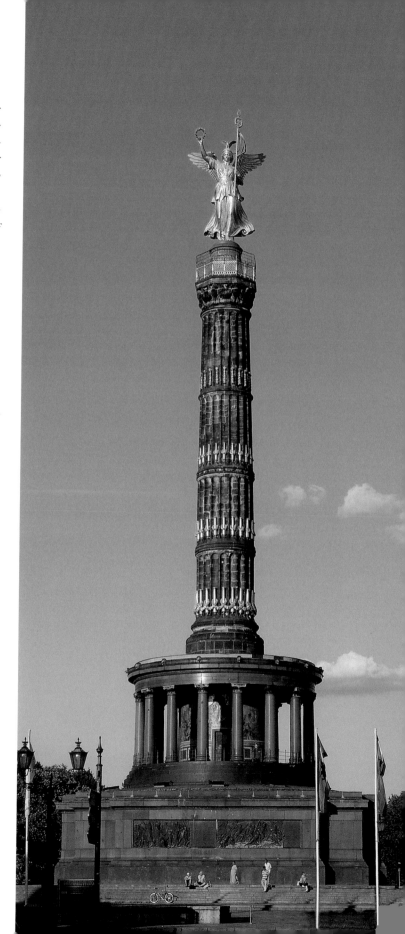

unten rechts und S. 119: Neue Synagoge in der Oranienburger Straße. Die Synagoge ist das Hauptwerk des maurischen Baustils in Berlin, der im 19. Jahrhundert häufig für Synagogen angewendet wurde. Der stattliche Ziegelrohbau wurde nach Entwurf von Eduard Knoblauch 1859 begonnen und 1866 von Friedrich August Stüler vollendet. Auffällig sind vor allem die Turmaufbauten mit Kuppeln auf oktogonalem Tambour, insbesondere die neu vergoldete, 50 m hohe Mittelkuppel. In der „Reichskristallnacht" 1938 geschändet und 1943 durch Bomben schwer beschädigt, wurde die Ruine von 1988 bis 1995 jedoch ohne den zerstörten Hauptbau wiederhergestellt.

links oben: Postfuhramt (Oranienburger Straße 35/36), 1875–81 für verschiedene Posteinrichtungen erbaut. Der Architekt Carl Schwatlo ließ einen repräsentativen, unterschiedlich farbigen Ziegelrohbau mit figürlichen Darstellungen ausführen. In den hofseitigen Stallgebäuden konnten in zwei Geschossen 200 Pferde Platz finden.

links unten: Aufwändige Klinkerfassade des S-Bahnhofs Hackescher Markt, 1878–82 von Johannes Vollmer

Right and below right: The New Synagogue on Oranienburger Straße. The synagogue is the major example of the Moorish architectural style in Berlin, which was frequently used for synagogues in the 19th century. The stately brick structure was begun in 1859 to a design by Eduard Knoblauch and completed in 1866 by Friedrich August Stüler. Its most striking features are the top sections of the towers, with domes on an octagonal tambour. The newly gilded 50-metre-high central dome is particularly impressive. Desecrated during 'Kristallnacht' in 1938 and badly damaged by bombs in 1943, the ruins, minus the main body of the building, were restored from 1988 to 1995.

Above left: Postfuhramt (Old Post Office, 35/36 Oranienburger Straße), built 1875-81 for various post office functions. The architect Carl Schwatlo had a showcase, brick building constructed, varying in colour and with decorative figures. The two-storey stable buildings on the courtyard side had room for 200 horses.

Below left: Elaborate clinker façade of the Hackescher Markt suburban railway station, 1878-82, by Johannes Vollmer.

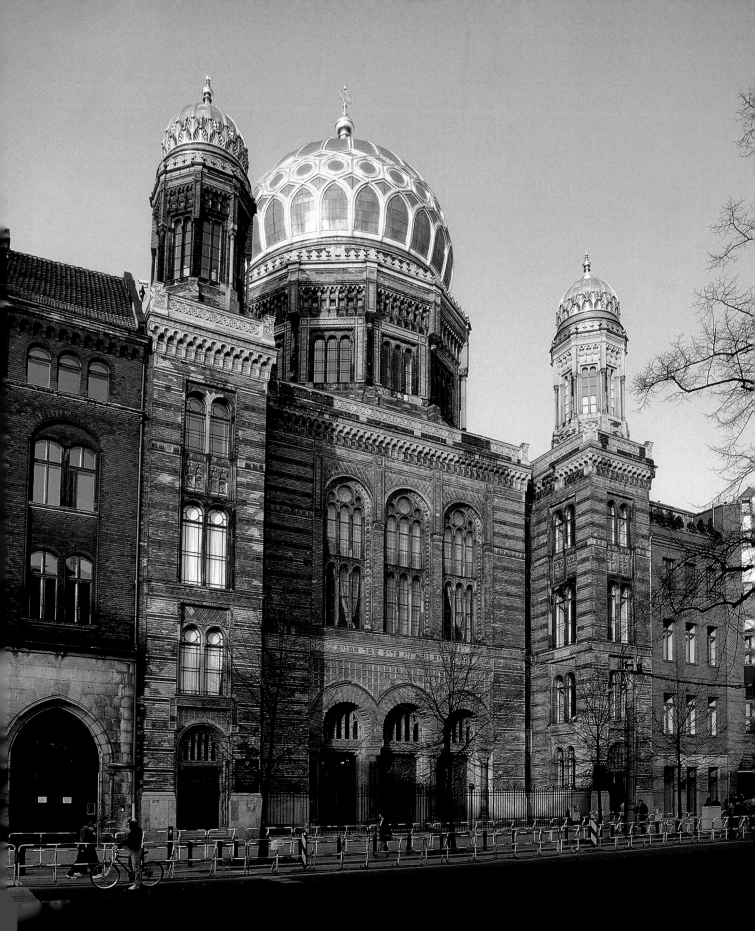

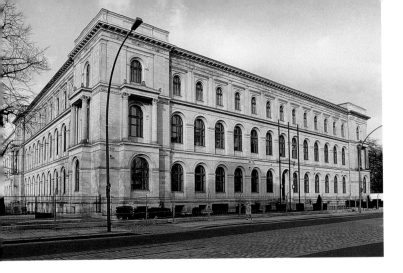

links oben und Mitte: Museum für Naturkunde (Invalidenstraße 43), 1883–89 von August Tiede im Stil der italienischen Renaissance erbaut. Im überdachten Lichthof steht der größte ausgestellte Saurier der Welt! unten links: Märkisches Museum (Stadtmuseum), 1901–07 von Ludwig Hoffmann als reizvoll gruppierte Gebäudeanlage in Anlehnung an einheimische Bauten der Backsteingotik und der Renaissance der Mark Brandenburg erbaut: Der Turm ähnelt z. B. der Bischofsburg in Wittstock, der Giebel und die Kapelle erinnern an die Katharinenkirche in Brandenburg. Neben der Treppenhalle steht eine Kopie des Brandenburger Rolands von 1474. unten rechts: Ehem. Preußisches Landtagsgebäude, 1892–97 von Friedrich Schulze erbaut, seit April 1993 Berliner Abgeordnetenhaus, das Parlament des Bundeslandes Berlin

Above left and centre: Museum für Naturkunde (Natural History Museum, 43 Invalidenstraße), built in Italian Renaissance style by August Tiede, 1883-89. In the covered courtyard is the largest dinosaur on display anywhere in the world!
Below left: Märkisches Museum (City Museum), built 1901-07 by Ludwig Hoffman as an attractively grouped complex of buildings, drawing on the Mark of Brandenburg's indigenous brick Gothic and Renaissance structures: The tower, for example, resembles Bischofsburg in Wittstock, while the gable and chapel are reminiscent of St. Catherine's Church in Brandenburg. Next to the stairway there is a replica of the statute known as the Brandenburg 'Roland', dating from 1474.
Below right: Former Prussian parliament building, 1892-97, designed by Friedrich Schulze. Since 1993, parliament building of the Federal State of Berlin.

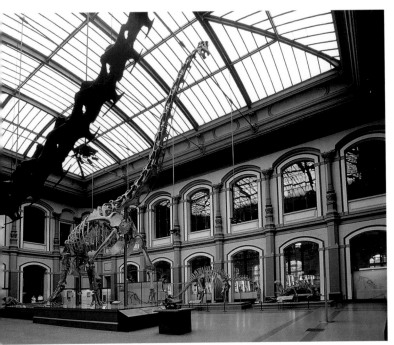

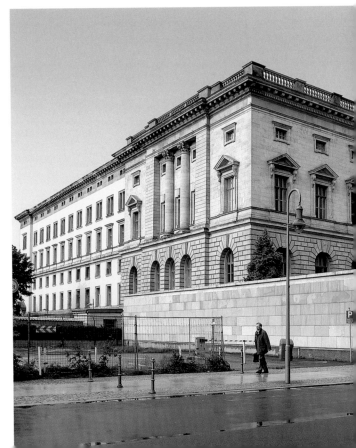

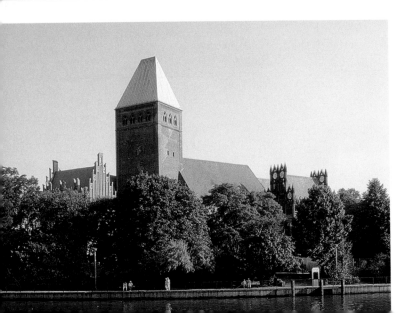

oben: Martin-Gropius-Bau, 1877–81, benannt nach seinem Architekten, als Kunstgewerbe-Museum erbaut und heute Ort für Wechselausstellungen. Architektonisch knüpft der gut proportionierte Bau im Stil der italienischen Renaissance an Schinkels Bauakademie von 1836 (S. 93) an.
unten rechts: Ehemaliges Preußisches Herrenhaus (Leipziger Straße 3/4), 1899–1904 von Friedrich Schulze, seit Sommer 2000 Sitz des Bundesrats, stattliches neobarockes Gebäude mit großem Ehrenhof und Säulenportikus

Above: Martin-Gropius-Bau, 1877-81. Named after its architect and built as a museum of the applied arts, it is now a venue for temporary exhibitions. The well-proportioned building in the Italian Renaissance style ties in architecturally with Schinkel's Bauakademie of 1836 (p. 93).
Below right: Former Prussian manor (3/4 Leipziger Straße), 1899-1904, designed by Friedrich Schulze. Since summer 2000, seat of the Bundesrat (upper house of the German parliament). Stately, Neo-Baroque building with large courtyard of honour and colonnaded portico.

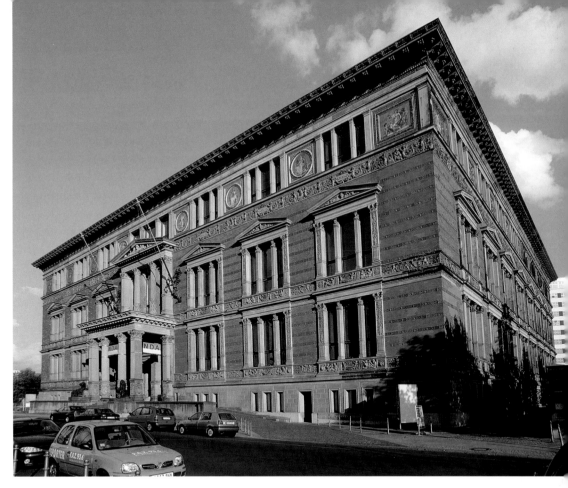

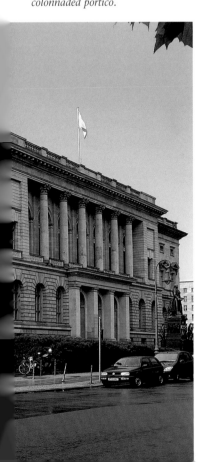

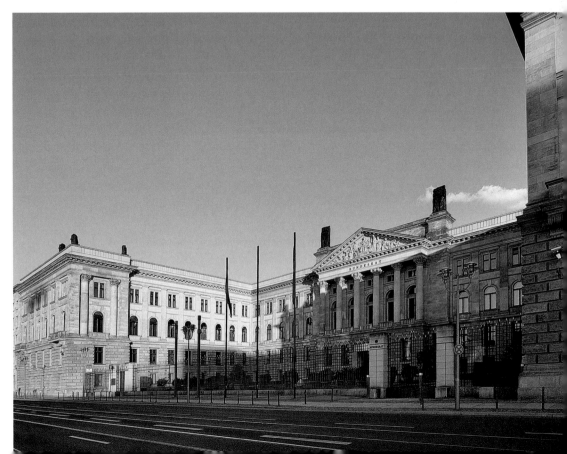

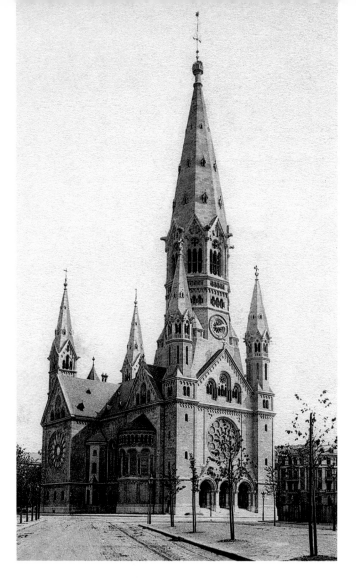

Kaiser-Wilhelm-Gedächtnis-Kirche

Die Kaiser-Wilhelm-Gedächtnis-Kirche bildet den städtebau-
lichen Mittelpunkt des Zentrums City-West am Breitscheid-
platz, von dem sternförmig die großen Geschäftsstraßen ab-
gehen: der Kurfürstendamm, die Tauentzien-, Hardenberg-
und Kantstraße sowie die Budapester Straße. Die herausragen-
de städtebauliche Lage veranschaulicht die Bedeutung als
zweites großes Prestigeprojekt im wilhelminischen Kirchen-
bau neben dem Berliner Dom. 1891–95 von Franz Heinrich
Schwechten erbaut, war der Sakralbau mit ehemals 113 m ho-
hem Turm und reichen Goldmosaiken als Symbol kaiserlicher
Macht mit dem Andenken an den ersten Kaiser des Deutschen
Reichs, Wilhelm I., verbunden. Die Verwendung spätromani-
scher Bauformen des Rheinlands sollte eine Verbindung zum
staufischen Kaiserreich des Mittelalters herstellen. Im 2. Welt-
krieg beschädigt, entschied man sich für den Abriss der Kir-
che. Nur der Turm blieb als Ruine erhalten. Die Turmreste ste-
hen heute als Mahnmal des Krieges und dienen als malerische
Staffage für den Kirchenneubau Egon Eiermanns, der 1957 bis
1963 einen weiteren, 53 m hohen Turm und eine achtecki-
ge Kapelle danebenstellte (siehe S. 140–141).

Kaiser-Wilhelm-Gedächtnis-Kirche

*Located on Breitscheidplatz, the Kaiser Wilhelm Memorial
Church forms the architectural hub of the city centre in the west
of Berlin, with five major commercial streets, the Kurfürstendamm,
Tauentzienstraße, Hardenbergstraße, Kantstraße and Budapester
Straße, stretching out from here in the form of star. The church's
outstanding location within the city demonstrates the importance
given to it as the second major prestige project of Wilhelmine
church construction after Berlin cathedral. Built in 1891-95 by
Franz Heinrich Schwechten, the church, formerly with a 113-
metre tower and rich gold mosaics as a symbol of imperial might,
was associated with remembrance of the first Kaiser of the
German Empire, Wilhelm I. The use of late Romanesque archi-
tectural styles from the Rhineland was designed to create a link
to the Hohenstaufen Empire of the Middle Ages. The church hav-
ing been badly damaged in the Second World War, it was decid-
ed to pull it down. Only the tower was retained as a ruin. The
tower remnants stand today as a reminder of the horrors of war
and serve as picturesque decoration for the church building erect-
ed next to it from 1957 to 1963, Egon Eiermann's 53-metre tower
and octagonal chapel (see pp. 140-141).*

S. 124 und 125: Kaiser-Wilhelm-Gedächtniskirche, 1891–95 von Franz
Heinrich Schwechten, Ansicht um 1905 (S. 124 oben) und Mosaiken
der Gedächtnishalle unter dem Hauptturm nach Entwürfen von Fritz
Schaper (1841–1919) mit der Darstellung der Hohenzollernherrscher
von Kurfürst Friedrich I. (1415–1440) bis zum letzten Kronprinzen
Friedrich Wilhelm (gestorben 1951) und dem Zug der Hohenzollern-
fürsten mit ihren Gemahlinnen zum Agnus. Die Marmorreliefs von
Adolf Brütt berichteten u. a. aus dem Leben Wilhelms I. (unten links).

*p. 122 and 123: Kaiser-Wilhelm-Gedächtniskirche, 1891-95 by Franz
Heinrich Schwechten, view c. 1905 (p. 124 top). The memorial hall's
mosaics beneath the main tower, designed by Fritz Schaper (1814-
1919), portray the Hohenzollern aristocracy from Elector Friedrich I
(1415-1440) to the last crown prince, Friedrich Wilhelm (d. 1951),
plus the Hohenzollern princes proceeding forwards with their wives for
the Agnus Dei. The marble reliefs by Adolf Brütt depict, amongst
others, scenes from the life of Wilhelm I (below left).*

Neben dem Berliner Dom entstanden weitere neobarocke Prachtbauten und Anlagen, wie der Neptunbrunnen, 1888–91 von Reinhold Begas (ursprünglich vor dem Stadtschloss, heute vor der Marienkirche), das Postmuseum (heute „Museum für Kommunikation Berlin"; Leipziger-/Mauerstraße), 1894–97 von Techow und Ahrens nach Entwürfen von E. Hake erbaut, und das alte Stadthaus, 1902-11 von Ludwig Hoffmann

Besides the Berlin Cathedral further grand Neo-Baroque buildings and structures were built, such as the Neptune Fountain, 1888-91, designed by Reinhold Begas (originally in front of the City Palace, now in front of St. Mary's Church), the Post Office Museum (now the 'Berlin Communications Museum' on Leipziger-/Mauerstraße), built in 1894-97 by Techow and Ahrens to designs by E. Hake, and the 'Alte Stadthaus', 1902-11, designed by Ludwig Hoffmann.

Berliner Dom

Der Berliner Dom – nach Entwürfen von Julius Raschdorff 1894–1905 als imposantes neobarockes Bauwerk mit reicher Innenausstattung errichtet – orientiert sich in seinen Architekturformen am Petersdom in Rom. Seine Bedeutung spiegelt sich anhand seiner exponierten Lage am Lustgarten zwischen dem Alten Museum und dem ehem. Stadtschloss und seinen Funktionen als Oberpfarr- und Domkirche sowie als Grabkirche der Hohenzollern wider. Der schlichte Vorgängerbau, der nach Plänen von Knobelsdorff durch Johann Boumann 1747–50 errichtet und 1817–22 durch Schinkel klassizistisch umgestaltet worden war, musste auf Druck Kaiser Wilhelms II. dem Repräsentationsbau „als Hauptkirche des preußischen Protestantismus in Berlin" weichen. Nach Kriegsschäden wurden die Kuppeln vereinfacht wiederaufgebaut. Die sich im Norden anschließende sog. Denkmalskirche wurde 1975–76 entfernt. In der Domgruft stehen 90 Sarkophage und Grabmäler von Angehörigen des Hauses Hohenzollern, darunter das Bronzegrabmal für Kurfürst Johann Cicero von Peter Vischer (1530) und der Prunksarg Friedrichs I. (1713) sowie der Sarkophag der Königin Sophie Charlotte (1705), beide von Andreas Schlüter, die in vergoldetem Zinnbleiguss ausgeführt wurden.

Berliner Dom

Designed by Julius Raschdorff and built in 1894-1905 as an imposing Neo-Baroque building with richly decorated interior, the 'Berliner Dom' (Berlin Cathedral) draws on the architectural style of St. Peter's in Rome. Its importance is reflected both by its dominant position facing the 'Lustgarten' (Pleasure Garden) between the 'Altes Museum' (Old Museum) and the former 'Stadtschloss' (City Palace) and by its functions as primary parish church, cathedral and burial church of the Hohenzollerns. The plain building that preceded the cathedral, designed by Knobelsdorff and built by Johann Boumann in 1747-50, was remodelled by Schinkel in Classicist style in 1817-22. However, under pressure from Kaiser Wilhelm II it had to give way to the new showcase building "as the leading church of Prussian Protestantism in Berlin". After being damaged in the War, the cathedral's domes were reconstructed in simplified form. The so-called 'Denkmalskirche' adjoining the cathedral to the north was removed in 1975-76. In the cathedral crypt there are 90 sarcophagi and tombs of members of the House of Hohenzollern. These include the Peter Vischer's bronze tomb (1530) for Elector Johann Cicero, Friedrich I's ceremonial coffin (1713) and Queen Sophie Charlotte's sarcophagus (1705), the latter two both made of gilded cast tin/lead, designed by Andreas Schlüter.

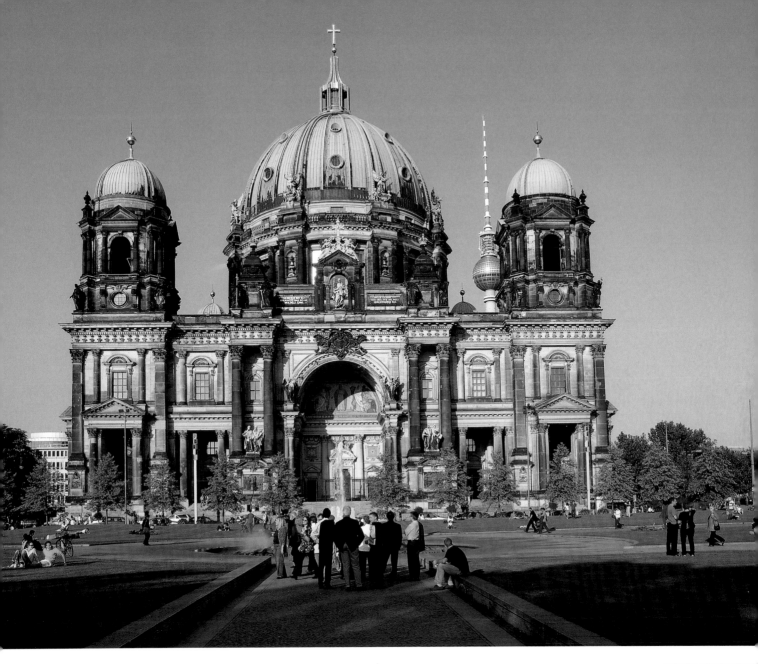

oben: Dom, heutiger Zustand
links: Vorgängerbau (18./19. Jahr-
hundert) des heutigen Doms um
1890
rechts: Heutiger Dom um 1900

Above: Cathedral, as it is today
Left: The building (18th/19th centu-
ry) that preceded today's cathedral,
c. 1890.
Right: Today's cathedral c. 1900.

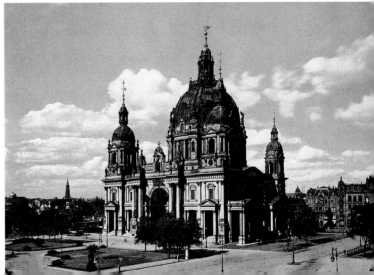

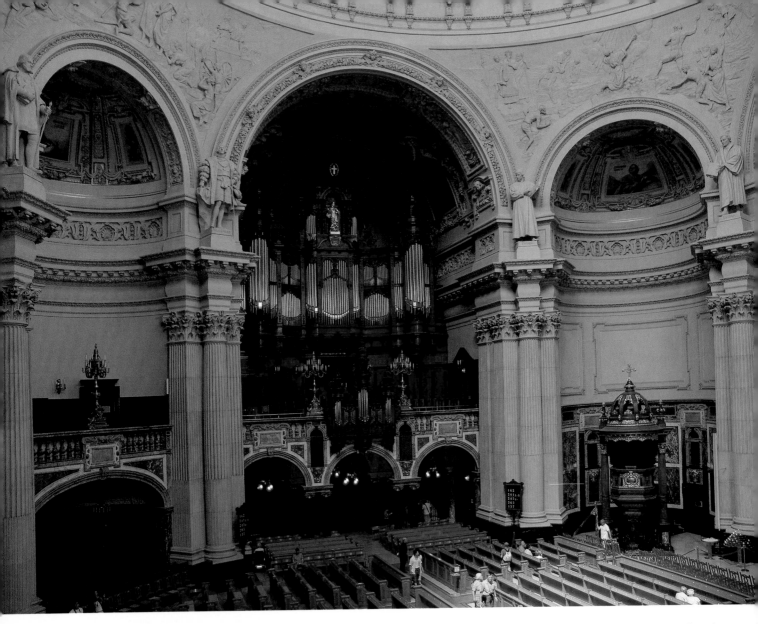

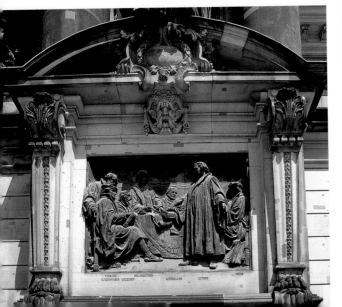

oben: Dom, Innenraum mit neobarocker Orgel und Kanzel

links unten: Luther im Kreis der Reformatoren, Bronzerelief von Johann Götz an der Domfassade seitlich des Triumphbogenportals

unten rechts: Mitteleingang mit der Bronzetür von Otto Lessing

Above: Cathedral, interior with Neo-Baroque organ and chancel.

Below left: 'Luther amongst the Reformers', bronze relief by Johann Götz on the cathedral façade to the side of the triumphal arch doorway.

Below right: Middle entrance with bronze door by Otto Lessing

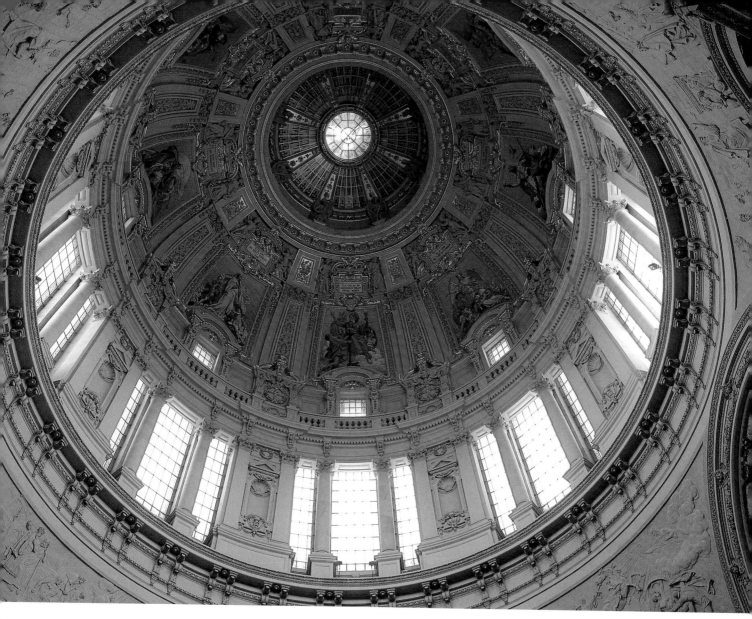

oben: Dom, Kuppel. Die Restaurierung bzw. Rekonstruktion des Kuppelmosaiks wurde 2002 fertig gestellt.

links: Sarkophage der Hohenzollern, Zustand um 1900: links das Bronze-Grabdenkmal des Kurfürsten Johann Cicero, Bronze, 1530 von Peter Vischer d. Ä. und Hans Vischer, in der Mitte das des Großen Kurfürsten Friedrich Wilhelm (gest. 1688) und rechts der Fürstin Dorothea (gest. 1689), beide von Johann Michael Döbel, wahrscheinlich nach Entwurf von Johann Arnold Nering.

Above: Cathedral, dome space and dome. Restoration / reconstruction of the dome mosaic was completed in 2002.
Left: The Hohenzollerns' sarcophagi, as they were c. 1900: On the left, the bronze plaque of 1530 commemorating Elector Johann Cicero by Peter Vischer d. Ä. and Hans Vischer, in the middle the Great Elector Friedrich Wilhelm (d. 1688) and on the right Princess Dorothea (d. 1689), both by Johann Michael Döbel, probably to a design by Johann Arnold Nering.

127

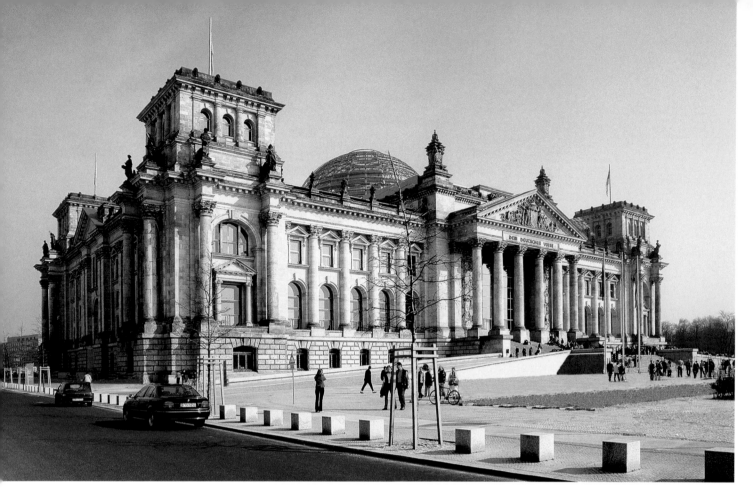

Reichstagsgebäude

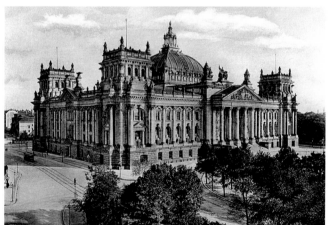

Der 1884–94 nach Plänen von Paul Wallot errichtete, 137 m lange und 97 m breite neobarocke Prunkbau mit einer mächtigen Glaskuppel und einer Kaiserkrone an der Spitze sollte von der Größe und Stärke des 1871 in Versailles ausgerufenen, wiederbegründeten Deutschen Reiches künden (links Ansicht um 1900). Das Reichstagsgebäude war von 1894 bis 1933 Tagungsort der Parlamente des Kaiserreichs und der Weimarer Republik. Beim Reichstagsbrand vom 28. Februar 1933 wurde der Plenarsaal (Abb. links unten) vernichtet. Stark kriegsbeschädigt, sprengte man 1954 die Kuppelreste und richtete ab 1961 das Gebäude nach Plänen Paul Baumgartens als Berliner Dependance des Bundestages (seit 1972) und als Tagungs- und Ausstellungsort ein. Am 4. Oktober 1990 fand hier die erste Sitzung des gesamtdeutschen Bundestags statt. Nach dem Umzugsbeschluss des Bundestags am 29.10.1991 erhielt 1993 der englische Architekt Sir Norman Foster den Auftrag für den Umbau zum Deutschen Bundestag mit der heutigen Glaskuppel (Abb. oben).

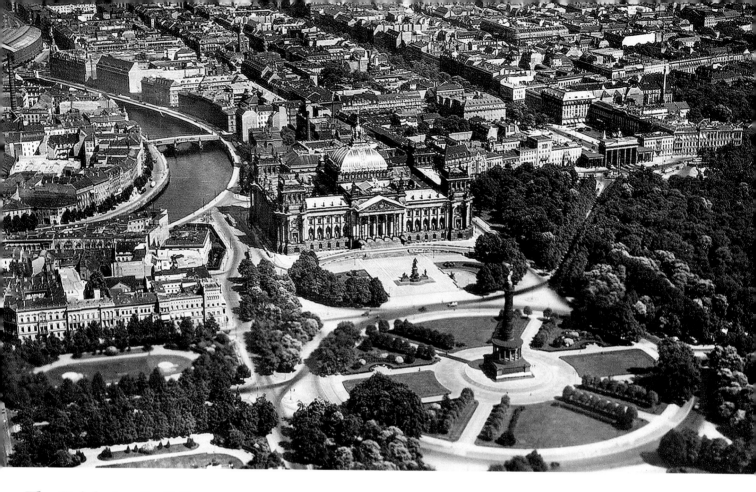

The Reichstag building

This grand Neo-Baroque building, 137 by 97 metres in size, was built in 1884-94 to plans by Paul Wallot. With a great glass copula topped with an imperial crown, it was intended to signify the might and strength of the reformed German Empire, proclaimed in 1871 at Versailles (left: view from c. 1900). The imperial parliament and subsequently that of the Weimar Republic sat here from 1894 to 1933. The debating chamber (pictured bottom left) was destroyed in the Reichstag fire on 28th February 1933, and having been badly damaged in the War, what was left of the copula was blown up in 1954. In the years from 1961, the building was reconfigured to plans by Paul Baumgarten as a conference and exhibitions venue and (from 1972) as Berlin's venue for occasional sessions of the Bundestag (German Parliament), with the first-ever session to represent the whole of reunited Germany held here on 4th October 1990. Following the decision taken on 29th October 1991 to relocate the Bundestag to Berlin, English architect Sir Norman Foster was commissioned in 1993 to convert the building into the 'Deutscher Bundestag' with its new glass copula (pictured above).

oben: Reichstag, Siegessäule und Pariser Platz um 1930
unten: Parlamentarische Gesellschaft (Wohnsitz des Reichstagspräsidenten) gegenüber dem Reichstagsgebäude, 1897–1904 von Paul Wallot

Above: Reichstag, Victory Column and Pariser Platz c. 1930.
Below: 'Parlamentarische Gesellschaft' (residence of the President of the Reichstag) opposite the Reichstag building, 1897-1904 by Paul Wallot.

20./21. Jahrhundert *20th/21st century*

Bis 1918

Up to 1918

Im 19. Jahrhundert hatte sich Berlin zu einer der führenden Kunststädte Europas entwickelt. Zahlreiche Privatsammlungen waren entstanden. Gegen Ende des 19. Jahrhunderts gelangte auch die sog. Klassische Moderne nach Berlin, einsetzend mit einem ersten Skandal um die Ausstellung des norwegischen Künstlers Edvard Munch 1892. Die vom „Verein Berliner Künstler" veranstaltete Ausstellung wurde von dessen Vorsitzenden Anton von Werner eigenmächtig geschlossen. Als Konsequenz wandten sich daraufhin die jungen Künstler vom Verein ab und gründeten 1898 die Berliner Sezession, zu der Max Liebermann, Walter Leistikow, Fanz Skarbina, Ludwig von Hofmann, Lesser Ury und andere gehörten. Die Auseinandersetzungen veränderten die Kunstlandschaft Berlins.

During the 19ᵗʰ century, Berlin had developed into one of Europe's leading cities for the arts, with numerous private collections assembled. Towards the end of the century, so-called 'Classic Modernism' also made its way to Berlin, starting with an initial scandal surrounding an exhibition by Norwegian artist Edvard Munch in 1892. Put on by the 'Verein Berliner Künstler' (Society of Berlin Artists), the exhibition was closed down by the society's chairman, Anton von Werner, without consulting other members. As a consequence of this, many younger artists left the society and in 1898 formed the 'Berliner Sezession'. Among their number were Max Liebermann, Walter Leistikow, Fanz Skarbina, Ludwig von Hofmann and Lesser Ury. These disputes changed the artistic landscape of Berlin.

links: Max Liebermann, Selbstporträt mit Zeichenblock, Lithographie o. J. (1912)
Zwei hockende weibliche Akte, Lithographie 1920 von Otto Mueller, der zur Künstlergruppe „Die Brücke" gehörte.

Left: 'Self-Portrait with Drawing Pad', undated lithograph (put at 1912) by Max Liebermann
'Two Crouching Female Nudes', 1920 lithograph by Otto Mueller, one of the 'Brücke' group of artists.

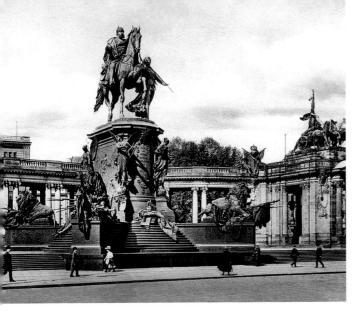

Nationaldenkmal Kaiser Wilhelms I. (1797–1888), neun Meter hohes Reiterstandbild von Reinhold Begas, zum 100. Geburtstag Wilhelms I. am 22. März 1897 eingeweiht. Es stand vor dem ehem. Stadtschloss. Reste des Denkmals wurden 1949–51 abgerissen. Wie viele Denkmäler jener Zeit diente das Nationaldenkmal der Verherrlichung der Hohenzollernherrscher. Mit dem Ende des 1. Weltkriegs nahm 1918 auch die Herrschaft der Hohenzollern und der Monarchie ein Ende.

National monument to Kaiser Wilhelm I (1797-1888). Nine-metre-high equestrian statue, created by Reinhold Begas to mark Wilhelm I's 100th birthday.
Unveiled 22nd March 1897, it used to stand in front of the former City Palace. The remains of the monument were pulled down in 1949-51. Like many monuments of that era, the national monument served to glorify the Hohenzollern rulers. With the end of World War I in 1918 both the rule of the Hohenzollerns and of the monarchy came to an end.

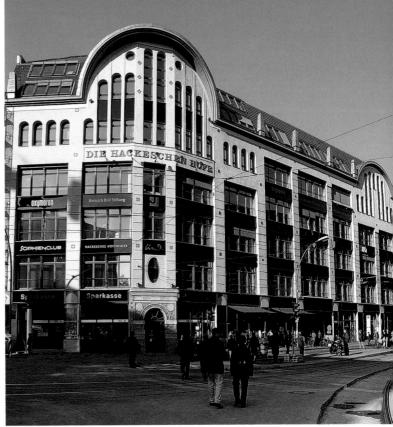

Jugendstilfassade von August Endell (1906/07) der Hackeschen Höfe am Hackeschen Markt. Die acht Innenhöfe entstanden vom 18. bis 20. Jahrhundert.

August Endell's 1906/07 Jugendstil façade to the 'Hackesche Höfe' on Hackescher Markt. The eight inner courtyards date from the 18th to the 20th century.

Ab 1908 wurde Berlin zudem der Wohnort der Künstlergruppe „Die Brücke", die neben den Mitgliedern der Gruppierung „Der Blaue Reiter" aus München den deutschen Expressionismus prägten. Zunächst war es Hermann Max Pechstein (1881–1995), der sich als Erster 1910 in Berlin niederließ. 1911 folgten Erich Heckel (1883–1970), Schmidt-Rottluff (1884–1976) und Kirchner (1880–1938). Otto Mueller (1874–1930), seit 1908 in Berlin wohnhaft, trat 1910 der „Brücke" bei.
Um 1900 erlebte Berlin auch eine wirtschaftliche Blütezeit. Die scheinbar festgefügte Ordnung des Kaiserreichs zerbrach im 1. Weltkrieg (1914–18), in den auch die jungen Künstler zogen und in dem diese z. T. umkamen. Die zunehmend durch Hunger und Elend gekennzeichnete Lage der Menschen führte zu Streiks und endete in der Novemberrevolution. Die Proklamation der Republik am 9. November 1918 bewirkte das Ende der Monarchie. Kaiser Wilhelm II. (1859–1941) dankte ab und floh in die Niederlande.

From 1908, Berlin was also home to the group of artists known as the 'Brücke' (Bridge), who, along with the 'Blaue Reiter' (Blue Riders) from Munich, shaped German Expressionism. The first of this group was Hermann Max Pechstein (1881–1995), who settled in Berlin in 1910. He was followed in 1911 by Erich Heckel (1883–1970), Schmidt-Rottluff (1884–1976) and Kirchner (1880–1938). Otto Mueller (1874–1930), resident in Berlin from 1908, joined the group in 1910.
Around 1900, Berlin was also experiencing an economic boom. However, the apparently firmly cemented order of the Empire collapsed during the First World War (1914-18), into which the young artists were also drawn and during which a number of them perished. People increasingly found themselves in a situation of hunger and poverty. This led to strikes and ultimately the November Revolution. The proclamation of the Republic on 9th November 1918 spelled the end of the monarchy. Kaiser Wilhelm II (1859-1941) abdicated and fled to Holland.

1918–45

1918–45

1920 wurde das Stadtgebiet der Reichshauptstadt von ca. 65 qkm auf eine Größe von 878 qkm mit ca. 3,8 Mio. Einwohnern erweitert. Die Eingemeindung beendete die kommunale Selbstständigkeit von sieben Städten, die teilweise zu Großstädten aufgestiegen waren, 59 Landgemeinden und 27 Gutsbezirken.

Nach der Inflation ging es ab 1923 wirschaftlich aufwärts. Die größte Wachstumsbranche war dabei erneut die Elektronikindustrie mit den Weltfirmen Siemens und AEG. Berlin wurde bald die führende Industriestadt in Europa.

Nach 1923 setzte ein Bauboom ein. Dabei waren vor allem neue Bauaufgaben betroffen: Wohnsiedlungen, Hochhäuser, Filmpaläste, Sportanlagen, Flughäfen und Tankstellen. Der technische Fortschritt erforderte auch neue Bautypen. Waren die Projekte der frühen 1920er-Jahre noch expressionistisch geprägt, setzte sich Mitte des Jahrzehnts die Neue Sachlichkeit durch. Nach 1930 werden traditionellere Formen

In 1920, the imperial city's boundaries were extended from covering an area of c. 65 square kilometres to one of 878 with a population of c. 3.8 million. The incorporation of outlying areas ended the administrative independence of seven towns, some of which had become quite large, 59 rural parishes and 27 estate districts.

Following a period of inflation, from 1923 the economy began to flourish. The sector enjoying the greatest growth was once again the electronics industry with the global firms of Siemens and AEG. Berlin soon became the leading industrial city in Europe.

A building boom set in during this period, affecting predominantly new construction projects, such as housing estates, tower blocks, picture houses, sports facilities, airports and petrol stations. Technical advances demanded new forms of building. While projects in the early 1920s were still characterised by Expressionism, 'Neue Sachlickeit' (New Practicality) asserted itself by the middle of the decade. Post 1930, more traditional

Berlin – Hauptstadt moderner Architektur: Mosse-Haus (Jerusalemer Straße 46–47) von Erich Mendelsohn, 1923 (links), Haus des Rundfunks (Masurenallee 8–14) von Hans Poelzig, 1929–31 (oben) und Universum-Kino (Kurfürstendamm 153–156) von Erich Mendelsohn, 1927–1931 (unten)

Berlin – Capital of modern architecture: Mosse-Haus (46–47 Jerusalemer Straße) by Erich Mendelsohn, 1923 (left), Haus des Rundfunks ('Broadcasting House', 8–14 Masurenallee) by Hans Poelzig, 1929–31 (above) and the 'Universum' cinema (153–56 Kurfürstendamm) by Erich Mendelsohn, 1927–1931 (below).

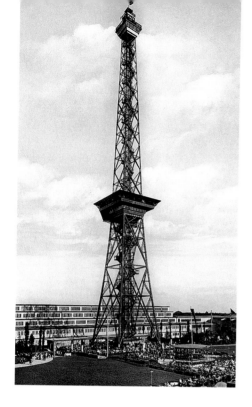

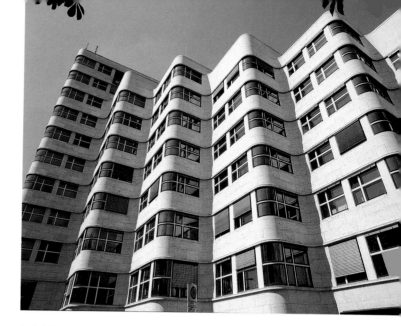

links: Funkturm (Messedamm 12–18) von Heinrich Straumer, 1924–26, 150 Meter hoher Turm, anlässlich der 1. Großen Deutschen Funkausstellung errichtet

rechts: Shell-Haus (Reichpietschufer 60–62) von Emil Fahrenkamp, 1930–31, einer der frühesten Stahlskelettbauten

Left: The 1924-26 'Funkturm' (radio tower, 12-18 Messedamm), designed by Heinrich Straumer. 150-metre tower built for the 1st Great German Wireless Exhibition.
Above: Shell-Haus (60-62 Reichpietschufer) by Emil Fahrenkamp, 1930-31. One of the earliest steel-frame buildings.

wieder beliebter. Eine große Herausforderung stellte der Bau von Siedlungen für die überbevölkerten Städte dar. Berlin wurde dabei zu einem Zentrum des sozialen Wohnungsbaus. Darüber hinaus entwickelte sich der Staat zu einem Motor der Stadtentwicklung, da große Infrastrukturprojekte, wie der Ausbau der U- und S-Bahn, des Flughafens Tempelhof, der Elektrizitäts- und Wasserversorung, bewältigt werden mussten. Mit Peter Behrens, Emil Fahrenkamp, Erich Mendelsohn, Ludwig Mies van der Rohe, Hans Heinrich Müller, Bruno Paul, Hans Poelzig, Hans Scharoun, Heinrich Tessenow und Bruno sowie Max Traut waren in Berlin Architekten der Weltelite tätig, die dann häufig nach der Machtübernahme der Nationalsozialisten in die USA auswanderten und das Neue Bauen in die Neue Welt importierten.

Deutschland verlassen musste – wie viele Deutsche jüdischen Glaubens – auch Albert Einstein (1879–1955), der 1914 dem Ruf an die Preußische Akademie der Wissenschaften gefolgt war und hier 1915 die Allgemeine Relativitätstheorie sowie 1927 die Quantentheorie formulierte.

Als Folge der Weltwirtschaftskrise von 1929 wuchs die Arbeitslosigkeit auf Rekordhöhe. Die damit einhergehende politische Radikalisierung führte zur Entmachtung der gewählten Stadtregierung und zur Machtübernahme durch die Nationalsozialisten am 30. Januar 1933, nachdem Reichspräsident von Hindenburg Adolf Hitler zum Reichskanzler

forms once again became more popular. One of the great challenges of the time was to build housing estates for over-populated towns and cities. In the attempts to meet this challenge, Berlin became a centre for social residential architecture. The government also became a driving force for urban development, as major infrastructure projects had to be accomplished, such as expansion of the underground and suburban rail network, Tempelhof airport and the electricity and water supply systems. Some of the world's elite architects worked in Berlin at that time. These included Peter Behrens, Emil Fahrenkamp, Erich Mendelsohn, Ludwig Mies van der Rohe, Hans Heinrich Müller, Bruno Paul, Hans Poelzig, Hans Scharoun, Heinrich Tessenow and Bruno and Max Traut. After the National Socialists took power, many of these then emmigrated to the USA and imported the 'New Architecture' into the New World.

Another who had to leave Germany – like many Germans of Jewish faith – was Albert Einstein (1879-1955), who in 1914 had been drawn by its reputation to the Prussian Academy of Science and formulated here in 1915 his General Theory of Relativity and in 1927 his Quantum Theory.

As a consequence of the global economic crisis of 1929, unemployment rose to record levels. The accompanying political radicalisation led to the overthrow of the elected government and on 30th January 1933, after President von Hindenberg appointed Adolf Hitler Reichs Chancellor, to the takeover of power by

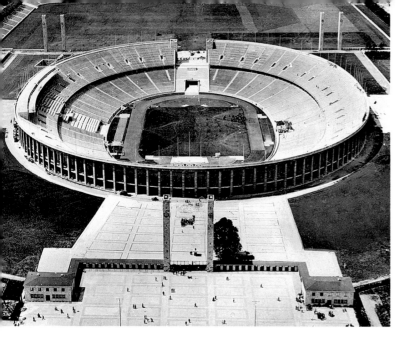

Above left: 90,000-capacity Olympic Stadium, built 1934-36 for the 1936 Olympic Games. Designed by Werner March.

Below left: Italian embassy (21-23 Tiergartenstraße), designed by Friedrich Hetzelt, 1941.

Above right: Ernst Sagebiel's Tempelhof Airport, 1936-41, the largest interconnected building in the world.

Middle right: Exhibition centre complex, Richard Ermisch's monumental-style 1937 'Palais am Funkturm' (Hammarskjöldplatz).

Below right: Ludwig Moshamer's 1942 Japanese embassy (24-27 Tiergartenstraße), built in monumental dimensions for Germany's World War II ally. After being damaged in the War and torn down, subsequently reconstructed.

p. 135 left: The Brandenburg Gate in 1945, photo panel on 8th May 2005.

p. 135 right: Aerial shot of central Berlin in 1945.

links oben: Olympiastadion der XI. Olympischen Sommerspiele 1936 mit 96000 Zuschauerplätzen von Werner March, 1934–36

links unten: Italienische Botschaft (Tiergartenstraße 21–23) von Friedrich Hetzelt, 1941

rechts oben: Flughafen Tempelhof von Ernst Sagebiel, 1936–41, das größte zusammenhängende Gebäude der Welt

rechts Mitte: Messegelände, Palais am Funkturm (Hammarskjöldplatz) von Richard Ermisch, 1937, im Monumentalstil errichtet

rechts unten: Japanische Botschaft (Tiergartenstraße 24–27) von Ludwig Moshamer, 1942, in monumentalem Maßstab für das im 2. Weltkrieg mit Deutschland verbündete Land errichtet, nach Kriegszerstörungen und Abriss in alten Formen rekonstruiert.

S. 137 links: Brandenburger Tor 1945, Foto-Leinwand zum 8.05.2005

S. 137 rechts: Luftbild der Berliner Innenstadt 1945

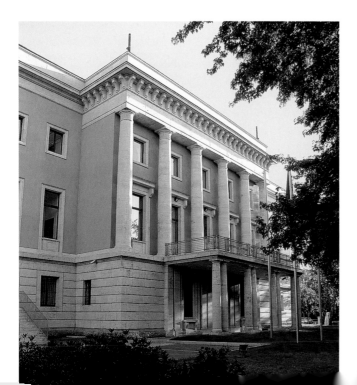

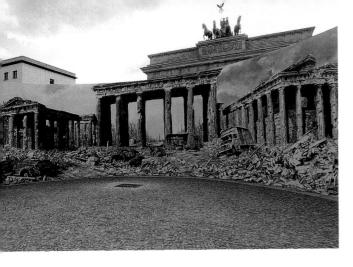

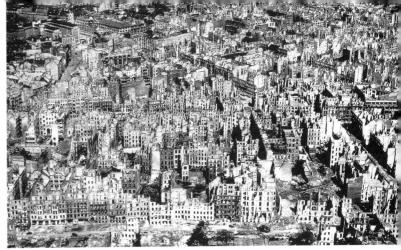

ernannt hatte. Einen Monat nach der Machtübernahme brannte der Reichstag. Die Nationalsozialisten nahmen dies zum Vorwand, ihre politischen Gegner zu beseitigen. Auf dem Opernplatz wurden am 10. Mai 1933 20 000 Bücher missliebiger Schriftsteller verbrannt. Straßenterror gegenüber Andersdenkenden, Juden, Sinti, Roma und ausländischen Mitbürgern wurde zur Regel. Während des 2. Weltkriegs wurden diese Bevölkerungsgruppen in Konzentrationslagern systematisch ermordet. Im Laufe der „Reichskristallnacht" 1938 wurden in Berlin 3 700 jüdische Geschäfte und fast alle Synagogen zerstört.

Unter Hitler entstanden monumentale Militär- und Repräsentationsbauten, wie der Flughafen Tempelhof und das „Reichssportfeld" für die Olympischen Spiele von 1936, die propagandistisch missbraucht wurden. 1937 setzte Hitler Albert Speer als „Generalbauinspektor für die Neugestaltung der Reichshauptstadt" ein. Der Ausgang des Krieges und die seit 1940 und verstärkt ab 1943 einsetzenden Luftangriffe auf die Millionenstadt unterbanden die größenwahnsinnigen Planungen Hitlers und Speers.

Während des 2. Weltkriegs (1939–1945) beschloss die nationalsozialistische Führungsspitze auf der Wannseekonferenz 1942 die so genannte „Endlösung der Judenfrage", worauf bis zum Ende des 2. Weltkriegs 6 Mio. Juden ermordet wurden. In Plötzensee (heute Gedenkstätte) wurden von 1933 bis 1945 Hunderte von politischen Gefangenen und Widerstandskämpfern erhängt oder enthauptet. Durch den Luftkrieg und den unsinnigen Häuserkampf während der Eroberung Berlins durch die rote Armee vom 21. April bis 2. Mai 1945 wurden 50 000 Menschen getötet, 39 % des Wohnungsbestandes der Stadt (612 000 Wohnungen), mehr als 26 qkm Stadtraum und 65 % der Industrieanlagen wurden zerstört. Adolf Hitler nahm sich im Bunker der Reichskanzlei das Leben.

the National Socialists. A month later, the Reichstag went up in flames. The National Socialists used this as a pretext to remove their political opponents. On 10th May 1933, 20,000 books by out-of-favour authors were burnt on 'Opernplatz' (Opera House Square). Street violence against dissenters, Jews, Sinti, Romanies and foreign residents became the norm. During the Second World War, these population groups were systematically murdered in concentration camps. In the course of 'Kristalnacht' (also known as 'Reichsprogromnacht') in 1938, 3,700 Jewish shops were destroyed in Berlin along with almost all of the city's synagogues.

Under Hitler, monumental military and showcase structures were built, such as Tempelhof airport and the 'Reichsportfeld' sports complex for the 1936 Olympic Games, which were misused for propaganda purposes. In 1937, Hitler appointed Albert Speer as 'Chief Architect for the Redesign of the Capital of the Reich'. The outcome of the War and the air raids from 1940 on, deployed more heavily from 1943, put a stop to Hitler and Speer's megalomaniac plans.

During the Second World War (1939-45), the leaders of the National Socialists agreed at the 1942 Wannsee Conference the so-called 'Final Solution of the Jewish Question', following which 6 million Jews were murdered by the end of the War.

In Plötzensee (today a place of memorial) hundreds of political prisoners and resistance fighters were hanged or beheaded between 1933 and 1945. The air raids and the senseless house-to-house battles from 21st April to 2nd May as the Red Army took Berlin in 1945 resulted in the deaths of 50,000 people, and 39% of the city's housing stock (612,000 apartments), more than 26 square kilometres of urban land and 65% of the city's industrial premises were destroyed. Adolf Hitler took his own life inside the bunker of the Reichs Chancellery.

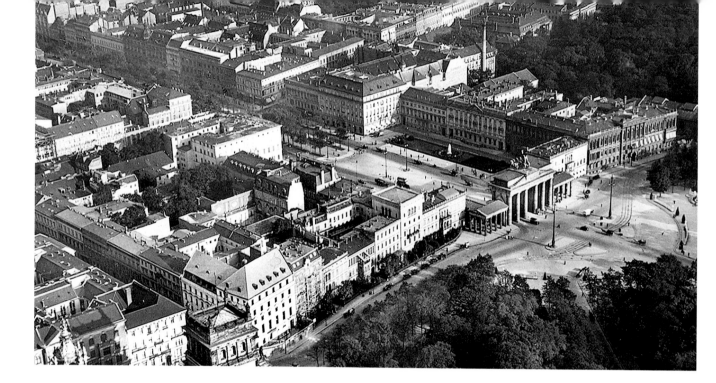

1945–89

1945 glich Berlin einem Trümmerfeld. Drei Viertel der Wohnungen waren zerstört oder zumindest nicht sofort wieder bewohnbar. Die Einwohnerzahl fiel von 4,33 auf etwa 2 Millionen, darunter waren viele Flüchtlinge. „Groß-Berlin" wurde von den Siegermächten des 2. Weltkriegs in vier Sektoren eingeteilt. Die Sowjetunion erhielt acht, die Vereinigten Staaten und Großbritannien bekamen je sechs Verwaltungsbezirke zugesprochen, von denen Großbritannien zwei Bezirke Frankreich überließ. Im Juni 1948 begann die Blockade von West-Berlin durch die sowjetischen Truppen. Die anglo-amerikanische Luftbrücke versorgte knapp ein Jahr lang – bis zum Ende der Blockade am 12. Mai 1949 – West-Berlin.
1949 erfolgte die Gründung der DDR mit Ost-Berlin als Hauptstadt. Der Volksaufstand in Ost-Berlin vom 17. Juni 1953 wurde blutig mit Panzern beendet. Am 13. August 1961 begann der Bau der Berliner Mauer um West-Berlin. Sie war

1945–89

In 1945, Berlin resembled a wasteland. Three quarters of the apartments had been destroyed or were not immediately inhabitable and the population fell from 4.33 to around 2 million, including many refugees. 'Greater Berlin' was divided by the Second World War's victorious powers into four sectors. The Soviet Union was allocated eight administrative districts, the United States and Great Britain six each, of which Great Britain ceded two to France. In June 1948, the Soviet troops began their blockade of West Berlin. For almost a year, West Berlin received its supplies via the Anglo-American airlift, until the blockade was lifted on 12th May 1949.
There followed later in 1949 the formation of the GDR, with East Berlin as the capital. The popular uprising in East Berlin on 17th June 1953 was ended bloodily with tanks deployed. On 13th August 1961, the Berlin Wall began to be built around West Berlin. In total, it was 161 kilometres long, 45 kilome-

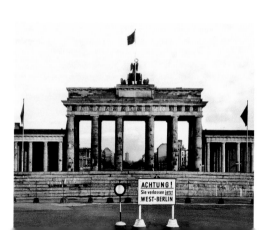

links: Brandenburger Tor von Westen, um 1970
rechts: Dokumentationszentrum Berliner Mauer, Bernauer Straße

Left: Brandenburg Gate from the west, c. 1970
Below: Berlin Wall Documentation Centre, Bernauer Straße

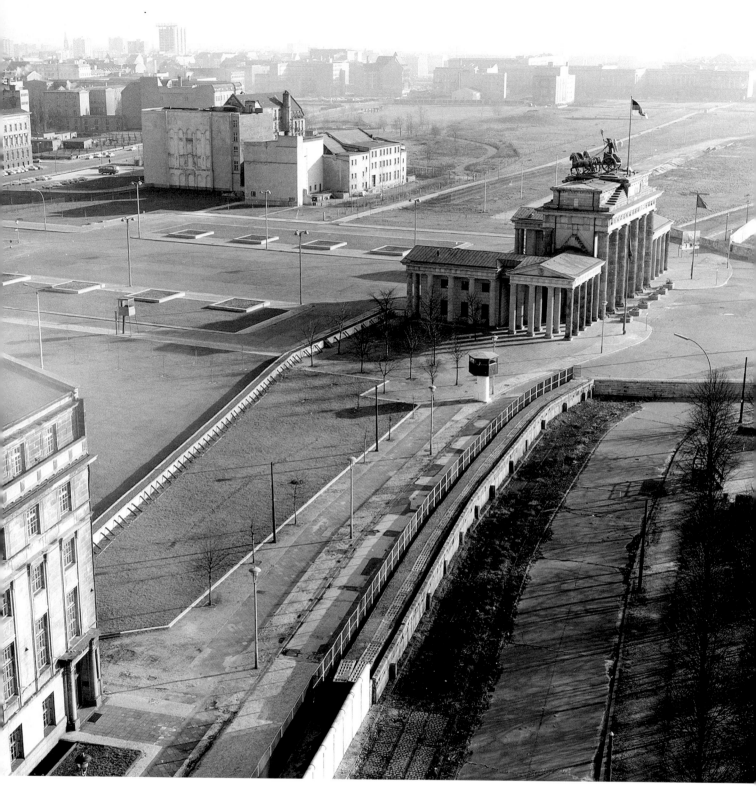

oben: Pariser Platz mit dem Brandenburger Tor und den Mauersperr-
anlagen 1967. Die historische Bebauung ist zerstört.
S. 136 oben: Zustand um 1930.

*Above: Pariser Platz in 1967 with the Brandenburg Gate and the
barriers around the Wall. The historic buildings have been destroyed.
p. 136 top: As it was c. 1930.*

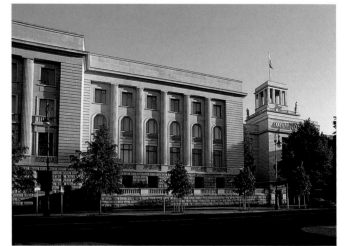

oben links: Luftbrückendenkmal vor dem Flughafen Tempelhof von E. Ludwig, 1951

oben Mitte: Checkpoint Charly. Am ehemaligen Mauer-Kontrollpunkt standen sich im Oktober 1961 sowjetische und amerikanische Soldaten gegenüber und entgingen nur knapp einem 3. Weltkrieg. Daran erinnern die Porträts eines amerikanischen bzw. sowjetischen Soldaten von Frank Thiel von 1998.

rechts oben: Sowjetisches Ehrenmal (Straße des 17. Juni, vor dem Brandenburger Tor), Lew E. Kerbel und Wladimir E. Zigal, 1945–46

rechts Mitte oben: Russische Botschaft (Unter den Linden 55–65), von Anatoli Strichewski, 1950

rechts Mitte unten: Frankfurter Allee, 1951–60

rechts unten: Palast der Republik von Heinz Graffunder und Karl-Ernst Swora, 1973–76, Abriss 2006

unten links: Neuer Friedrichstadtpalast (Friedrichstraße 107) von Walter Schwarz, Manfred Prasser und Dieter Bankert, 1980–84

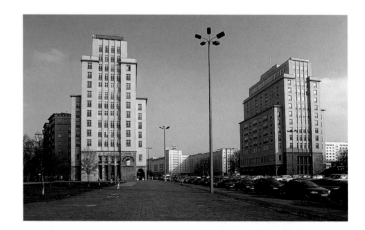

Above left: Berlin Airlift memorial in front of Tempelhof Airport, by E. Ludwig, 1951.

Above centre: Checkpoint Charlie. In October 1961, Soviet and American soldiers stood opposite each other at this former Berlin Wall control point and only just avoided a third World War. This is recalled by Frank Thiel's 1998 portraits of one American and one Soviet soldier.

Above right: Soviet Memorial (on 'Straße des 17. Juni', near to the Brandenburg Gate), Lew E. Kerbel and Wladimir E. Zigal, 1945–46.

Middle right top: Russian embassy (55-65 Unter den Linden), designed by Anatoli Strichewski, 1950.

Middle right bottom: Frankfurter Allee, 1951–60.

Below right: 'Palast der Republik' by Heinz Graffunder and Karl-Ernst Swora, 1973–76, demolition 2006.

Below left: 'Neuer Friedrichstadtpalast' (107 Friedrichstraße) by Walter Schwarz, Manfred Prasser and Dieter Bankert, 1980–84.

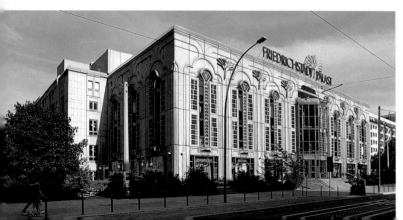

oben: Marx-Engels-Forum – Denkmal mit den vier Meter hohen Bronzefiguren von Karl Marx und Friedrich Engels, nach Entwurf von Ludwig Engelhardt, 1984–86, Spandauer Straße
rechts: Der Berliner Fernsehturm von 1965–69 ist mit 368 Meter das höchste Bauwerk Deutschlands.
unten: Trabant, das Auto der DDR, DDR-Museum im Dom-Aquarée

Above: Marx-Engels Forum – Monument with four-metre-high bronze figures of Karl Marx and Friedrich Engels, designed by Ludwig Engelhardt, 1984–86. On Spandauer Straße.
Right: The Fernsehturm (television tower) was built from 1965-69, with 368 meters it is the highest building in Germany.
Below: A Trabant, the car of the GDR, GDR museum in the Dom-Aquarée

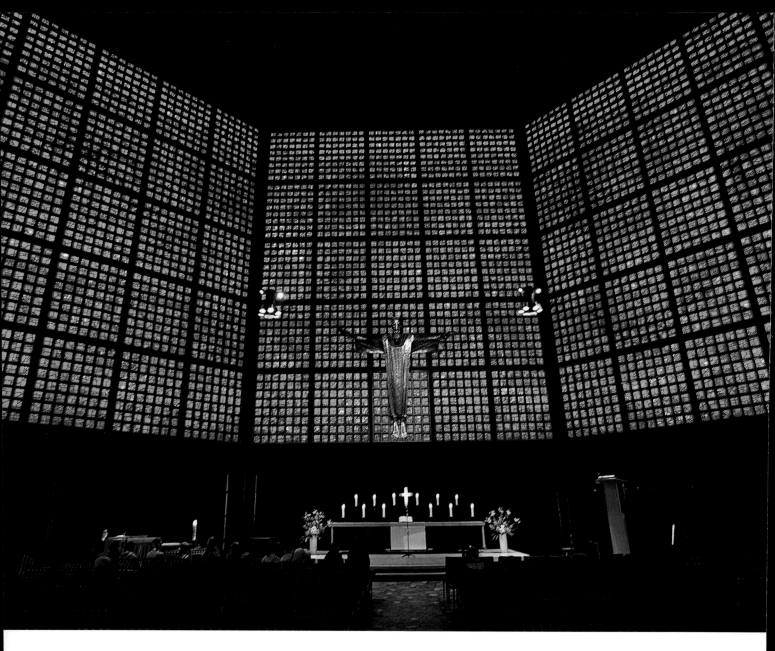

insgesamt 161 Kilometer lang, von denen sich 45 quer durch die Stadt zogen. Als Antwort auf den Mauerbau besuchte 1963 der amerikanische Präsident John F. Kennedy West-Berlin und proklamierte vor dem Schöneberger Rathaus: „Ich bin ein Berliner". 1971 brachte die Unterzeichnung des Vier-mächte-Abkommens wesentliche Verbesserungen im Transit-verkehr zwischen West-Berlin und der Bundesrepublik Deutschland sowie nach Ost-Berlin.

Nach der Kriegszerstörung begann im Ostteil Berlins der Wie-deraufbau als Hauptstadt des „Bauern- und Arbeiterstaats" DDR. Ideologische Aspekte standen im Vordergrund, wenn 1950 das kriegsbeschädigte Stadtschloss (zugunsten eines Auf-

tres of which ran right through the city. In response to the wall being built, US President John F. Kennedy visited Berlin in 1963 and proclaimed in front of the Schöneberg town hall: "Ich bin ein Berliner". In 1971, the signing of the Four Power Agreement brought significant improvements to travel between West Berlin and West Germany, as well as to East Berlin.

Following the destruction of war, reconstruction began in the eastern part of Berlin as the capital of the GDR's 'peasant and worker state'. Ideological concerns dominated as in 1950 the war-damaged City Palace was demolished (in favour of a parade ground and later of government buildings), several churches were pulled down and a kilometre-long, 90-metre-

links und rechts:
Kaiser-Wilhelm-
Gedächtnis-Kirche,
Neubauten von
Egon Eiermann,
1957–63. Die
Turmreste des neo-
romanischen
Kirchbaus von
Franz Heinrich
Schwechten aus
den Jahren 1891–
95 (siehe S. 122–
123) stehen heute
als Mahnmal des
Krieges. Der neue
Glockenturm ist
53 m hoch. Die
blauen Glasmale-
reien schuf Gabriel
Loire.

*Left and right:
Kaiser-Wilhelm-
Gedächtnis-Kirche,
new buildings by
Egon Eiermann,
1957-63. The
remains of the
tower of Franz
Heinrich
Schwechten's
Neo-Romanesque
church dating from
1891-95 (see pp.
122-123) now
stand as a
reminder of the
horrors of war. The
new bell-tower is
53 metres high.
The blue stained-
glass windows
were created by
Gabriel Loire.*

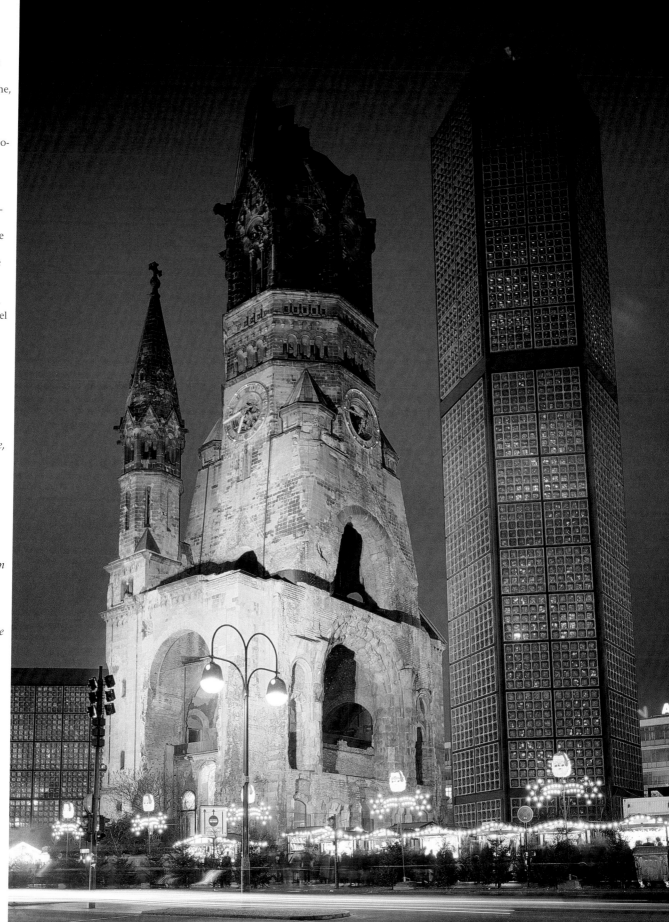

links: Haus der Kulturen der Welt (früher: Kongresshalle) von Hugh Stubbins, 1956–57
rechts: Bauhausarchiv (Klingelhöferstraße 13–14) von Walter Gropius, 1976–78

Left: Hugh Stubbins' 1956-57 'Haus der Kulturen der Welt' (House of World Cultures, formerly a congress hall).
Right: Bauhaus Archive (13-14 Klingelhöferstraße), designed by Walter Gropius, 1976–78.

marschplatzes und von später Regierungsgebäuden) und Kirchen abgebrochen und nach dem Vorbild sowjetrussischer Großstädte eine 90 Meter breite, kilometerlange Prachtstraße durch Ost-Berlin angelegt wurde. Diese Straße – die Frankfurter Allee (früher: Stalinallee, Karl-Marx-Allee) – führt vom Alexanderplatz nach Osten und wird von „Arbeiterpalästen", d. h. monumentalen, 100 bis 300 Meter langen und sieben- bis neungeschossigen Wohnburgen im „Zuckerbäckerstil" gesäumt. Am Schlossplatz errichtete man 1962 das Staatsratsgebäude der DDR, 1963–66 das Außenministerium (1995 abgerissen) und 1974–76 den Palast der Republik, der als Sitz der Volkskammer und öffentliches Veranstaltungs- und Freizeitzentrum für einen Wandel der DDR zu einer größeren Volksnähe stand. Zu einem Markenzeichen der DDR-Architektur wurde seit den 1960er-Jahren die Plattenbauweise für zumeist überdimensionierte, monotone Wohnblöcke, wie z. B. entlang der Leipziger Straße oder für die 1975 beschlossene Trabantenstadt Marzahn.

Den Paradestraßen des Ostens setzte West-Berlin beim Wiederaufbau des kriegszerstörten Hansaviertels eine aufgelockerte Bebauung im Stil der „internationalen Moderne" mit Hochhäusern und flachen Einfamilienhäusern gegenüber, die demokratische Werte wie Freiheit und Pluralismus zum Ausdruck bringen sollten. Dazu wurde 1957 die Internationale Bauausstellung unter Beteiligung namhafter Architekten wie Alvar Aalto und Walter Gropius ausgerufen. Ebenso entstand unweit des durch den Krieg und die Berliner Mauer brachliegenden Potsdamer Platzes seit 1960 das Kulturforum als Ersatz für die im unzugänglichen Ostteil der Stadt gelegene Museumsinsel. Das Konzept für das Kulturforum, das aus locker gruppierten Einzelbauten besteht, stammt von

wide ceremonial avenue was created through East Berlin, following in the style of major Soviet cities. This street – the Frankfurter Allee (formerly Stalinallee and then Karl-Marx-Allee) – runs east from Alexanderplatz and is lined by 'workers' palaces', i.e. monumental blocks of flats built 'wedding cake style', 100 to 300 metres long and seven to nine storeys high. In 1962, the GDR's state council building was erected on Schlossplatz (Palace Square), along with the foreign office (demolished in 1995) and the Palace of the Republic, which as the seat of the 'Volkskammer' (People's Chamber) and a public events and leisure centre stood for a move by the GDR towards greater closeness with its people. From the 1960's, pre-cast concrete slab construction (Plattenbau) became a trademark of East German architecture, used largely for oversized, monotone tenement blocks, such as along Leipziger Straße, and in the Trabant town of Marzahn, created by a resolution of 1975.

In rebuilding the war-ravished Hansa quarter, West Berlin juxtaposed the parade avenues of the East with informal development in the style of 'International Modernism', made up of high-rise towers and low-rise single-family homes intended to express democratic values of freedom and pluralism. In 1957, the International Building Exhibition was also staged, with renowned architects such as Alvar Aalto and Walter Gropius taking part. Not far from Potsdamer Platz, which lay idle as a consequence of the War and the Berlin Wall, the 'Kulturforum' emerged from 1960 onwards as a substitute for the inaccessible Museum Island in the eastern part of the city. The idea of the Kulturforum, which consists of casually grouped individual buildings, comes from Hans Scharoun, who also designed the 'Philharmonie' (Philharmonic Hall, 1960-63) and the

Kulturforum:
oben: Neue National-
galerie von Mies van
der Rohe, 1965–68
links: Gemäldegalerie
von Hilmer & Sattler,
1992–98
rechts: Philharmonie
(1960–63), Kammer-
musiksaal (1984–88)
und Musikinstrumen-
tenmuseum (1978–84)
von Hans Scharoun
Neue Staatsbibliothek
von Hans Scharoun,
1967–78

Kulturforum:
Above: Mies van der Rohe's 1965-68 New National Gallery.
Left: Hilmer & Sattler's Picture Gallery, 1992-98.
Right: Hans Scharoun's Philharmonic Hall (1960-63), Chamber Music
Hall (1984-88) and Museum of Musical Instruments (1978-84), Hans
Scharoun's 1967-78 New National Library.

Hans Scharoun, der zudem die Philharmonie (1960–63) und die Neue Staatsbibliothek (1966–78) entwarf. Hier entstand auch Ludwig Mies van der Rohes berühmte Neue Nationalgalerie (1965–68). Zur Deckung des Wohnbedarfs wurden in West-Berlin monotone Großsiedlungen wie die Gropiusstadt (1962) und das Märkische Viertel (1963) erbaut.

Im Zuge der Negativbewertung der modernen Architektur und der daraus resultierenden Hinwendung zur Denkmalpflege im Laufe der 1970er-Jahre entstand die Wohnanlage „Block 270" von Josef Paul Kleihues (1975–77) am Vinetaplatz im Wedding, bei der es sich um die erste Blockrandbebauung in Berlin seit dem 2. Weltkrieg und um ein frühes Beispiel einer behutsamen Stadtsanierung handelt. Kleihues leitete auch die Internationale Bauausstellung von 1987, die den Grundsatz der „Kritischen Rekonstruktion" empfahl, wonach für ein einheitliches Stadtbild im historischen Bestand vorgefundene Regeln wie die Blockrandbebauung und Traufhöhe eingehalten werden sollten, ohne die dekorativen Details zu kopieren. Auf diese theoretischen Positionen wurde nach dem Mauerfall 1989 dankbar zurückgegriffen. Auch im Ost-Teil Berlins hatte sich, wie der Wiederaufbau des Nikolaiviertels zeigt, diese Auffassung inzwischen durchgesetzt.

'Neue Stadtbibliothek' (New City Library, 1966-78). Ludwig Mies van Rohe's famous 'Neue Nationalgalerie' (1965-68) was also built in this area. To cater for the need for housing in West Berlin, large, monotonous estates were built, such as Gropiusstadt (1962) and the 'Märkisches Viertel' (1963).

With a negative view being taken of modern architecture and a consequent move in the course of the 1970s towards preserving architectural heritage, Josef Paul Kleihues' 'Block 270' residential complex (1975-77) appeared on Vinetplatz in Wedding. This was the first perimeter block development in Berlin since the Second World War and an early example of sensitive urban restoration. Kleihues also directed the 1987 International Building Exhibition, which put forward the principle of 'critical reconstruction', according to which for a consistent cityscape within historic building stock architects should adhere to existing rules, such as perimeter block development and matching eaves height, without however copying decorative details. Thankfully, after the fall of the Wall in 1989, it was to these theoretical positions that architects did indeed turn. This concept has now also asserted itself in the eastern part of Berlin, as seen in the reconstruction of the Nikolaiviertel.

Gemäldegalerie: Maria mit dem Kind und dem kleinen Johannes dem Täufer, Öl auf Pappelholz, Durchmesser 86 cm, von Raffael (1483–1520), 1505
rechts: Thronende Maria mit dem Kind und den beiden Johannes, Öl auf Pappelholz, 185 x 180 cm, von Botticelli (1445–1510), 1484

Picture Gallery: 'Madonna and Child with the Infant Saint John the Baptist', oil on poplar, diameter 86 cm, 1505 work by Raphael (1483-1520).
Right: 'The Virgin and Child Enthroned', oil on poplar, 185 x 180cm, 1484 work by Botticelli (1445–1510).

Gemäldegalerie:
links: Der Mann
mit dem Goldhelm,
Öl auf Leinwand,
67,6 x 50,7 cm, von
Rembrandt (1606–69)
bzw. Umkreis,
um 1650/55

rechts: Amor als Sieger
Öl auf Leinwand,
156 x 113 cm, von Ca-
ravaggio (1571–1610),
1602

Picture Gallery:
Left: 'The Man
with the Golden
Helmet',
oil on canvas,
67.6 x 50.7cm, by
Rembrandt (1606-69)
one of his circle,
c. 1650/55.

Right: 'Amor as
Victor', oil on canvas,
156 x 113 cm, 1602
work by Caravaggio
(1571–1610).

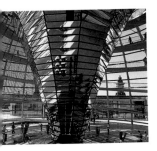
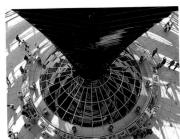
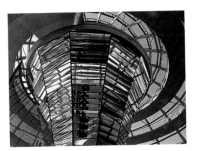
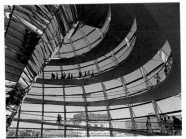

Seit 1989

Der Fall der Mauer – am 9. November 1989 – bedeutete das Ende der Teilung Berlins. Mit der Auflösung der DDR am 3. Oktober 1990 und der gleichzeitigen Wiedervereinigung Deutschlands wurden die Weichen für den Regierungsumzug von Bonn nach Berlin gestellt, der 1991 entschieden und 1999 vollzogen wurde. 1994 zogen die Alliierten und sowjetischen Streitkräfte aus Berlin ab.

Seit dem Jahr 1999 erfüllt Berlin seine Aufgabe als Hauptstadt eines wiedervereinigten Deutschland. Innerhalb weniger Jahre wurden Altbauten umgebaut und repräsentative Neubauten für die Regierung und Ministerien, Botschaften und Verbände errichtet. In Berlin bestand für das ausgehende 20. und frühe 21. Jahrhundert die einzigartige Situation, das Stadt- und Regierungszentrum einer historisch gewachsenen Millionenstadt vollständig neu zu planen und auch großteils neu zu errichten. Diese Situation wurde gemeistert, wobei

Since 1989

The fall of the Wall – on 9th November 1989 – meant the end of the division of Berlin. With the dissolution of the GDR on 3rd October 1990 and the simultaneous reunification of Germany, all was set for the relocation of the government from Bonn to Berlin, a move that was agreed in 1991 and carried out in 1999. In 1994, the Allies and the Soviet military withdrew from Berlin.

Since 1999, Berlin has been fulfilling its role as the capital of a reunited Germany. In a matter of only a few years, old buildings have been converted and prestigious new ones erected for the government, ministries, embassies and national associations. At the end of the 20th and start of the 21st century, a unique opportunity existed in Berlin to plan afresh in its entirety and in large measure to build anew the heart and governmental centre of a major, historically mature city. This was masterfully accomplished through the work of architects

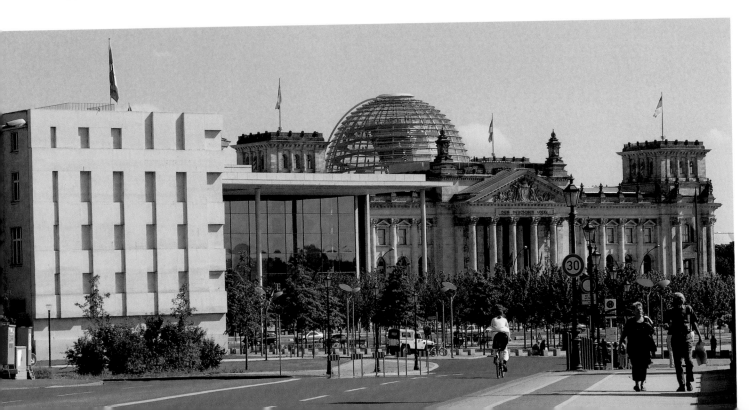

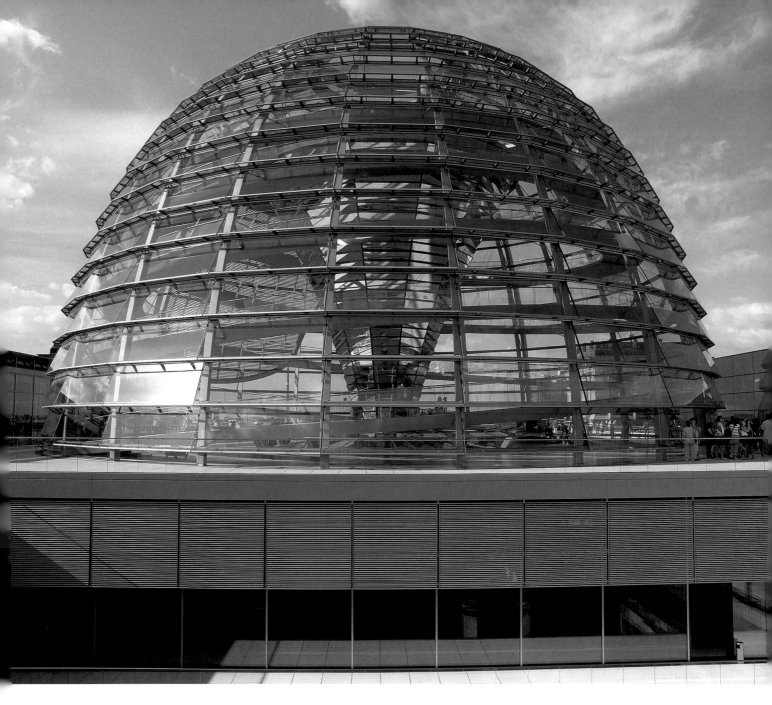

oben und S. 148: Reichstagsgebäude mit der Kuppel von Sir Norman Foster, 1994–99 (s. auch S. 128–129)

1993 erhielt der englische Architekt Sir Norman Foster den Auftrag für den Umbau des Reichstagsgebäudes zum Deutschen Bundestag. Der Bundestag beschloss 1995 entgegen Fosters ursprünglichem Entwurf und nach heftig geführten Diskussionen – Foster hatte zunächst ein baldachinartiges Dach über dem Gebäude vorgesehen – die Wiederherstellung einer ursprünglich vorhandenen Kuppel, jedoch in einer reduzierten und modernen Form. Die inzwischen berühmt gewordene begehbare Glaskuppel, die für die Öffentlichkeit zugänglich ist, sitzt direkt über dem Plenarsaal.

Above and p. 148: Reichstag building with Sir Norman Foster's cupola, 1994-99 (see also pp. 128-129).

In 1993, the English architect Sir Norman Foster was commissioned to remodel the Reichstag building as the 'Deutscher Bundestag', the German parliament building. In 1995, the Bundestag rejected Foster's original design, which had envisaged a baldachin-style roof over the building, and after heated discussions agreed to the reproduction of a dome, as had originally existed, albeit in a reduced, modern form. Sitting directly above the debating chamber, the glass cupola that the public are now able to access and walk around has since become famous.

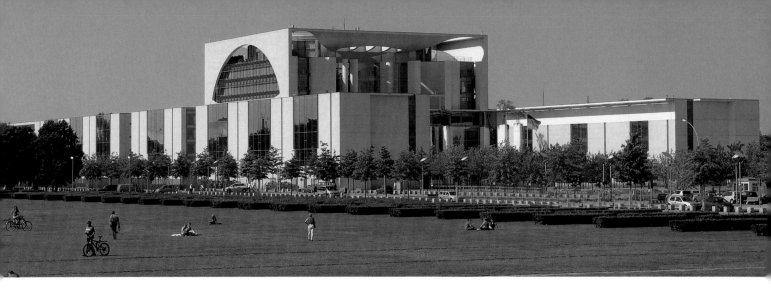

Architekten von Weltruf – Sir Norman Foster, Meinhard von Gerkan, Frank O. Gehry, Helmut Jahn, Josef P. Kleihues, Rem Koolhaas, Hans Kollhoff, Daniel Libeskind, Ieoh Ming Pei, Renzo Piano, Aldo Rossi und Oswald Mathias Ungers – tätig wurden.

Die Planungen sahen vor, die Regierungsbauten überwiegend im Spreebogen um das Reichstagsgebäude und im Bezirk Mitte nahe der sich kreuzenden Achsen Unter den Linden und Friedrichstraße anzusiedeln. Die Niederlassungen der Bundesländer entstanden unter anderem in der „Allee in den Ministergärten". Die Botschaften ließen sich z. T. an ihren Vorkriegsstandorten und im südlichen Tiergarten zwischen Klingelhöferdreieck und Kulturforum nieder.

of world renown, namely: Sir Norman Foster; Meinhard von Gerkan; Frank O. Gehry; Helmut Jahn; Josef P. Kleihues; Rem Koolhaas; Hans Kollhoff; Daniel Libeskind; Ieoh Ming Pei; Renzo Piano; Aldo Rossi and Oswald Mathias Ungers.

The plans proposed locating the government buildings predominantly on the bend of the Spree around the Reichstag building and in the district of Mitte near to the intersecting axes of 'Unter den Linden' and 'Friedrichstraße'. Many of the regional offices of the individual Federal States were built on 'Allee in den Ministergärten'. A number of embassies returned to their pre-war sites, while others were built in the southern part of the 'Tiergarten' between 'Klingelhöferdreieck' and the 'Kulturforum'.

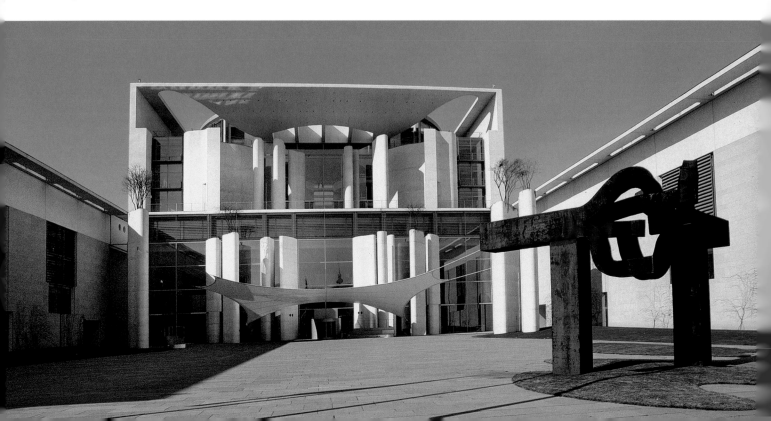

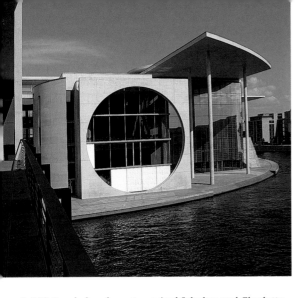

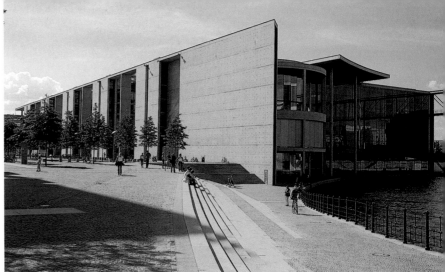

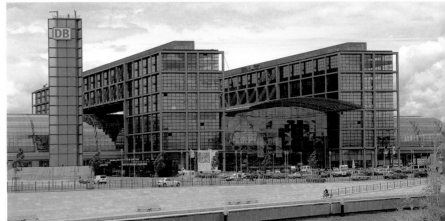

S. 150: Bundeskanzleramt von Axel Schultes und Charlotte Frank, 1997–2001
oben links und unten: Marie-Elisabeth-Lüders-Haus von Stephan Braunfels, 2000–2004, Abgeordnetenhaus
oben rechts: Paul-Löbe-Haus von Stephan Braunfels, 1997–2000, das 200 m lange und 100 m breite Abgeordnetenhaus
rechts: Lehrter Bahnhof (Invalidenstraße) – neuer Zentralbahnhof Berlins – von v. Gerkan, Marg & Partner, 1996–2006

p. 150: Bundeskanzleramt (Office of the German Chancellor), by Axel Schultes and Charlotte Frank, 1997–2001.
Above left and below: Marie-Elisabeth-Lüders-Haus by Stephan Braunfels, 2000–2004, government building.
Above right: Paul-Löbe-Haus by Stephan Braunfels, 1997–2000, government building, 200 m long / 100 m wide.
Right: Lehrter Bahnhof (Invalidenstraße) – Berlin's new central railway station – by v. Gerkan, Marg & Partners, 1996–2006.

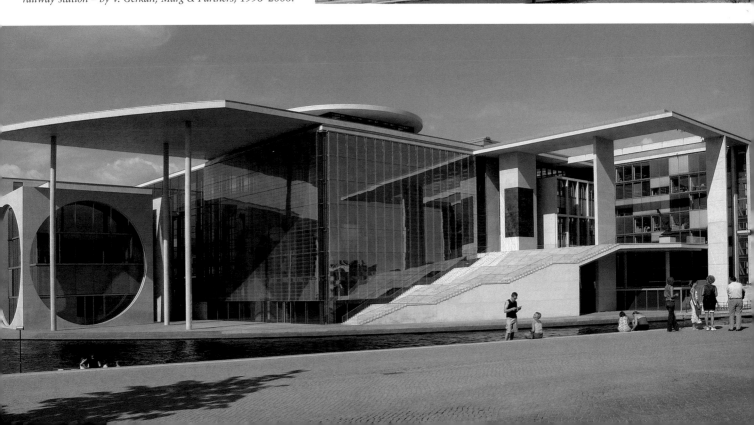

oben links: Bundesministerium des Innern (Alt-Moabit 98–101) von Kühn Bergander Bley, 1992–94
oben rechts: Bundespräsidialamt (Spreeweg 1) von Martin Gruber & Helmut Kleine-Kraneburg, 1996–98

Above left: Federal Ministry of the Interior (98-101 Alt-Moabit), by Kühn Bergander Bley, 1992–94.
Above right: Bundespräsidialamt (Office of the German President, 1 Spreeweg), by Martin Gruber & Helmut Kleine-Kraneburg, 1996–98.

Bundesministerium für Auswärtige Angelegenheiten (Werderscher Markt/Kurstraße 36) von Thomas Müller und Ivan Reimann, 1997–99.
unten: Botschaft Mexikos (Klingelhöferstraße 3) von Teodore González de León und J. Francisco Serrano, 1999–2000

Federal Ministry for Foreign Affairs (Werderscher Markt / 36 Kurstraße), by Thomas Müller and Ivan Reimann, 1997–99.
Below: Mexican embassy (3 Klingelhöferstraße), designed by Teodore González de León und J. Francisco Serrano, 1999–2000.

Botschaft Österreichs (Tiergartenstraße 12–14) von Hans Hollein, 1999–2001
unten: Botschaft Großbritanniens (Wilhelmstraße) von Michael Wilford, 1999–2000

Austrian embassy (12-14 Tiergartenstraße), by Hans Hollein, 1999–2001.
Below: British embassy (Wilhelmstraße), by Michael Wilford, 1999–2000.

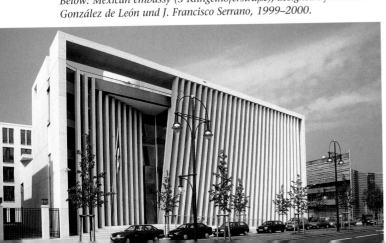

oben links: DZ-Bank
(Pariser Platz 3), Ansicht
zur Behrenstraße, von
Frank O. Gehry, 1997–
2000
oben rechts: Galeries
Lafayette (Friedrichstra-
ße 75) von Jean Nouvel,
1993–96
links: Erweiterungsbau
des Deutschen Histori-
schen Museums (Hinter
dem Giesshaus) von
Ieoh Ming Pei mit Eller
& Eller, 1999–2003

*Above left: DZ Bank (3
Pariser Platz), looking
towards Behrenstraße,
by Frank O. Gehry,
1997–2000.*
*Above right: Galeries
Lafayette (75 Friedrich-
straße), by Jean Nouvel,
1993–96.*
*Left: Extension to the
German Historical
Museum (on Hinter dem
Giesshaus), designed by
Ieoh Ming Pei with Eller
& Eller, 1999–2003.*

153

Die während der DDR-Zeit begonnene modernisierende Wiederherstellung des Bezirks Mitte wurde nach den Grundsätzen der „Kritischen Rekonstruktion" – wie schon während der Internationalen Bauausstellung von 1987 unter Leitung von Josef Paul Kleihues befürwortet (vgl. S. 143) – vorangetrieben. Die Planung fordert unter anderem die Blockrandbebauung, die sich an der geschlossenen Häuserbebauung des historischen Berlin orientiert. Einzelne Gebäude sollten nicht hervortreten, abgesehen von den für Berlin typischen markanten Eckgebäuden, die abgerundet oder mit einem Turm versehen sein können. Bevorzugt werden sollten traditionelle Baumaterialien. Der Pariser Platz mit dem Brandenburger Tor sollte seine alte Fassung zurückerhalten.

Der Potsdamer Platz, einst verkehrsreichster Platz Europas, 1989 Brachland auf dem Mauerstreifen, erhielt westseitig Hochhäuser, die als eine Art Tor in die scheinbar gewachsene Blockrandbebauung des debis-Areals bzw. zum Sony Center überleiten. In Absetzung von der Hochhausstadt US-amerikanischen Musters sollen die Hochhäuser hier nur Akzente setzen, wie sie in Berlin ähnlich die beiden Wohntürme am Frankfurter Tor (1957–60) oder die Kirchtürme am Gendarmenmarkt bilden.

The modernising restoration of the district of Mitte, begun during the GDR era, was continued based on the principles of 'Critical Reconstruction' – as already advocated during the 1987 International Building Exhibition directed by Josef Paul Kleihues (cf. P. 143). The plan called, amongst other things, for perimeter block development leaning on historic Berlin's enclosed style of construction. Individual buildings should not stand out, with the exception of striking corner buildings, typical of Berlin, which can be rounded or finished off with a tower. Traditional building materials should be used wherever possible. Pariser Platz, complete with the Brandenburg Gate, should be returned to its former state.

Potsdamer Platz, once the busiest square in Europe and in 1989 lying idle next to the Wall, was given high-rise buildings on its west side that act like a gateway leading into the seemingly mature perimeter block construction of the Debis Area and Sony Center. In contrast to American-style high-rise cities the tall buildings here are simply meant to create a mood, as is done likewise in Berlin by the high-rise flats (1957-60) at the 'Frankfurter Tor' and the church towers at Gendarmenmarkt

Holocaust-Mahnmal (Behrenstraße) von Peter Eisenman, 2001–05, Denkmal für die Ermordung von 6 Mio. Juden im Dritten Reich auf einem 19000 qm großen Gelände südlich des Pariser Platzes, bestehend aus rund 2700 unterschiedlich hohen Stelen

Peter Eisenman's 2001-05 Holocaust Memorial (Behrenstraße). In remembrance of the murder of 6 million Jews during the Third Reich, the memorial, made up of 2,700 slabs of varying heights, covers an area of 19,000 square metres to the south of Pariser Platz.

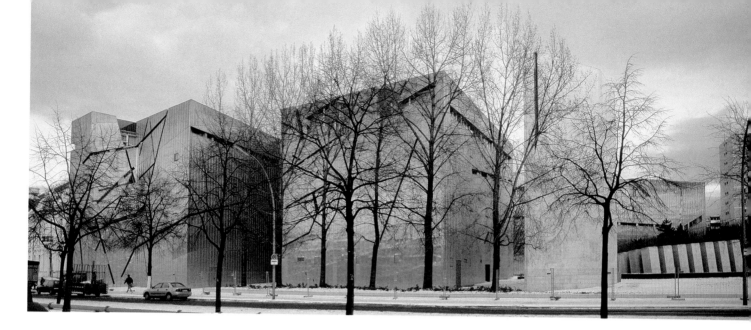

Jüdisches Museum (Lindenstraße 14 in Berlin-Kreuzberg) von Daniel Libeskind, 1992–99

Der neue Museumsbau ist eine große begehbare Plastik, eine symbolbeladene, zeichenhafte Architektur. Er hat die Form eines Blitzes bzw. eines gebrochenen, langgezogenen Davidsterns, dessen irrationaler Charakter durch die silbern glänzende Zinkverkleidung verstärkt wird. Innerhalb des Gebäudes nehmen drei Achsen Bezug auf die Geschichte des Judentums in Berlin. Sie werden als drei „Schicksalswege" interpretiert: Ein Weg führt in die Sackgasse des „Holocaust-Turmes", der zweite in den „E. T. A. Hoffmann-Garten", der die Flucht ins Exil markiert, der dritte Weg (des Lebens, der deutsch-jüdischen Symbiose) führt über eine Prachttreppe in die Ausstellungsgeschosse.

Jewish Museum (14 Lindenstraße in Berlin's Kreuzberg district), by Daniel Libeskind, 1992–99.
This new museum building is a large walk-through sculpture, a heavily symbolic, figurative piece of architecture. It is in the shape of a bolt of lightning or a broken, elongated Cross of David, with its irrational character further emphasised by its shining, silver zinc cladding. Inside the building, three axes relate to the history of Jews in Berlin. They are interpreted as three 'paths of fate': One route leads into the dead-end of the 'Holocaust Tower', the second into the 'E.T.A. Hoffman Garden', signifying flight into exile, and the third (that of life and German-Jewish symbiosis) leads via a grand staircase into the exhibition area.

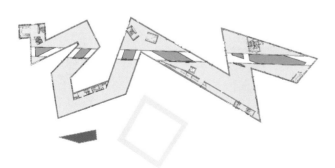

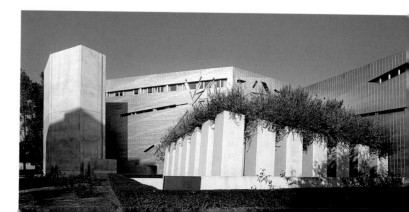

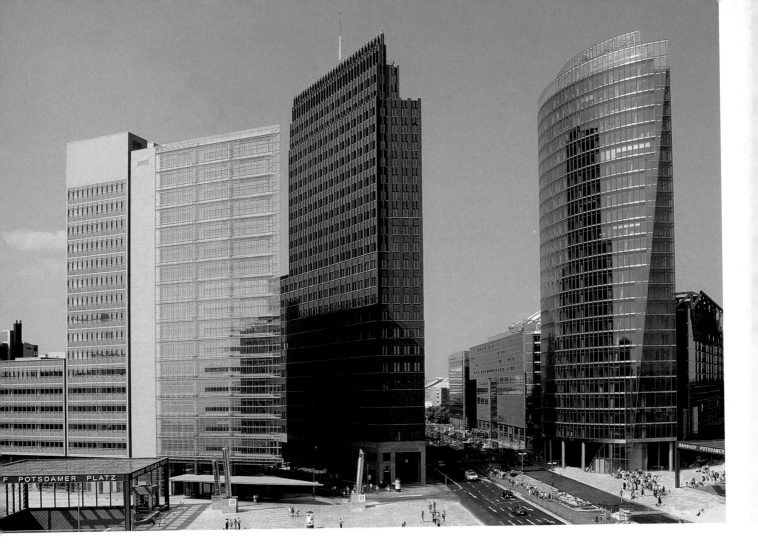

Potsdamer Platz

Der Potsdamer Platz gilt als Symbol für den Wiederaufbau der Berliner
Innenstadt und das Zusammenwachsen von Ost- und West-Berlin
nach 1989. Als Ergebnis des Wettbewerbs von 1991 entschied man
sich für eine dichte, mittelhohe Bebauung als Typus einer europäi-
schen Großstadt im Gegensatz zu einer amerikanischen „Hochhaus-
stadt". Lediglich unmittelbar am Potsdamer Platz stehen zwei etwa 90
m hohe Häuser als städtebaulicher Akzent. Auf dem südlichen Areal
von DaimlerChrysler entstanden im Zeitraum zwischen 1993 und
1999 Einzelgebäude in modern-traditioneller Bauweise mit Steinver-
kleidungsmaterialien nach Entwürfen verschiedener Architekten. In
den Proportionen und Baumaterialien gehen die Bauten auf die gestal-
terisch ebenfalls hochwertigen Bauten des Kulturforums ein. Das nörd-
liche Sony-Areal geht dagegen auf ein einheitliches Gesamtkonzept
von nur einem Architekten, dem Deutsch-Amerikaner Helmut Jahn zu-
rück und steht als moderne Stahl-Glasarchitektur, die zwischen 1996
und 2000 erbaut wurde, im Kontrast zur umliegenden Bebauung.
Das 88 m hohe, mit rotem Klinker verkleidete Hochhaus (1994–1999)
von Hans Kollhoff & Timmermann steht an der nördlichen Spitze des
DaimlerChrysler-Areals am Potsdamer Platz und bildet zusammen mit
dem 103 m hohen gläsernen Sony-Turm von Helmut Jahn und dem

Potsdamer Platz
*Potsdamer Platz is seen as a symbol of the reconstruction of Berlin's
city centre and the fusion of East and West Berlin post 1989.
Following a competition run in 1991, dense, medium height devel-
opment of the area was agreed upon as being typical of a major
European city in contrast to an American 'high-rise metropolis'.
There are thus just two buildings 90 metres high, standing directly
on Potsdamer Platz to provide architectural flair. Between 1993 and
1999, a number of individual buildings were built to designs by a
variety of architects on the southern DaimlerChrysler area. These
are of modern/traditional construction, with stone cladding. In
terms of their proportions and materials they reflect the
Kulturforum's buildings of equally high architectural quality. By
contrast, the northern Sony area is based on one complete holistic
concept by a single architect, the German-American Helmut Jahn.
As a piece of modern steel and glass architecture, which was built
between 1996 and the year 2000, it stands in contrast to the sur-
rounding buildings.
Three buildings form a striking high-rise ensemble on Potsdamer
Platz: Hans Kollhoff & Timmermann's 1994-99, red clinker clad,
88-metre tower on the northern tip of the DaimlerChrysler area;*

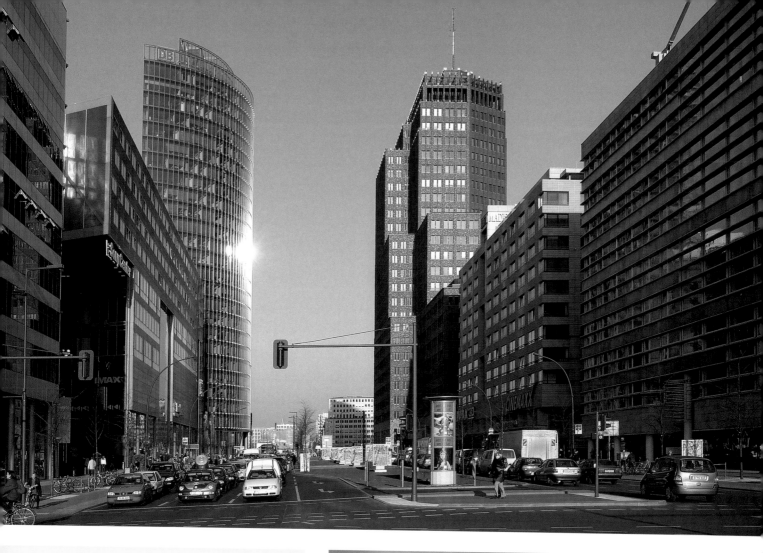

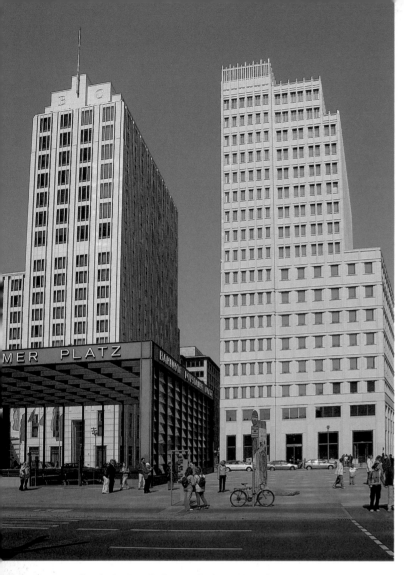

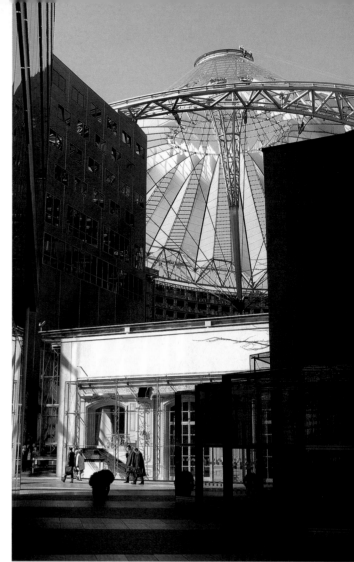

oben links: Ritz Carlton Berlin von Hilmer/Sattler/Albrecht, 2003–2004, und Delbrück-Haus von Hans Kollhoff, 2002–2003, am Potsdamer Platz

oben rechts und S. 159: Sony Center am Potsdamer Platz

ockerfarbenen und teilverglasten Büro-Hochhaus von Renzo Piano das markante Hochhausensemble des Potsdamer Platzes.

Das Sony Center gehört zu den eindrucksvollsten Neubauquartieren Berlins. Die großen verglasten Baukörper gruppieren sich um einen riesigen ovalen Platz, dem Sony Plaza, mit Cafés, Restaurants, Geschäften und Kinos. Sein gläsernes Zeltdach ist eine Stahlseil- und Stabkonstruktion, die ohne einen Mast auskommt und gleichsam über dem Platz zu schweben scheint. Das Dach ist eine Ingenieurleistung ersten Ranges. Reste des ehemaligen Luxushotels Esplanade von 1911 sind in den Neubau integriert. Dabei handelt es sich um die Innenräume „Frühstückssaal" und „Kaisersaal". Letzterer wurde 1996 in einer spektakulären Aktion hydraulisch um 75 Meter versetzt. Dabei mussten 1300 Tonnen bewegt werden.

Above left: Ritz Carlton Berlin by Hilmer/Sattler/Albrecht, 2003–2004, and Delbrück-Haus by Hans Kollhoff, 2002–2003, at the Potsdamer Platz

Above right and page 159: Sony Center at the Potsdamer Platz

Helmut Jahn's 103-metre-high, glass Sony tower; and Renzo Piano's ochre-coloured and partially glazed office tower block.

The Sony Center is one of the most impressive newly built areas of Berlin. The large glass-fronted buildings group themselves around the huge, oval Sony Plaza with its cafés, restaurants, shops and cinemas. Its glass, tent-like roof is a steel wire and spoke construction that requires no mast and appears to sway above the Plaza. It is an engineering feat par excellence.

Remnants of the former luxury hotel, the 'Esplanade', built in 1911, have been integrated into the new structure. The rooms involved are the 'Breakfast room' and the 'Kaisersaal', which in 1996 was repositioned by 75 metres in a spectacular process using hydraulics to move the room's 1,300 tons!

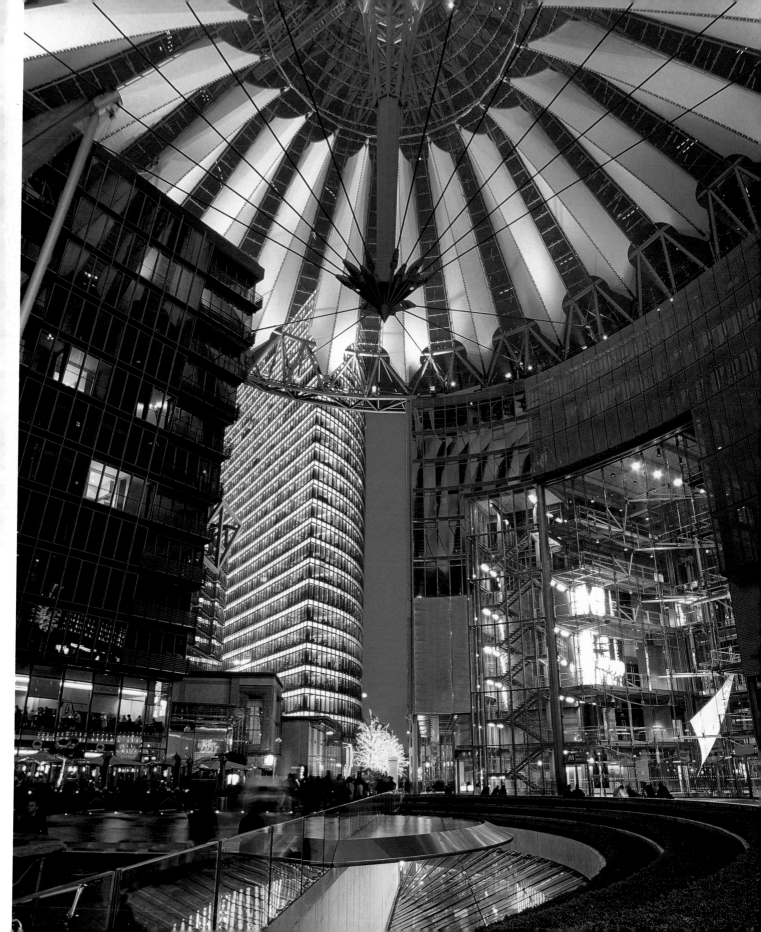

Register / Index

Text/Fotos/photos: Michael Imhof
Translation: Jonathan Darch

Bildnachweis/images: Alle Bilder/All images Michael Imhof und Michael Imhof Verlag (9, 11, 27, 32, 33, 37, 61, 70 oben/above: Reproduktionen nach Faksimile/reproductions of facsimile) außer/except Titel/title (Nefretete), 47, 54, 55, 59, 97, 101, 107-115, 144, 147: Bildarchiv Preußischer Kulturbesitz; 35 oben/above, 45, 54,55: Stiftung Preussische Schlösser und Gärten Berlin-Brandenburg; 31 unten/below: Stefan Müller, Berlin; 137: Deutsche Fotothek; 139 links unten/below left: DDR-Museum.

© 2. Aufl. 2009 Michael Imhof Verlag GmbH & Co. KG
Stettiner Straße 25, D-36100 Petersberg, Tel. 0661/962 82 86; Fax 0661/6 36 86
www.imhof-verlag.de

Reproduktion und Gestaltung/reproduction and design: Michael Imhof Verlag
Druck/Print: Himmer AG

Printed in EU

ISBN 978-3-86568-100-3